Sound Art

First published in the United States in 2007 by
Rizzoli International Publications, Inc.
300 Park Avenue South
New York, NY 10010
www.rizzoliusa.com

2010 / 10 9 8 7 6 5 4 3

ISBN 10: 0-8478-2969-3
ISBN 13: 978-08478-2969-9

Library of Congress Catalog Control Number: 2007926151

Designed by Emily Lessard and Willy Wong

Printed in China

Sound Art

Beyond Music,
Between Categories

Alan Licht

Foreword by Jim O'Rourke

Contents

Foreword

EVERYONE HAS A DIFFERENT POINT AT WHICH
THEY ARRIVE AT THE QUESTION "IS ART SOUND,
AND IS SOUND ART?" First separating sound from music can lead
someone down a path of falling under the spell of the sound of an empty
coffee can, and quite possibly be suitably satisfied. Others may feel the need
to return that coffee can back to the counter and set it into some kind of
constellate that organizes sounds into space. If that can is suitably attractive,
it may come to mind that the sound is married to that can, and what that
can means in a larger social sense. It's quite possible the absence of the coffee,
or more precisely the sound of the coffee, would lead to some reverie over
whether sounds have lives of their own, and if they miss each other when they
leave. This most usually leads to trying to find the sound which is not a
sound, which in its lack of soundness implies all sounds and we're right where
we started. So, in short, sound art may well be what you call it, and where
you are coming from. If you're an artist, in the (relatively) traditional sense, and
you find that neon tube is better heard and not seen, it could be sound art.
If you're a musician and the sound of the piano lid closing on someone's fingers,
who just can't seem to correctly play the rhythms derived from the gravita-
tional pull of the sun, you may well have some sound art. Of course, that's up
to you. This book examines a wide range of possibilities of redefining not
only the context in which sound is presented and framed, but in how we choose
to look at it. And when you look at sound, you may ask yourself, is it sound
or is it art, and we're right back where we started.

— JIM O'ROURKE

What is Sound Art?

SOUND ART AS A TERM

Sound art is a term that has been used with increasing frequency since the late 1990s but with precious little in the way of an accompanying, agreed-upon definition. As with many art movements, some of sound art's chief practitioners, who predate the appellation "sound art," are mistrustful of the term itself. What follows are three considerations of the term by three artists who take sound as their primary medium: Annea Lockwood and Max Neuhaus, who have been exploring sound as a natural element and new form of composition away from the concert hall and even instrumentation since the '60s, and an artist who has blurred the lines between the art world and music world over the past twenty-five years—Christian Marclay. That none of them seem to endorse the term is illuminating; while artists frequently resist critical categorization, in this case, it also pinpoints the confusion over what—and whom—"sound art" really refers to.

ROLF JULIUS
Music for the Eyes, 2003.
Installation at Frac
Limousin, Limoges, France.

Sound art. I find it a useful term, but why? I apply it to the pieces I make
using electroacoustic resources, and which I intend to be presented in
galleries, museums, other places in which sound is, increasingly, con-
ceived of as a medium per se, like video, lasers, but not as performance.
For example, I'm currently working on a large audio installation, *A Sound
Map of the Danube,* which I think of as Sound Art. I also recently finished
a commission for the All-Stars band, which it wouldn't cross my mind
to call "sound art." That's the big difference for me, between music and
sound art. There's some distinction to do with the conceptual, also.
I think maybe what's termed "Sound Art" doesn't intend connection to
the linguistic. Eventually, all styles of performance music become lan-
guages, even [John] Cage's antilinguistic works, as people become more
and more familiar with his intentions and sound worlds. Nevertheless,
perhaps the term was pragmatically conjured up for/by museum cura-
tors to account for sound's acceptance into their world.[1]

—ANNEA LOCKWOOD

When faced with musical conservatism at the beginning of the last cen-
tury, the composer Edgard Varèse responded by proposing to broaden
the definition of music to include all organized sound. John Cage went
further and included silence. Now even in the aftermath of the timid
"forever Mozart decades" in music, our response surely cannot be to put
our heads in the sand and call what is essentially new music something
else—"Sound Art" ... If there is a valid reason for classifying and nam-
ing things in culture, certainly it is for the refinement of distinctions.
Aesthetic experience lies in the area of fine distinctions, not the destruc-
tion of distinctions for promotion of activities with their least common
denominator, in this case, sound. Much of what has been called "Sound
Art" has not much to do with either sound or art.[2]

—MAX NEUHAUS

LOCKWOOD
Piano Garden

NEUHAUS
Southwest Stairwell

Well, I think it's great that there is this interest in sound and music, but the overall art-world structures are not yet ready for that, because sound requires different technology and different architecture to be presented. We still think of museum galleries as nineteenth-century galleries, like "How do we hang this on the wall, how do we light it?" But nobody knows anything about sound—how you hang a speaker, how you EQ it to the room. There isn't that kind of knowledge and expertise within the museum world. More and more museums have a lounge-type listening room, but there are still a lot of changes that need to happen before the art world is ready to present sound as art. And, you know, it doesn't matter because there are so many ways for people to enjoy sound these days. Sound is so easily diffused, spread around through the internet, downloaded to portable MP3 players and Walkmans, you name it. Everything is so portable and so easy to share that you don't need an art institution to tell people what to listen to. I think it is in sound's nature to be free and uncontrollable and to go through the cracks and to go places where it's not supposed to go.[3]

—CHRISTIAN MARCLAY

The term sound art dates back to William Hellermann's Sound Art Foundation, founded in 1982, which primarily seemed to work with "experimental music" or "new music," although it did organize an early show of sound sculpture and other exhibitable work at the Sculpture Center in 1983. A rash of high profile exhibitions at the turn of the century brought the term to greater familiarity while causing a lot of confusion as to what it actually referred to. *Sonic Process: A New Geography of Sounds* (Museu d'Art Contemporani de Barcelona, 2002) and *Bitstreams* (Whitney Museum of American Art, New York, 2001) dealt specifically with interfaces between digital art and electronic music and included electronic musicians like Coldcut or Matmos and experimental musicians like Elliott Sharp, Andrea Parkins, and David

Shea; *Sonic Boom* (Hayward Gallery, London, 2000) likewise featured
'90s electronic group PanSonic alongside veteran sound sculptors like Max
Eastley and Stephan von Heune and sound installationists/recording artists
Brian Eno, Paul Schutze, and Thomas Koner. The sound component to the
Whitney's survey of modern American art, *American Century,* was called
I Am Sitting in a Room and mostly consisted of recordings of experimental
music works by composers, despite the subtitle of *Sound Works by American
Artists 1950–2000. Volume: Bed of Sound* (P.S. 1, New York, 2000) similarly
functioned as a survey of experimental music, rather than sound art; unfor-
tunately presented to listeners on CD players with headphones or competing
with each other in a large space, it managed to include some bona fide sound
artists (Neuhaus, Ben Rubin) but also threw in experimental pop and rock
groups (Cibo Matto, Sonic Youth, the Residents, Yamataka Eye), experimen-
tal/electronic composers (David Behrman, Joel Chadabe, Tod Dockstader),
free-jazz composers (Butch Morris, Ornette Coleman, Muhal Richard
Abrahams), and rock stars like Lou Reed (who deserves some recognition
as an experimental musician but should not be considered a sound artist).

 None of these exhibitions purported to be an exhibition of sound art per
se, but as a result, there has been a tendency to apply the term "sound art"
to any experimental music of the second half of the twentieth century,
particularly to John Cage and his descendents. Cage himself redefined music
as "an organization of sound" rather than a composition of melody and
harmony, but what is more important is his contention that music is every-
where, in all sounds—that all sounds can be music. His statement can be
taken two ways—that all sounds can be listened to as music or that they can
be used as musical material by composers. Therefore, he is still thinking in
terms of music, itself already an established art form, with sound as a poten-
tial tool for composition as opposed to another art medium in and of itself.
Sound art has also been applied retroactively to noise music, sampling, and
various forms of musical collage. The use of concerts and performance delin-

ENO
Glint

CAGE
Cartridge Music

eates these genres as music (i.e., time-based) rather than sound art, although noise in particular may come under the heading of "sound by artists" given the tradition of noise-making by the Dadaists as an extension of their visual and literary activities. As Michael J. Schumacher put it, "Looking at a pair of speakers on a stage totally undermines appreciation of the work"—sound art is not about a stage show.

Calling oneself a "sound artist" lends a certain legitimacy that "experimental musician" may not have. Even the term "experimental," in many people's minds, may have some psychological indication that the musician may not know what they're doing (or that the listener can't understand what they're doing), which, however erroneous and unfair, still strikes an unwanted undertone of semiprofessionalism as a calling card.

Music, like drama, sets up a series of conflicts and resolutions, either on a large or small scale (it can be as small as a chord progression resolving to the tonic chord or as large as a symphonic work that adheres to the narrative arc complete with exposition, climax, denouement, and coda). A friend recently commented that avant-garde art is now commercially viable and extremely successful, whereas avant-garde literature, music, and film are usually uncommercial and generally unsuccessful. He's right, but that is because art doesn't have the inherent entertainment value of a narrative that those other art forms have. It doesn't have to appeal to the masses to be successful—as long as it catches one collector's (or curator's) attention, the person who created it can make a fair amount of money from it. Literature, music, and film, however, depend on popular opinion and public demand. This is because they're the primary sources of entertainment besides sports. And *that* is because of the potential to be engrossed by a storyline and characters, dazzled by spectacle, or have a catchy tune stuck in your head all day. If an effort in any of these disciplines fails to live up to this potential, it's largely considered to be a disappointment; in fact, it's *intrinsically* disappointing regardless of its actual aesthetic worth. Part of the reason "sound art" has become such a popular term

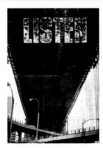

NEUHAUS
Listen

is because it rescues music from this fate by aligning this kind of sound work with the aims of non-time-based plastic arts, rather than the aims of music.

Sound art belongs in an exhibition situation rather than a performance situation—that is, I would maintain, a necessary correlative in defining the term (although one could point to Indian sand paintings, which are erased after a day, as an example of artwork whose rejection of permanence is similar to live music performance). Music, especially pop music, unlike sound art, is like an amusement park ride: there's a beginning, middle, and an end to it; it's a short, consolidated experience of thrills and chills that can be readily reexperienced by simply going on the ride again, listening to the song again. Sound art, besides its intended connotation of (or literal inducement of) a trip to a gallery or a museum, can also be like a trip to the zoo, the dog pound, the park, the moon, or to your fridge, depending on its (or one's) orientation.

Sound art rarely attempts to create a portrait or capture the soul of a human being, or express something about the interaction of human beings—its main concern is sound as a phenomenon of nature and/or technology (this is yet another factor in its lack of mass appeal). Even sound poetry, which is sometimes classified as sound art, is bent on exploding language and exploring the varieties of vocal sound that can be produced by the human body rather than using the voice to communicate to the listener in the usual fashion. Only as the visual arts became increasingly abstract would the idea of sound art, as opposed to music, find fertile ground.

VISUAL VS. AURAL/SOUND VS. SILENCE

"The sense of hearing cannot be turned off at will. There are no earlids."
—R. MURRAY SCHAFER

While it may be true that we gather the majority of our information visually, and that we are more responsive to visual than aural stimuli, as light is

faster than sound (even Varèse admitted that "Art means keeping up with the speed of light"), it's equally true that no one is comfortable with silence any more than they're comfortable with darkness.[4] Both visual and aural information are not only essential to survival in any environment, to hear something that may be unseen and pose a threat, but sound can also indicate aliveness, even to an anthropomorphic degree. Sound also connotes companionship; part of the appeal of radio and records is simply that a voice is speaking or singing to the audient and engaging them in some way. Likewise ambient sounds remind the listener of his own presence in a living world, rather than an empty void. Even when reading, we "hear" in our heads, our own voice reciting the words, or if we're feeling particularly imaginative, another voice takes on the narrative. And we're always trying to find something to look at when faced with a sound that has no visual counterpart—no one listens to the radio in the dark, or closes their eyes when they're on the telephone. Look around: people driving with the radio on, walking around with headphones plugged into a Walkman or an I-Pod, creating their own soundtrack of prerecorded sound to replace the ambient sound that reality is surrounding them with.[5] I distinctly remember once putting on Steve Reich's *Music for 18 Musicians* at a particularly scenic highway expanse in Oregon because I knew the music would go well with the landscape and the speed of the van we were traveling in. Of course, there's a kind of layering of sound going on, as the sounds of civilization that a Walkman or an I-Pod are drowning out are already drowning out a natural soundscape that has been paved over. Muzak once served this purpose, reducing popular tunes to a generic instrumental common denominator that would soothe but not distract with the force of human expression or personality; often called aural wallpaper, calling it "aural air freshener" would be more appropriate since it masks either unwanted sounds or silence.

While visiting a museum, painting or sculpture is traditionally intended to inspire quiet contemplation; however, audio tours provide an aural guide

JULIUS
Music for the Eyes

even though most artworks are labeled with relevant information and back-ground. Ed Osborn has started a website called Audio Recordings of Great Works of Art (www.auralaura.com) in which he records the sounds made by visitors to household-name sculptures and paintings in museums around the world (the Venus de Milo, the Mona Lisa, etc.). And conceptual artist Lawrence Wiener has commented:

> When you look at a painting in a gallery you hear somebody talk behind you about their feet hurting. You hear all the noises around you. You start to talk to other people and that is how you see art. So why not hear it as well as see it all at the same time? But it is not a *Gesamtkunstwerk*. Every-thing is moving along at the same time. They are all growing. There is not one dominant.[6]

Visiting a sound art installation also requires quiet contemplation to allow for listening, but it doesn't always escape music's identity as a time-based art. As is the case with much video art (some of the early Bruce Nauman video pieces, like *Clown Torture,* come to mind), many sound artworks are one-liners. Too often an electronic signal is set up by a chain of effects and left to run in a room on its own, and the result is merely decorative. In this sense the nonperformative aspect of sound art makes it challenging to sell to the viewer or, to hold the viewer's attention because the gallery setting makes it easy for someone to just drift in and out, the way they would take a quick look to see if a painting or sculpture catches their eye, and then move on to the next location.

Sound art, then, rejects music's potential to compete with other time-based and narrative-driven art forms and addresses a basic human craving for sound. For the purposes of this study, we can define sound art in three categories:

1. An installed sound environment that is defined by the space (and/or acoustic space) rather than time and can be exhibited as a visual artwork would be.

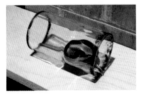

RODEN
Fulgurites

VITIELLO
*Fear of High
Places
and Natural
Things*

2. A visual artwork that also has a sound-producing function, such as sound sculpture.
3. Sound by visual artists that serves as an extension of the artist's particular aesthetic, generally expressed in other media.

The Origins of Sound Art in the Disjunction of Sound and Image

Centuries ago, sound mixed with visual art in the church. As Don Goddard has written, "motets, oratios, cantatas, requiems, fresco cycles, and altarpieces intoned or depicted the same subject matter, while architecture provided vaulted spaces for the acoustics and illusions of music, painting, and sculpture."[7] With the advent of the concert hall in the nineteenth century and the growth of cities and secular thought, the arts began to disperse from this meeting ground.

Music and movement have been combined most obviously in dance throughout history. Synaesthesia, the ongoing dialogue between the visual and music/sound, and the efforts of many to *illustrate* music or sound, either synchronously or asynchronously, particularly in the age of the moving image, has been documented in recent large-scale exhibitions like *Sons et Lumière* (Centre Pompidou, Paris, 2004) and *Visual Music* (organized jointly by the Museum of Contemporary Art, Los Angeles, and the Hirshhorn Museum, Washington, D.C., 2005) and the smaller *What Sound Does a Color Make?* (also 2005). Color organs, Piet Mondrian, and Wassily Kandinsky's music-inspired paintings, animation to music by Oskar Fischinger, the Whitney Brothers, Jordan Belson, and Walt Disney's *Fantasia,* Tony Conrad's flicker films, and late 1960s psychedelic light shows are all well worth experiencing but certainly are not sound art; similarly, video works that show a live interaction between a soundtrack and the image function as a codependent relationship between sound and image. MTV has become a mainstream example of the codependency of image and sound and has often been criticized for branding songs with a definitive illustration, limiting

TRIMPIN
Fire Organ

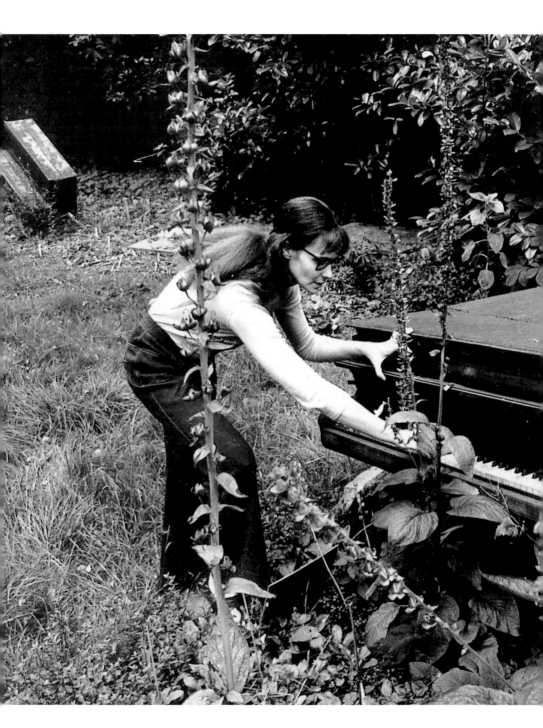

ANNEA LOCKWOOD
Piano Garden, c. 1970. Photo by Chris Ware.
© Keystone Press Agency Ltd.

THE SPACE IS IN THE
SHAPE OF A SQUARED
SPIRAL. LIKE MANY
STAIRWAYS OF THIS
KIND, IT HAS A SENSE
OF LABYRINTH: A FEELING
OF DISLOCATION OCCURS
AS ONE TURNS ITS
ENDLESS CORNERS AND
FINDS A SEEMINGLY
ENDLESS SUCCESSION OF
IDENTICAL PLACES AT
EACH LANDING.

THE WORK IS FORMED
FROM A SUCCESSION OF
TIMBRES. EACH OF THESE
SOUND COLORS HAS AN
ELEMENT IN COMMON WITH
ITS NEIGHBOR. THEIR
GRADUAL PROGRESSION,
LEADING FROM LANDING
TO LANDING, JOINS TWO
DISTANT SOUNDS AT THE
STAIRWAY'S EXTREMES.

MAX NEUHAUS

Southwest Stairwell, 1992. Colored pencil on paper. 32 x 20 inches (left) and 32 x 13 inches (right). Documentation of a sound work at Ryerson University, Toronto, Canada. Dimensions of the final work: 13 x 10 x 65 ½ feet. Extant fall 1968. The drawing includes Neuhaus's hand-written description of the original sound piece.

BRIAN ENO
Glint, 1986. Flexi-disc included with *Artforum*
magazine. Courtesy the author's collection/Artforum

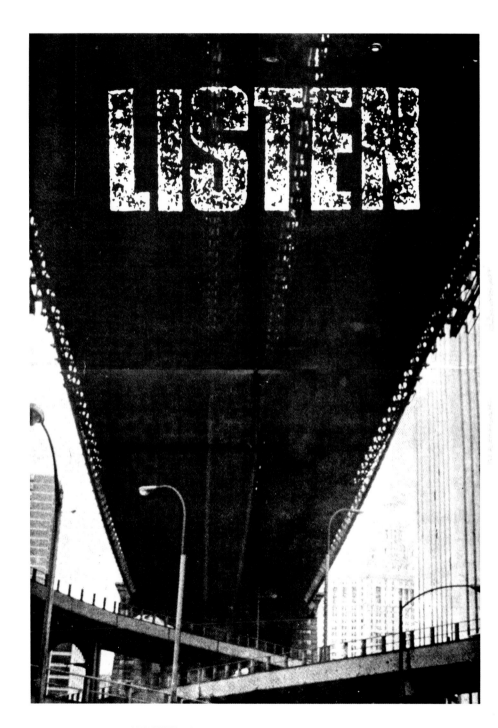

MAX NEUHAUS

Listen, 1976. This poster refers to his "Listen" series, which were "field trips" to listen to sounds guided by the artist (begun in 1966). This work was inspired by the sounds of traffic on the Brooklyn Bridge.

JOHN CAGE
Cartridge Music, 1960. A graphic score consisting of twenty pages of irregular shapes and four sheets of transparencies. The performer chooses one page and then overlays the transparencies on top. Henmar Press Inc. Used by permission

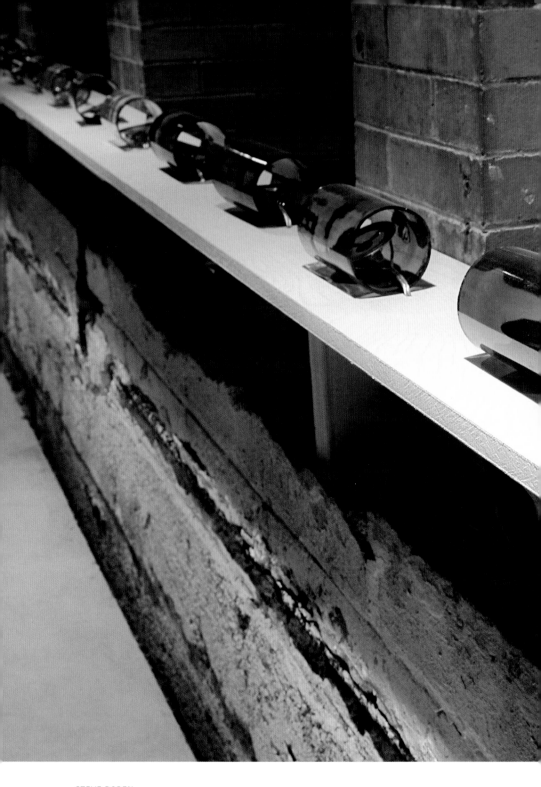

STEVE RODEN
Fulgurites, 2004. Speakers and glass bottles. Installation view at the Sculpture Center, New York City.

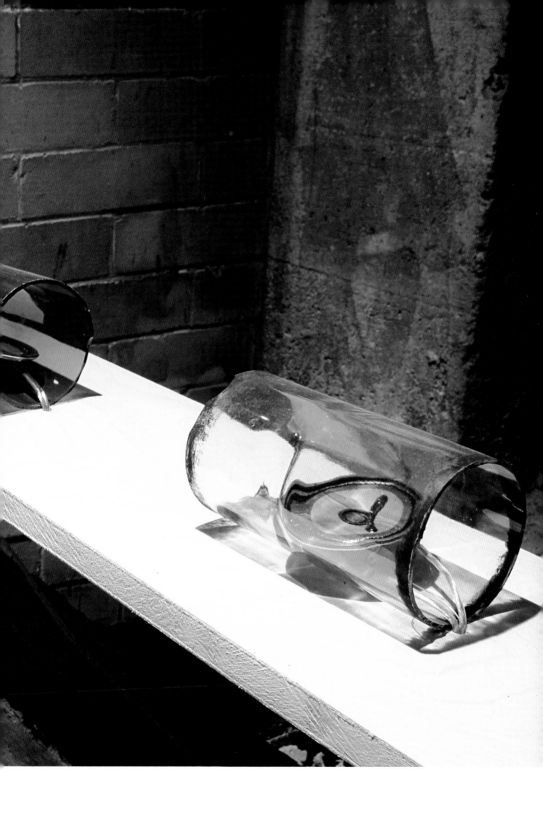

STEVE RODEN

Fulgurites (detail)

STEVE RODEN
Moon Field, 2002–3. Sculptural sound installation. Dimensions variable. Collection Museum of Contemporary Art San Diego. Also pictured (in window) is Robert Irwin, *1° 2 ° 3° 4°*, 1997. Apertures cut into existing windows. Collection Museum of Contemporary Art San Diego. © 2007 Robert Irwin/Artists Right Society (ARS)

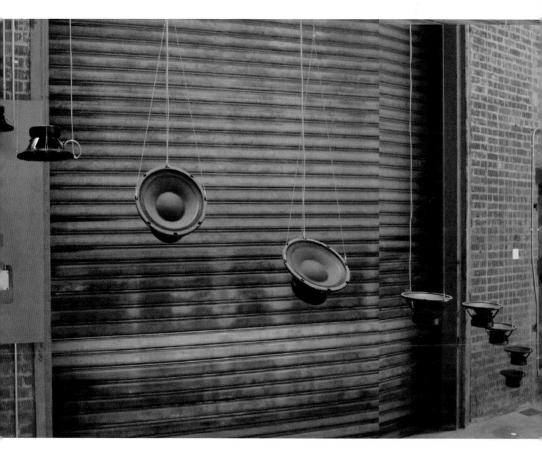

STEPHEN VITIELLO
Fear of High Places and Natural Things, 2004. Modified CD player,
stereo CD, nine 10-inch speakers. Courtesy of the artist and
The Project, New York City. (Special thanks to Vito Acconci)

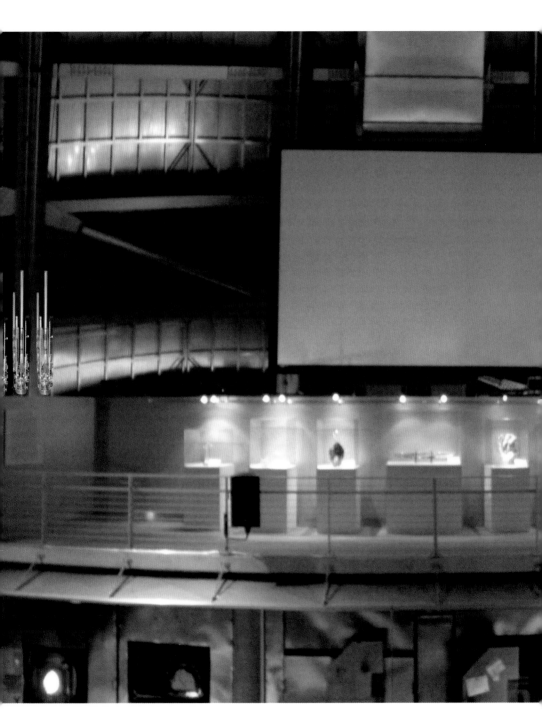

TRIMPIN

Fire Organ, 2006. Glass tubes. Dimensions variable.
Museum of Glass, Tacoma, Washington.

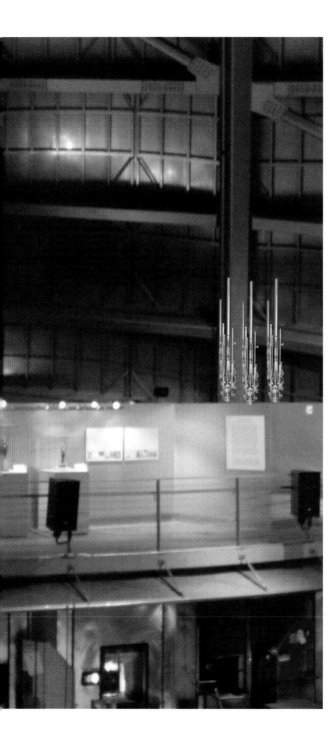

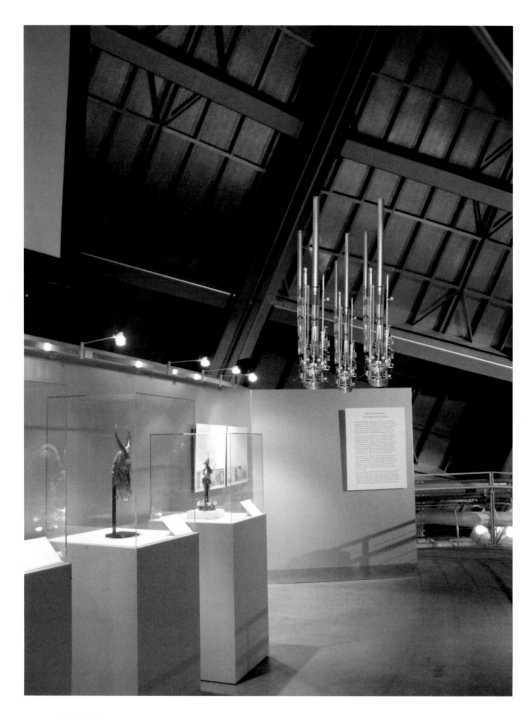

TRIMPIN
Fire Organ (detail)

the imagination's ability to come up with its own interpretation of how the music translates into visions. The focus on sound that ultimately would find its way to a genre of sound art started with the invisibility of sound through recording and radio and telephone transmission and continued through the *disjunction* of sound and image.

Disembodied Voices: Telephone, Radio, and Cinema

With the inventions of the telephone and the radio, human beings had their first technological experience of hearing each other's voices and other sounds come out of a device. An early forerunner of Muzak also grew out of the telharmonium, an instrument developed in the late 1890s that would pipe music (played on multiple keyboards) into different businesses and public areas by using the principles of the telephone receiver and transmission through installed loudspeakers.

In 1925 Kurt Weill called for an "absolute radio" to coincide with the "absolute cinema" (which did not tell a story but consisted of a montage of pure images), with noises, sounds of nature, and "unheard sounds" that could be produced by the manipulation of the electronics of microphones.[8] In silent films, human activity, depicted more realistically than ever before, and the world were rendered mute; pianists had to be brought in to break the silence (and mask the sound of the projector), while inter-titles and even "lecturers" were brought in to explain the action to audiences (much like a museum guided tour, come to think of it). Phonograph records and carnival barkers were also used early on to provide sound accompaniment to films, but as films got longer, records (which were not yet "long-playing" and only held a few minutes of sound) became impractical and with the presentation of films in larger rooms it became harder to hear the barkers.[9] With the coming of sound film, film purists were dismayed at the possible end of pure cinema, in which the story was told strictly visually.[10] The famous 1928 Soviet "Statement on Sound," signed by directors Sergei Eisenstein, Alexander Pudovkin, and

Grigori Alexandrov, lamented the encroaching "bargain basement realism" of synchronous sound and image, reducing cinema to little more than canned theater, and derailing the inroads made in montage. They advocated asynchronous sound, which would maintain the independence between sound and image. Eisenstein and Alexandrov made attempts at asynchronous sound films (*Old and New* and *Romance Sentimentale,* respectively), while Rene Clair's *Entracte* used an Erik Satie composition (originally made to accompany a ballet by Francis Picabia) called *Cinema*, which was comprised of musical segments in uniform length that did not conform to the film's edits. Dziga Vertov, who had trained as a musician and had made films out of frustration with the technical limitations of the time that prevented making audio montage to his satisfaction, was overjoyed at the prospect of sound in cinema, claiming that both synchronous and asynchronous sound were valid in the new cinema and called for a "complex interaction of sound and image," an idea he applied in *Enthusiasm* and *Three Songs of Lenin.* [11] Norman McLaren would use drawn soundtracks on his abstract films, which would fall somewhere in between synchronous and asynchronous. (His predecessor was Arsei Avraamov's drawn soundtrack, drawn directly onto the film of Abram Room's 1930 Five Year Plan documentary *The Plan for Great Works*.) Meanwhile, Walter Ruttman had created a "sound film without images," *Weekend* (1929), an eleven-minute, rapid montage of speech, noises, and music that he felt exemplified the "procedure of photographing audible phenomena in a nonstylized manner, with the inclusion of their specific spatial characteristics," further enthusing, pre-Cage, that "Every audible in the entire world becomes material." [12]

Of course, the Soviets' fears were realized as early sound film largely consisted of little more than stiffly recorded dialogue (with actors often stuck talking around a table with a microphone hidden in a plant) and some incidental music. In some animated films sound effects were used to help tell the story, synchronized with the action but not naturalistically representing it (a drum roll for running feet, for instance). In the cartoon *Gerald*

McBoing Boing, the character spoke in sound effects, not words. As Walter Murch has noted, "with animated films you have to create something that gives a sound where none is present"; unlike action films, there is no sound during the actual filming of a cartoon.[13] It's only later in the '30s that sound film begins to show signs of sophistication, with postsynched sound created in the studio, Foley effects (borrowed from radio), and a sound mix. Orson Welles's background in radio made the sound design of *Citizen Kane* and *Touch of Evil* impressive and a tool capable of being as important to storytelling as the visuals. [14]

Disjunctive image/sound reappears with Lettrist Isidore Isou's 1951 film *Treatise on Venom and Eternity* (Isou called it "discrepancy cinema" as the soundtrack had nothing whatsoever to do with the images; this is followed, in turn, by the Situationists "detourned" cinema, which takes found films and substitutes their own revolutionary voice-overs for the soundtrack[15]) and Jean Luc Godard's work in the '60s. This is usually a function of Godard's use of quotation and collage, one example being an instance in *Breathless* where Jean-Michel Belmondo and Jean Seberg discuss going to see a Western, and Godard superimposes a sound clip (not an image) from the film they're talking about seeing on the soundtrack.[16] Experimental filmmaker Peter Kubelka's *Unsere Afrikareise* (Our Trip to Africa, 1961) is culled from sound and image recorded on location in Africa, but uses exclusively asynchronous sound—though it is used to comment ironically on the images and is precisely timed to the rhythms of the edits. Sound bridges—sound from the next shot entering a scene early, disjunctive at first and then revealed to be part of the next scene—also becomes more common in the '60s commercial cinema. Michael Snow's 1975 four-hour film *Rameau's Nephew* is perhaps *the* encyclopedic statement on asynchronous sound in film; over twenty-six separate episodes, sound and image are toyed with in every imaginable permutation. About the work, Snow wrote: "Its dramatic development derives not only from a representation of what may involve us generally in life but

from considerations of the nature of recorded speech in relation to moving light-images of people. Thus it can become an event in life, not just a report of it."[17] In divorcing sound from image, sound takes on a life of its own, and this is what makes the concept of sound art possible.

Recording as Art

In a sense, recording was an even more radical invention than photography in that the human voice was thought to be uncapturable, whereas human likeness had been captured to greater and lesser degrees in drawing and painting; it was the invention that Edison himself was most proud of.[18] Since recording could replicate music performances, it was only a matter of time, in light of modernist trends in art, before experimental techniques were developed to take recording out of the realm of aural photography.[19] Musique concrete, developed in France in the late 1940s and '50s by Pierre Schaeffer (a radio engineer, naturally) and Pierre Henry, took documentary recorded sounds and processed them to the point of unrecognizability (speeding up or slowing down the tape, editing, and using distortion and other effects) so as to divorce them from the object that made them. The sound of a violin, untreated, makes one picture of a violin, although it isn't a violin per se, in the same way that a photograph of a violin is not a violin. With this movement, sound and image again become an issue in so-called acousmatic listening. The term derives from the disciples of Pythagoras who heard, but never saw, his lectures delivered from behind a curtain. As defined by Schaeffer, acousmatic listening is "Listening to sound without any visual clue to its source."[20]

Schaeffer, in fact, ultimately became discouraged when he couldn't distance sounds sonically far enough from their original source to his liking, and felt he could not escape musical form and break through to pure sound. Nevertheless, musique concrete stands as the missing link between music and sound art; the artist Francisco López, in particular, seems to pick up where Schaeffer left off.

SNOW
Tap

VARÈSE
*Poème
électronique*

Besides distancing sounds from their visual source, the natural acoustic of sound in a room is lost in modern-day multitrack recording, and must be reconstituted (redefined) through reverb and other effects. As Bernhard Leitner put it:

> Reverberant rooms have always been "softened" acoustically by covering the hard reflecting surfaces with carpets, tapestries, curtains, and the like. Today the reverse, a much more difficult task to perform, has already become a standard procedure in the music recording business. The same technology which enables us to reproduce music without musicians and the appropriate space, allows us to simulate the reverberating space that had been eliminated in the recording. We can create different acoustics in one and the same space. [21]

It is this sense of perspective with the introduction of studio effects, particularly echo, that Brian Eno felt made "the process of making music much closer to the process of painting." David Toop has written that in the echo-heavy Jamaican reggae dub genre "the mixing board becomes a pictorial instrument" creating "depth illusion" (and moreover, a dub "version" or remix could be compared to an engraving or etching of a painting). Beyond the simulated space of echo or reverb, in mono mixes there is a depth of field, foreground, and background similar to painting; this is present in stereo also, but splits the "imaging" into a vertical dichotomy (which is lost to some extent on headphones). However, many sound artists have, until the CD era, been poorly represented on record: some like Phill Niblock and La Monte Young, objected to the twenty-minute album side durations as being too short to accommodate their long-form pieces (and not having control over the volume of playback, which was intended to be as loud as possible). Yasanao Tone and Maryanne Amacher resisted releasing stereo recordings of their work at all because it didn't capture the spatial

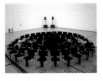

LÓPEZ
Dusseldorf

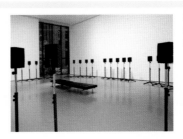

CARDIFF
40 Piece
Motet

dimension of their work. A CD of a sound artwork could be compared to a sculpture exhibition catalog with photo reproductions of the works. With 5.1 surround sound, the idea of a sound environment replaces the painting analogy; as it becomes more common in home systems, sound art may well become as non-site-specific as music has.

Eno points out that recording took music away from site specificity, as you could bring a recording of the symphony into your home as opposed to having to go to the concert hall. Glenn Gould gave up performing concerts in the mid-'60s because he thought that records would replace the concert hall. This was partly due to an egalitarian attitude on his part; in the home, everyone had the best seat in the house, and in home playback:

> the listener is able to indulge preferences and, through the electronic
> modifications with which he endows the listening experience
> [presumably bass and treble or equalization controls on a home stereo]
> imposes his own personality upon the work. As he does so,
> he transforms that work, and his relation to it, from an artistic to
> an environmental experience. [22]

In this way Gould unwittingly conceptualizes albums as a kind of interactive sound installation. Not only could the home listener enjoy the piece of music at any time, but through volume and equalization on a hi-fi system he effectively becomes an executive conductor/producer.

Spatiality

"Every sound has a space-bound character of its own. The same sound
sounds different in a small room, in a cellar, in a large, empty hall, in a
street, in a forest, or on the sea."

—BELA BELAZS[23]

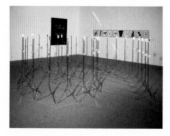

FILLIOU
Musique
télépathique
nø 5

With record players capable of turning any home into a concert hall, and recording consolidating the nineteenth-century restriction of sound to one central location, new investigations of site specificity and spatiality began.

Long before sound art though, man had been attuned to sound's relationship to architectural and natural spaces. Bill Viola has written of Gothic cathedrals:

> When one enters a Gothic sanctuary, it is immediately noticeable that sound commands the space. This is not just a simple echo effect at work, but rather all sounds, no matter how near, far, or loud, appear to be originating at the same distant place ... Chartres and other edifices like it have been described as "music frozen in stone" ...
>
> Ancient architecture abounds with examples of remarkable acoustic design—whispering galleries where a bare murmur of a voice materializes at a point hundreds of feet away across the hall or the perfect clarity of the Greek amphitheaters where a speaker, standing at a focal point created by the surrounding walls, is heard distinctly by all members of the audience.[24]

In modern times architecture has been less preoccupied with acoustics; "sound as a medium is still lost a lot in our culture," sound artist Bill Fontana has said. "Architects hardly think about it. We design space visually and don't think about the relationships between sounds that exist in spaces."[25] Viola notes that modern acoustics have been developed to combat unintelligibility due to the reverberations in modern room design, which he considers ironic because "the acute reverberation in the Gothic cathedral, although a result of construction and not specific intention, was considered an essential part of its overall form and function."[26]

To some extent, many sound installations are a kind of room tone

renovation/rehabilitation, and even a kind of health spa; sound artist and
architect Bernhard Leitner has said in an interview:

> What is true for music applies to any acoustical stimulus: the sound
> quality of a room affects the nervous system. Heart, breathing, and blood
> pressure which are largely beyond conscious control are affected. And
> psychosomatic implications should also not be underestimated.
> In other words our entire physical and mental well-being is affected by
> the sound of a room. Because modern architecture has underestimated
> if not completely ignored these phenomena, it certainly has caused
> substantial damage. In this context we must, however, point out that we
> have great difficulties talking about the way we hear a room, the way
> we come to terms with "audible" space. We simply lack the terminology.
> In this respect our visually-oriented language fails us.[27]

The use of spatiality in Western European music composition goes back
to the sixteenth century, when composers like Giovanni Gabrieli were writ-
ing works to be performed in churches for multiple choirs. Gabrieli wrote in
particular for St. Mark's Cathedral in Venice, which boasted two choir lofts
and two organs facing each other (also an early example of site-specific com-
position). Bernhard Leitner cites another, even more complex example from
the seventeenth century:

> In 1628 the Salzburg cathedral was inaugurated with the performance of
> a spatial/musical composition by Orazio Benevoli, for which fifty-three
> instruments and twelve choirs were distributed throughout the interior
> of the cathedral in order to emphasize its acoustic effects through the
> ensemble playing of different groups, through echoes and dialogues,
> or through a general tutti. The resulting monumental spatial effect was
> achieved in an altogether different way from that used in the nineteenth

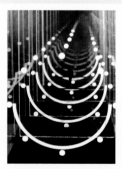

LEITNER
Sound Tube

century where one simply projected an increased volume of sound into the space from a single place, the podium. Likewise, in court ceremonies small groups of musicians were distributed all around the room in such a flexible way that they could change places at short notice and thus create different spatial effects as well as meanings.[28]

One exception to this nineteenth-century practice is Mahler's Third Symphony, where there is one section in which the brass play offstage; another is Berlioz's Requiem. In the nineteenth and early twentieth centuries, George Ives and Henry Brant composed pieces for multiple bands or orchestras situated in different areas of an outdoor space. Ives, father of the famous composer Charles Ives, had two marching bands play two different tunes while marching through a town park, starting at opposite ends. Ives would listen for the differences in sound in relation to each band's position at any given time. He would also have his son listen as he played cornet from across a pond, later immortalized by Charles in his composition *The Pond (Remembrance)*. Charles would use spatiality to some degree in the orchestration of pieces like *The Unanswered Question*, but it was Brant who took spatial composition for acoustic instruments to its twentieth-century apogee.[29] In *Antiphony I* (1953), five orchestras are spread throughout the stage and auditorium. Brant went on to compose over one hundred spatial pieces (needless to say, these do not translate well to stereo recordings).

The musique concrete crowd was already thinking of spatialization in the early '50s. At Pierre Schaeffer's suggestion, Jacques Poullin invented a device called *pupitre d'espace* ("space desk" or "space control") which utilized induction coils to move sounds around in space. Varèse had even earlier imagined "a series of sound projections in space by means of the emission of sound in any part or in many parts of the hall." In his *Poème Électronique*, realized at the Brussels World's Fair in 1958, a tape piece of bells, sirens, treated voices, and piano traveled in various routes through four hundred

loudspeakers spread throughout the Philips Pavilion designed by Le Corbusier (with the help of Iannis Xenakis), a kind of twentieth-century secular version of writing music for a cathedral space. Xenakis's tape piece *Concret PH*, made from the sound of burning coal, was also played through the system. [30]

Karlheinz Stockhausen is often associated with spatial music, developing a series of compositions he dubbed Raummusik ("music in space"). Though history has shown him to usually be the second, not the first one to experiment with any given avant-garde technique, he has maintained, "From the very beginning I've thought about where the instruments would have to be placed, I didn't want to simply have an automatic spacing of sound."[31] *Gruppen* (1955) for three orchestras, for example, comes three years after Brant's *Antiphony I*, but in his defense Stockhausen's piece involved "moving timbres . . . a chord is moving from orchestra to orchestra with almost exactly the same instruments (horns and trombones) and what changes aren't the pitches but rather the sound in space," whereas Brant's music emphasizes contrasting a variety of musical styles (in the footsteps of Ives).[32] *Carre* (1959) was for four orchestras and four choirs surrounding the audience. In 1956 Stockhausen composed *Gesang der Jungling,* a landmark musique concrete piece that incorporated singing and electronics and utilized five loudspeakers spread throughout the auditorium. The electronic piece *Kontakte* (1960) dealt with the speed of sound moving from one speaker to the other. [33] Stockhausen also thought of putting musicians on swings to make the sound move and conducted workshops at Darmstadt of "walking and running music" where singers and instrumentalists made movements. In *Ensemble* (1967), a four-and-a-half hour performance as part of one of his seminars in Darmstadt, at the program's end the musicians continued playing in open roofed cars or open car windows and met again twenty miles outside of town. Stockhausen also took movement of the audience into account: "You have to compose differently when you know that the listeners are coming and going." In *Sternklang* five groups of musicians were separated by bushes and trees. The sound changed

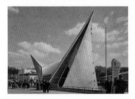

VARÈSE
Poème
électronique
in Philips
Pavilion

XENAKIS
Persepolis

for the listeners as they approached each group, who would then walk over and listen to another.

New Kinds of Site Specificity

Laszlo Moholy-Nagy began to imagine "sound waves issuing from unexpected sources—for example, a singing or speaking arc lamp, loudspeakers under the seats or beneath the floor of the auditorium."[34] Piet Mondrian envisioned a new kind of concert hall for Neo-Plastic music where "people could come and go freely without missing anything because the compositions would be repeated just like in movie theaters."[35] Stockhausen's former student, La Monte Young, had envisioned "a continuous sound composition for installation in homes, offices, galleries, classrooms, swimming pools, ocean liners, bathyspheres, airplanes, spaceships, etc." Young tuned a piano in his home using just intonation and made a recording. *The Well-Tuned Piano* is also an early site-specific piece. Tuned to just intonation, Young tuned a piano in his home and made a recording. He was unable to perform the work live until ten years later, when he had the opportunity to retune a piano for an appearance at a music festival. The piano itself had to be "installed," since moving it would ruin his special tuning in just intonation (it's also restrung to achieve the tuning), as would changes in humidity and temperature in the location space. After the world premiere in Rome in 1974, Young sold the "well-tuned" piano as an art object to the presenter, Fabio Sargentini, who then offered him an additional $1,000 to sign it. Dia Art Foundation later bought the piano from Sargentini for $14,000 and brought it to New York, where it was installed in the organization's Harrison Street space. A piano is not easily moved to begin with, but the fragility imposed by Young on the well-tuned piano makes it more like a sculpture or a "permanent installation" you would find in a museum of visual art. Young himself has rarely toured or released albums, endeavors perhaps too time constricted to accommodate his visions of "continuous sound compositions"; he has made his own music somewhat site specific, even now the *Dream House*

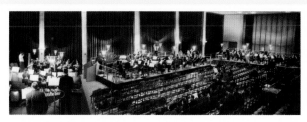

STOCKHAUSEN
Cologne Radio Orchestra

above his own loft on Church Street in New York is his primary site for an occasional concert.

Mark Rothko made paintings to fill a space created by Philip Johnson, the Rothko Chapel in Houston, and Morton Feldman composed a piece to be performed there. "To a large degree my choice of instruments (in terms of forces used, balance, and timbre) was affected by the space of the chapel as well as the paintings," he wrote. "Rothko's imagery goes right to the edge of his canvas, and I wanted the same effect with the music—that it should permeate the whole octagonal-shaped room and not be heard from a certain distance . . . the sound is closer, more physically with you than in a concert hall."

Perhaps in response to this increased interest in spatiality both in modern composition and in sound art, concert halls have become considerably more flexible. At Carnegie Hall, Zankel Hall has a surround-sound system, with the potential for moving seating around. In the performance space of the Centre Pompidou's Institut de Recherche et Coordination Acoustique/Musique's (IRCAM) "the wall consists of hundreds of panels that can be flipped around to get the acoustic that you want, and a ceiling that can be lowered." Radio France operates the Olivier Messiaen Concert Hall with a spatial sound system ("an orchestra of loudspeakers") designed by musique concrete composer Francois Bayle, who dubbed it "acousmonium." The soon to be unveiled Experimental Media and Performing Arts Center (EMPAC) at Rensselear Polytechnic Institute boasts "spaces with twenty-four bit range, [and] there will be projectors but in enclosures that will eliminate any sound, an absolutely silent environment with changeable seating arrangements."

Although most of this experimentation has been conducted in the avant-garde wing of the classical music world, one very well known rock album provides an example of new site specificity. In his book on Led Zeppelin's 1971 fourth album, Erik Davis notes that guitarist/producer Jimmy Page would place mics in various parts of the room while recording, and would then "record and balance the difference between these mics, capturing a time lag that reflected

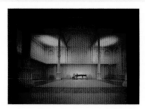

ZAZEELA
AND YOUNG
*The Magenta
Lights* and
*The Well-
Tuned Piano*

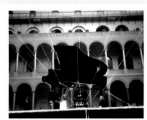

PANHUYSEN
*Two Suspended
Grand Pianos*

the acoustic shape of the room itself." Davis goes on to quote Page himself as saying that he was trying to "capture the sound of the room live"—not the music, or the band, but the room.[36] This can be heard especially in the famous and often-sampled drum introduction to the album's final track *When the Levee Breaks*. Davis details the setup:

> For the session [drummer John] Bonham placed his new kit on the floor of a large open stone stairwell ... Two ambient Beyer M160 stereo mics were then strung up on the two landings above, ten and twenty feet overhead, and then run through a giant echo unit ... the setup was heresy; room mics were never used to record drums ... as [writer] Andy Fyfe puts it, what you hear is not just the drums, but the drums reacting to the acoustic space of the room. But you are also hearing something more uncanny than this: you are hearing *the room respond to the drums*.[37]

Around the same time, composer Alvin Lucier noted, "Every room has its own melody hiding there until it is made audible," while a decade before Yoko Ono wrote an instruction to the performer of *Tape Piece II* to "take the sound of the room breathing." Music was once created to be heard live in a specific space; with the advent of recording and forms of aural transmission the attunement to a specific space became a lost art looking to be rediscovered. Since the space was no longer integral to the music, it was left to sound to articulate the properties of the space itself, which then moved to the foreground, just as color and geometrical shapes had in modernist painting. The performer was removed, putting the focus on sound itself, and on its environment.

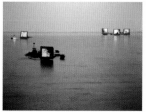

JULIUS
Music, far away

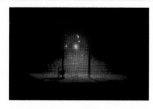

VON HAUSS-
WOLFF
Freq_Out 4

MICHAEL SNOW
Tap, 1969. Framed black-and-white photo, framed typewritten text
(not shown), loudspeaker with wire, and tape recorder and tape (not shown).
Dimensions variable. Collection of the National Gallery of Canada, Ottawa

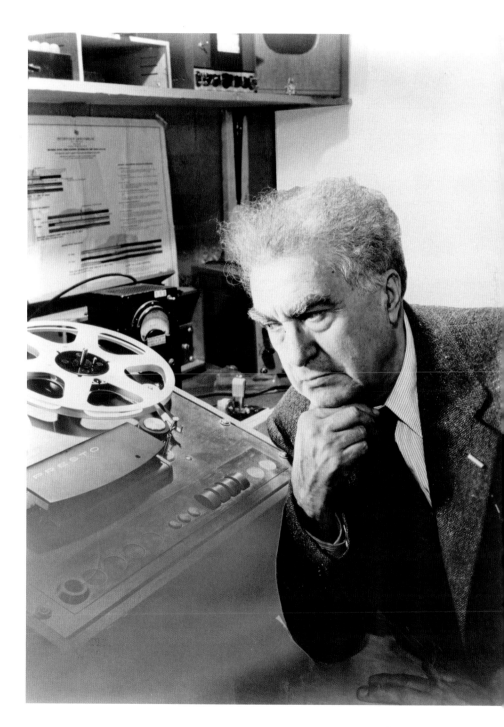

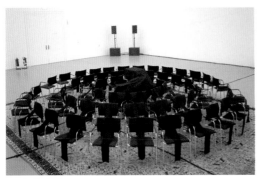

FRANCISCO LÓPEZ
Dusseldorf, 2004. Seating arrangement for concert
performance. Courtesy the artist

JANET CARDIFF
40 Piece Motet, 2001. Installation view of the exhibition *Take Two: Worlds and Views from
the Contemporary Collection* at the Museum of Modern Art, New York City, 2005. Digital Image
© The Museum of Modern Art/Licensed by SCALA/Art Resource, NY

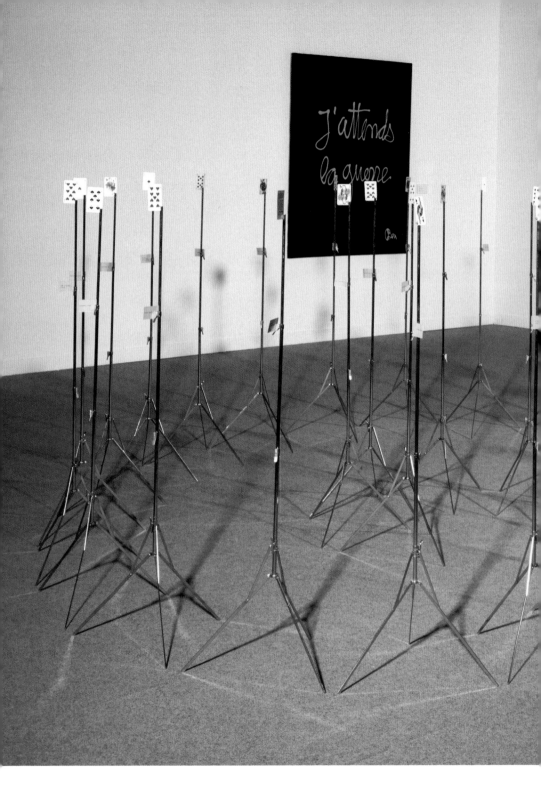

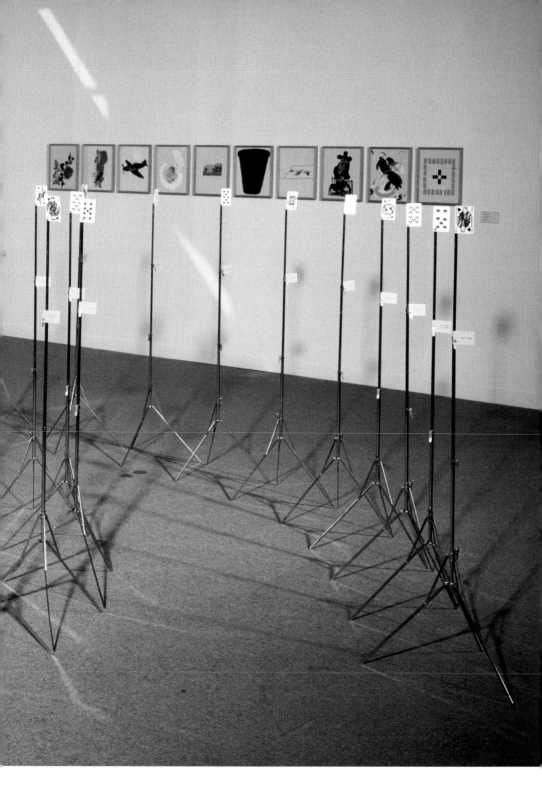

ROBERT FILLIOU

Musique télépathique nø 5, 1976–78. Musée National d'Art Moderne, Centre Georges Pompidou, Paris. Photo by Philippe Migeat. CNAC/MNAM/Dist. Reunion des Musées Nationaux/Art Resource, NY. © Marianne Filliou

BERNHARD LEITNER
Sound Field, 1971. Installed in New York City.
Courtesy the artist

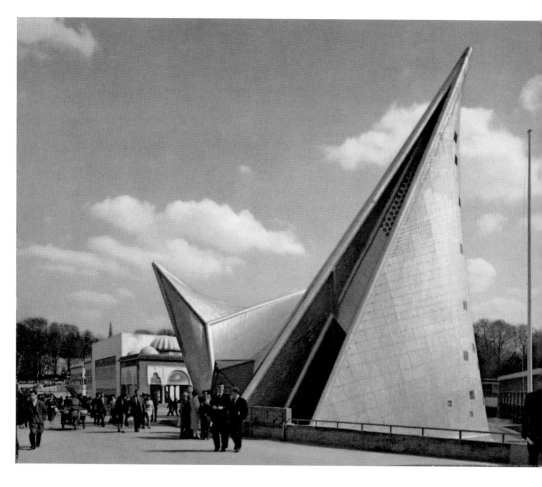

EDGARD VARÈSE
Philips Pavilion. Designed by Le Corbusier for the
Brussels World's Fair, 1958, it housed Edgard Varèse's
Poème électronique. Courtesy Philips Company
Archives

EDGARD VARÈSE

Poème électronique at the Brussels World's Fair, 1958. Interior view of
projection during the screening.

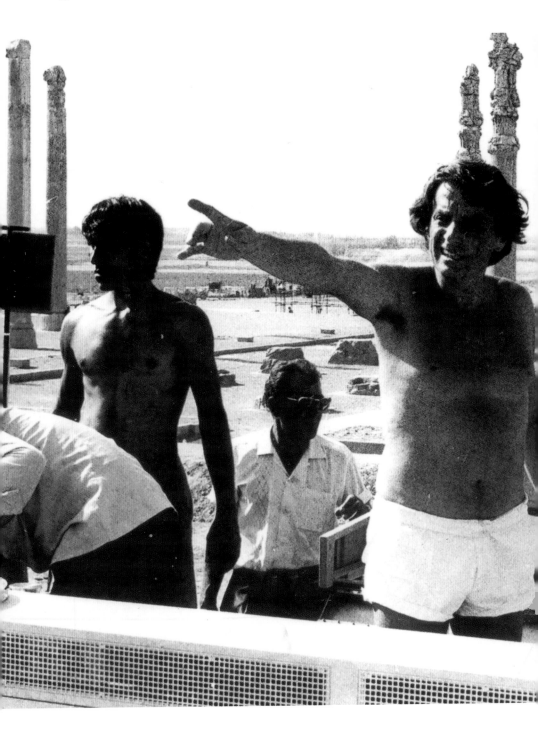

IANNIS XENAKIS
Directing rehearsals for his open-air light and sound
show, *Persepolis*, in the ruins of Persepolis, Iran, 1971.
Photo by Malie Letrange

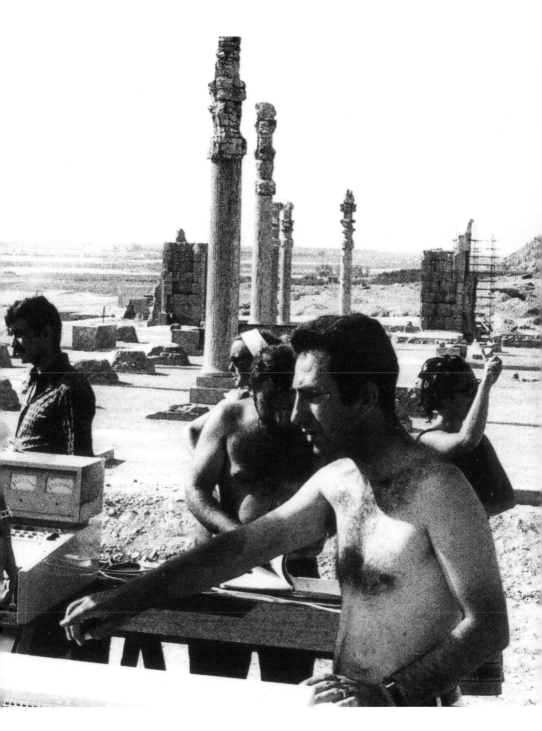

KARLHEINZ STOCKHAUSEN
Rehearsing for the world premiere of the Cologne Radio Orchestra under his direction and Bruno
Maderna and Pierre Boulez in Cologne, Germany, March 24, 1958. © Archive of the Stockhausen
Foundation for Music, Kuerten (www.stockhausen.org)

MARIAN ZAZEELA AND LA MONTE YOUNG
The Magenta Lights, 1981. An installation at Young's *Dream House*, 6 Harrison Street, New York City, with
Young performing *The Well-Tuned Piano* at Dia Center's custom Bösendorfer Imperial Grand, 1981. Photo by
John Cliett. Copyright © 1987 La Monte Young and Marian Zazeela

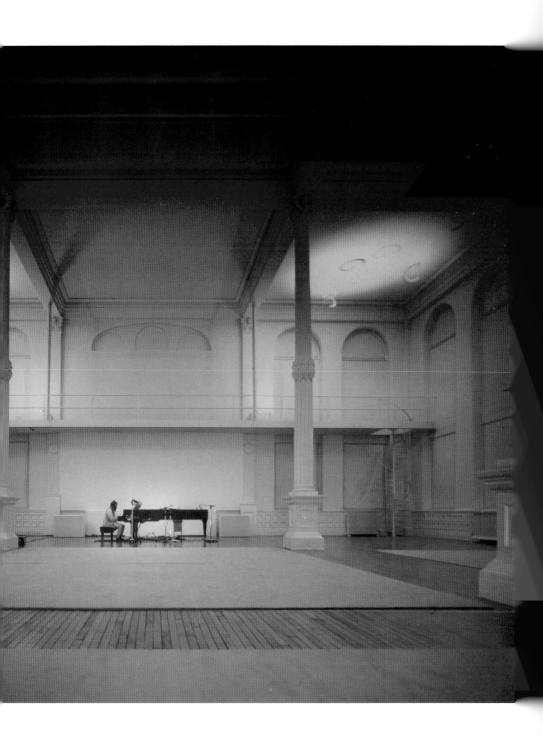

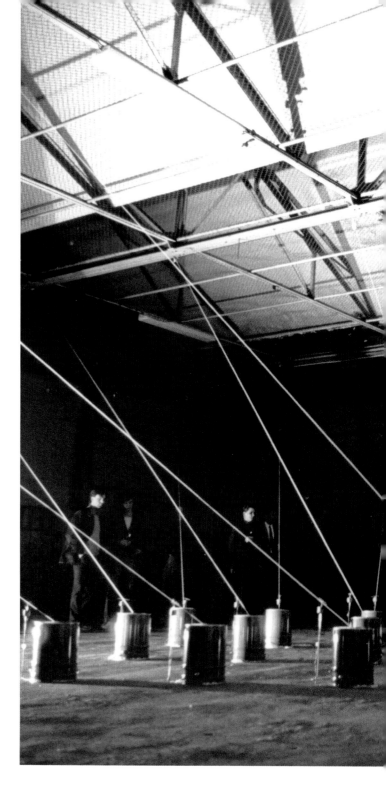

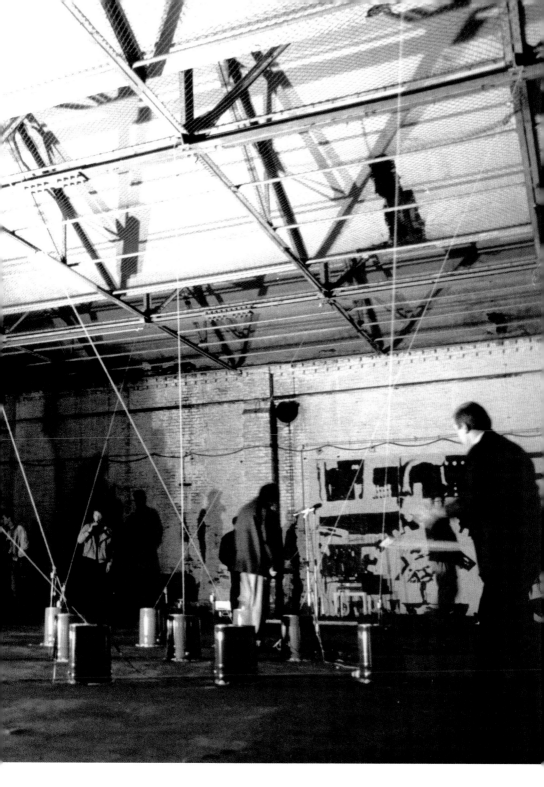

PAUL PANHUYSEN
Projection, 1987. Installation at Echo
Festival 2, Eindhoven, Netherlands.
Photo by Paul van den Nieuwenhof

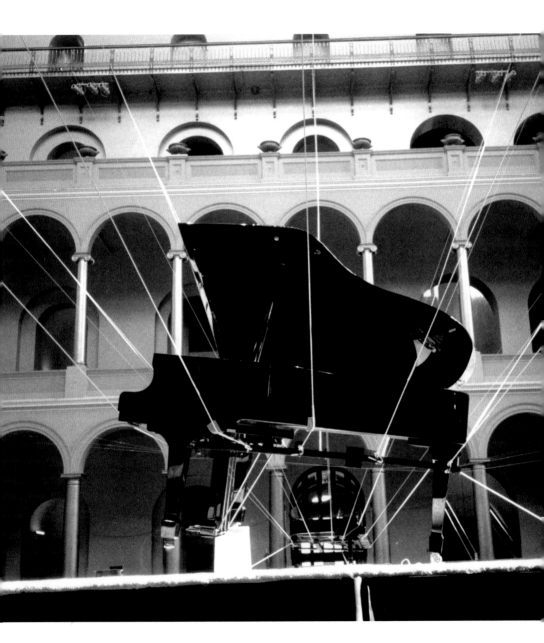

PAUL PANHUYSEN
Two Suspended Grand Pianos, 1990. Installation
at the Great Hall National Building Museum, Wash-
ington, D.C. Photo by the artist

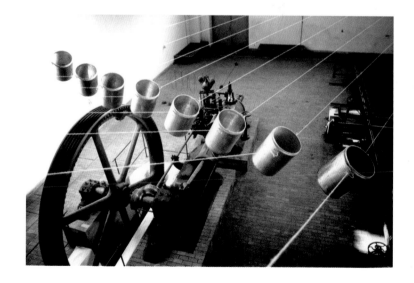

<u>PAUL PANHUYSEN</u>
*Sznurki, Linky, Knoty, or Singing the World
into Existence*, 1990. Work in progress in
Lodz, Poland. Photo by the artist

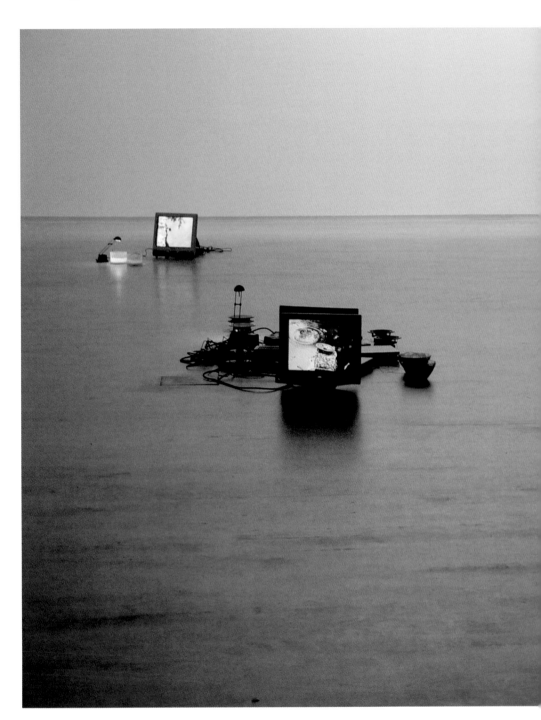

ROLF JULIUS
Music, far away, 2005. Installation at Berlinische
Galerie, Berlin.

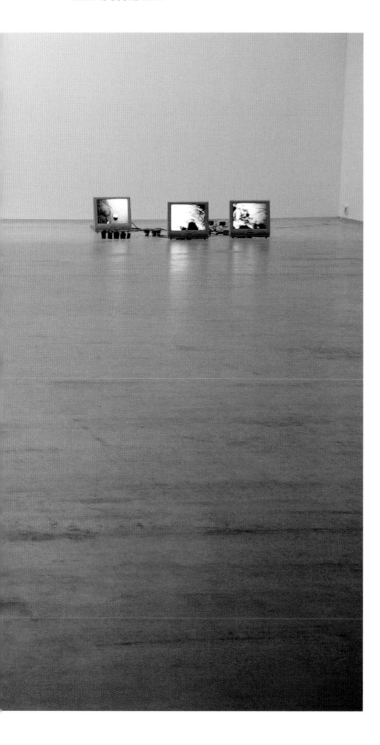

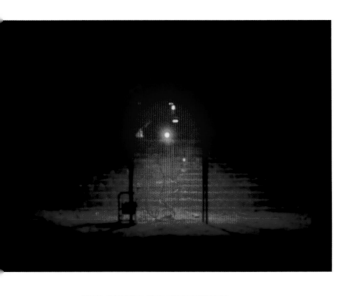

CARL MICHAEL VON HAUSSWOLFF
View of sound installation from Freq_Out 4, June
2006 at Sonambiente in Berlin. Photo by the artist

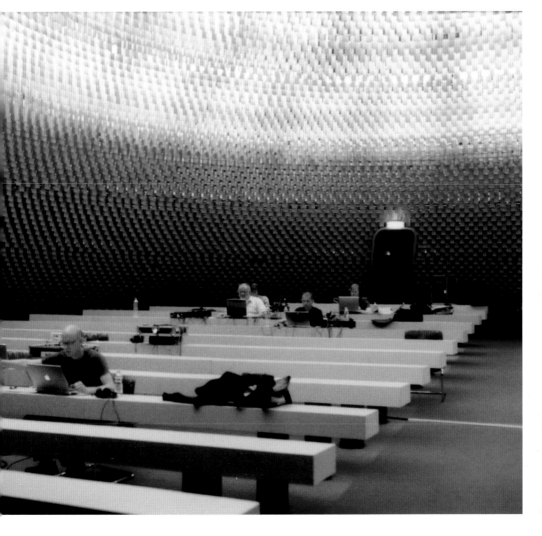

CARL MICHAEL VON HAUSSWOLFF
Installation view from Freq_Out 3, October 2005, Communist Party
HQ, Nuit Blanche, Paris. Invited artists work on sound pieces with an
assigned frequency range. Photo by the artist

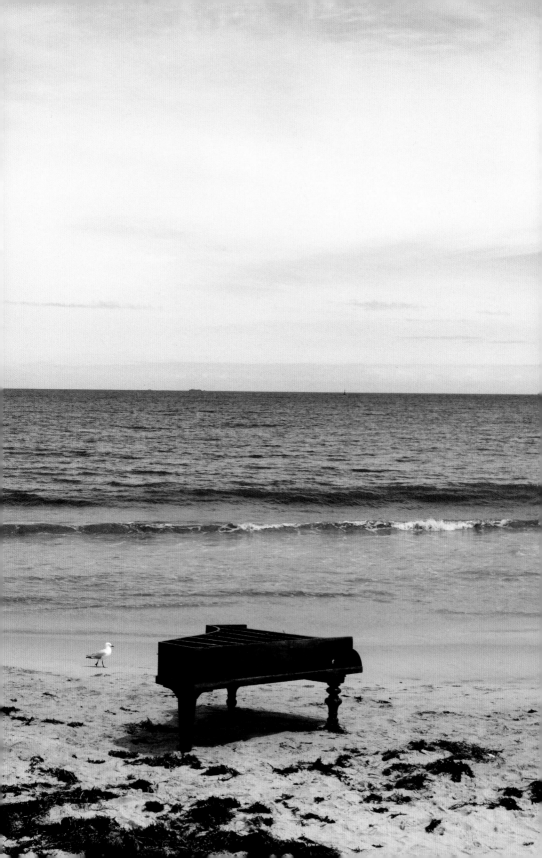

Environment and Soundscapes

NATURE: BEYOND THE CONCERT HALL

The concert hall traditionally served to present the "sounds that are separated from the outside world ... a closed space separated from the outside world and the sonic domain of everyday life," in the words of Brian Eno. The boundaries of the concert hall itself were questioned before the advent of recording. R. Murray Schafer has traced the evolution of the concert hall as "a substitute for outdoor life." He notes that "imitation of landscape in music corresponds historically to the development of landscape painting," first in the Flemish Renaissance masters and later developing into a separate genre in the nineteenth century.[1] The spread of art galleries in urban areas is what Schafer feels is responsible for the

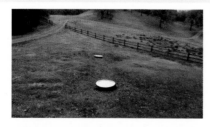

FONTANA
Earth Tones

ANNEA LOCKWOOD
Southern Exposure: Piano Transplant No. 4, 2005. Photo © Peter Illari. Realization of an earlier piece calling for a "defunct" piano to be set up on a beach and left to sound on its own.

trend, as the paintings function as "windows" to an increasingly inaccessible natural world. "An art gallery is a room with a thousand avenues of departure, so that once having entered, one loses the door back to the real world and must go on exploring." Equally, music turns "the walls of the concert hall into windows, exposed to the country," and he cites Vivaldi, Haydn, Handel, Schubert, and Schumann. He makes note of the approximation of a hunting horn in Haydn's *La Chasse* and other works, horns being particularly representational of the freedom of the outdoors.

Classical music had many responses to nature, whether it was Vivaldi's *Four Seasons,* Handel's *Water Music,* or Olivier Messiaen's transcriptions of bird calls, all intended to be somehow illustrative or representational of natural phenomena. Writer Jonathan Cott remarked to Karlheinz Stockhausen, "Debussy once wrote about his ideas for an open-air music which, he said, would allow the composer to get away from arbitrarily fixed tone values and forms. He talked about a harmonic dream in the soul of the crowd ... breezes, scents, flowers, leaves ... all united in music."[2]

However, it is the *listening* to sounds in nature, and the observance of nature, which is a key feature in sound art. This is anticipated by John Cage and his cohorts. Cage said he preferred a walk in the woods to going to a concert (Eno prefers the park), while Michael Nyman notes that Morton Feldman once said that his music should be approached "as if you're not listening, but looking at something in nature; the loud and repeated sounds [in his music] are akin to any unexpected natural features that might suddenly appear out of nowhere on a country walk."[3]

According to Nyman, silences in Christian Wolff's early pieces:

> are openings which let the sounds of the environment mingle with and perhaps even obliterate the composed sounds. Cage tells the story of a performance Wolff gave where the sounds of traffic and boat horns coming through the open window were louder than the piano sounds. Someone

SNOW AND
WIELAND
Dripping Water

NEUHAUS
Water Whistle III

asked him to play again with the windows closed to which Wolff replied "that it wasn't really necessary, since the sounds of the environment were in no sense an interruption of those of the music." As Wolff remarked (of the early experimental music in general) "the work is at once itself and perspicacious."[4]

With these composers' embrace of natural sounds, soon the concert hall was traded for the great outdoors. In 1969 Stockhausen staged an outdoor concert in the Giacometti courtyard (with Joan Miró sculptures) at the museum of the Maeght Foundation at St. Paul de Vence, in which musicians sat on roofs, ramps, and in the courtyard, integrating sounds from frogs, cicadas, and other animals. After three hours each musician started to walk off, still playing, into the forest. At 2 AM there was "a twenty-minute-long dialogue with car horns. I [Stockhausen] started it but then all the people who hadn't left began making horn music with each other; and as one after the other drove off, they exchanged sounds for miles down the road."[5] It's important to note, however, that for all the boundary pushing, it's significant that Cage, Wolff, and Stockhausen are still thinking in terms of a performed concert with an audience, not music as a free-standing installation that would attract visitors.

Stuart Marshall made a series of little-known outdoor sound works in the early 1970s; in one, *Golden Hill,* sound sources are placed in trees but the "listener" is meant to avoid hearing them—if he does hear them he is instructed to make a signal.[6] David Dunn also started making outdoor performances in the early '70s, including *Nexus 1* (1973) scored for three trumpets in the interior of the Grand Canyon and (*espial*) for solo violin and three tape recorders in the Anza-Borrego Desert in California.

Other Uses of Environmental Elements
Besides using the outdoors as inspiration or even a concert space, there is a long tradition of using the wind as a sound maker. The Aeolian harp is a string

instrument designed originally by the ancient Greeks in which the strings were all tuned to one note. It was placed on a window sill and "played" by the wind without human interference, creating melodic interactions between the overtones. In Gordon Monahan's version of the ancient instrument, a piece called *Aeolian Piano* (1984), made at Holownia-Hansen Farm, Jolicure, Canada, he stretched fifty-foot piano wires between two wooden bridges on a friend's property, then added an upright piano and more piano wires parallel to the original ones, this time one hundred feet in length. The wind resonated the strings (and in the absence of wind, still air produced low resonances). He later created a permanent installation, *Aeolian Silo,* (1990) in which piano strings stretched across the top of a silo at Funny Farm, Meaford, Ontario. Leif Brush created *Meadow Piano* in 1972, more of a gridlike structure using sensors that make aural responses to weather conditions and microphones to pick up and record insect activity around the structure. Australian Alan Lamb has made pieces out of the sound produced by the wind "playing" telephone wires, and rigging up an organ and other contraptions to play them himself. Max Eastley, too, has created Aeolian sound sculptures, not only harps but flutes and other instruments meant to be played by the wind. So have Bill and Mary Buchen, created wind gamelans and sun catchers alongside numerous Aeolian harps. They also created a "harmonic compass," which uses a hill's topography to create a tuning system for an enormous (250 feet) sound sculpture. Harry Bertoia's commissioned outdoor sound sculpture at the River Oaks Shopping Center in Calumet City, Illinois, (1966) was meant to be "played" by the wind. Liz Philips creates synthesizer pieces that are triggered by wind patterns via weather vanes and anemometers. Douglas Hollis's *Sound Site* (1977) had several wind-activated sound sculptures installed along the Niagara River; his Seattle installation *Sound Garden* (1983) has organ pipes meant to sound by the wind. Patrick Zentz has a variety of works triggered by wind motion (tuning forks, flutes, string instruments). Felix Hess's wind fireflies are machines with a microphone and a flashing green light that

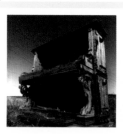

MONAHAN AND
HOLOWNIA
*Long Aeolian
Piano*

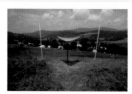

BUCHEN
*Harmonic
Compass*

are triggered by wind patterns; his cracklers subtract the light and add a speaker and an oscillator, and are triggered by air pressure. And for a 1994 recording, Garlo set up fifty-four acoustic guitars on the Pyla Dune on the French coast, the highest in Europe, and let their open strings be vibrated by the wind, releasing the results as *Vent De Guitares.*

Leif Brush's *Terrain Instruments,* a series of works begun in the late '60s, are electronic devices that turn various environmental motion sources (leaves, wind, precipitation) into sound via various metal wires strung through trees. He has also constructed "audible sculptures" like "signal discs" and "cricket chord monitors" to record the movements and weather sounds themselves. In an installation on the roof of the School of the Art Institute of Chicago, he used galvanized steel strands, "windmonitors," and "windslicers" to channel the wind into a sound source for an Arp synthesizer.

Noise
The other type of environmental sound is man-made noise, "the general hum of the city," as Eno called it. The Futurist Luigi Russolo was the first influential noise thinker, who disparaged music as "a fantastic world superimposed on the real one." Prompted by fellow Futurist F. T. Marinetti's *Zang tumb tumb,* an onomatopoeic work based on wartime sounds heard first-hand on the World War I front, and long before Cage observed that all sounds are music, Russolo declared in his famous "Art of Noises" manifesto of 1913: "We have had enough [of Beethoven et al.], and we delight much more in ... the noise of trams, of automobile engines, of carriages, and brawling crowds."[7] He notes the development of classical musical towards more complicated harmonies that include dissonance, and that "this evolution of music is comparable to the multiplication of machines ... musical sound is too limited in its variety of timbres ... we must break out of this limited circle of sounds and conquer the infinite variety of noise-sounds." He considers noise "pleasing"; "We want to give pitches to these diverse noises, regulating them harmoni-

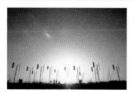

HOLLIS
Sound Garden

RUSSOLO
Photo of his
intonarumori
(noise intoners)

cally and rhythmically." He calls for the invention of instruments to make a noise-sound orchestra—in other words, a domestication of environmental noise. He has also identified machinery as sound producers, which paves the way for sound sculpture (especially Jean Tinguely's noise machines). One of Russolo's scores is *Noise Music: Awakening of a City* for "howlers, boomers, cracklers, scrapers, exploders, buzzers, gurglers, and whistles." He went on to create his own noise-making machines, *intonarumori* (noise intoners), which he used in concerts across Europe just before World War I. He later developed a noise harmonium that was considered for production as an accompaniment to silent films, but when "talkies" appeared soon after its invention, those plans fell apart.

Other artists were also interested in the idea of organizing noise into compositions. Piet Mondrian called for a new music with "a new order of sounds and nonsounds (determined noise)" in two essays from 1921 and 1922, "The Manifestation of Neo-Plasticism in Music and the Italian Futurists' Bruiteurs" ("bruiteurs" were *intonarumori*) and "Neo-Plasticism: Its Realization in Music and Future Theater." George Antheil, the avant-garde composer, "dreamed of urban orchestral machines whose sounds would 'shoot obliquely into space.'"[8] But while he did employ a siren in his *Ballet Mecanique* (1924), Antheil nonetheless denied that he was copying machine sounds elsewhere in the piece.[9]

R. Murray Schafer has described the sonic differences between urban and rural environments:

> When man lives mostly in isolation or in small communities their ears operated with seismographic delicacy. In the rural soundscape sounds are greatly uncrowded … for the farmer, the pioneer, or the woodsman the minutest sounds have significance. The shepherd, for instance, can determine from sheep bells the precise state of his flock.[10]

TINGUELY
*Homage to
New York*

TONE
Volkswagen

He goes on to mention that before outdoor lighting at night, man used hearing his horse's hoofbeats during nocturnal travel to determine whether he was still on the road, and the degree of pavement to determine his proximity to a city. Ancient/country/night soundscapes were much like "hi-fi" sounds, able to be distinctly heard "because of the low ambient noise level" whereas city sounds are "low-fi" and are "masked by broad-band noise ... in order for the most ordinary sounds to be heard they must be amplified."

While it is now common for post–musique concrete tape composers and sound artists to combine natural and man-made sounds and noises, La Monte Young may be the first composer to find common ground between natural sounds and machine sounds. Young cites his influences as:

> the sound of the wind; the sounds of crickets and cicadas; the sounds of telephone poles and motors; sounds produced by steam escaping such as my mother's tea kettle and the sounds of whistles and signals from trains; and resonances set off by the natural characteristics of particular geographic areas such as canyons, valleys, lakes, and plains.[11]

He used to sing or whistle along with motors in his high school's machine shop (which ultimately developed into his later singing against electronic drones). While early pieces like *Four Dreams of China* reference both natural and man-made sounds (in the work and in the titles as well, with names such as *First Dream of Spring* and *Second Dream of the Stepdown Transformer*), this becomes more apparent as he begins working with Tony Conrad and John Cale's amplified strings. In his 1966 essay "Inside the Dream Syndicate," Conrad wrote: "Although the stiff man does turn a latter-day ear to the music of the machine, the earlier Japanese cricket keepers and reed cutters just as easily liked the upper partials ..."[12] He goes on to discuss the fine-tuning of pitches and harmonics from noise in the highly amplified violin and viola drones he and Cale played in the group:

Noises are not *ever* pitchless, to say the least … machines suggest the patterns potentiated by manipulation and selection of high harmonic-content timbre complexes, but infinitesimal control has to be used to get the precisely wanted range of interrelations … Ours is the first genera-tion with tape, with proper amplification to break down the dictatorial sonority barriers erected by the master instruments of the cultures. It is no longer necessary to press upon groaning mechanical instrumentation to produce the terrific power and sonority necessary for dealing with partial complexity and without shattering the all-important sound—the throbbing reverberance that has fixed musical attention on consonance and formal design.[13]

For his part, Cale has stated that by putting electric guitar strings on his viola in the group, he got "a drone [that sounded] like a jet engine!"[14] The group also tuned to the sixty-cycle hum found in everyday home electricity. In *Dream House* Young says "50 Hertz AC (derived from 220 volt power line frequency) will be used as the standard to which all other frequencies are related and tuned since it functions as the underlying drone of the city and all AC-powered equipment."

Dirt as Noise

Like noise, dirt is unwanted depending on the context; soil is fine for letting trees, flowers, and vegetables grow, but folks don't want it in the house, just like people keep windows closed, especially in urban environments, to keep out the noise. However, just as noises became incorporated into music, dirt became incorporated into painting. George Braque started mixing sand in pigment in 1912, Andre Masson in 1927, and then Jean Dubuffet in the 1940s.[15] Robert Rauschenberg made *Dirt Painting for John Cage* (1952–53) "which sprouted real plants and initially was periodically watered."[16] The '60s Earthworks movement, or Land art, took this interest in dirt to new

RAUSCHENBERG
Dirt Painting for
John Cage

OLDENBURG
Placid Civic
Monument

lengths. Claes Oldenburg's *Placid Civic Monument* (1967), a hole dug in New York's Central Park, is considered the first Earthwork; from there it spread to Robert Smithson's *A Non-site* (an indoor Earthwork) in 1968 where he put sand from a site in Pine Barrens, New Jersey, in a gallery, and continued the work as a series by putting certain amounts of outdoor soil from various locations in gallery installations. Hans Haacke grew grass in a museum gallery in *Grass Grows* (1969). He also did an equivalent to noise or instrument destruction in the 1969 *Fog Flooding Erosion,* in which he flooded grass with outdoor sprinklers, resulting in soil erosion (and a lot of mud).[17]

Like composers' search for music spaces beyond the concert hall and sounds beyond those of musical instruments, Earthworks became the logical extension of the search for art beyond the walls of galleries and museums, and beyond paint, canvas, and clay into other materials. Art could be environment rather than object and so could sound. Rather than be packaged into discrete chunks (songs, compositions) it could be an ongoing presence that simply became part of the surroundings themselves.

Walter De Maria is a pivotal figure here. In the late 1950s he was artistic director for mixed-media events at the San Francisco Art Institute, a series produced by Young.[18] He befriended Young and both moved to New York in the early '60s. De Maria was a drummer and played informally with Young, in an early version of the Velvet Underground, and with Henry Flynt. He had already started formulating the idea of working with land as art, as evidenced by the pieces collected in *An Anthology,* edited by Young and Jackson MacLow (in works such as *Art Yard, Beach Crawl,* and *On the Importance of Natural Disasters*). De Maria's *Two Parallel Lines* (of chalk, running for a full mile in the Nevada desert, conceptualized in 1962 but not realized until 1968) resembles Young's 1960 *Composition 1960 #10 to Bob Morris* ("Draw a straight line and follow it"). He recorded an album in 1968 recently released on CD called *Drums and Nature,* which features him drumming on top of cricket sounds on one side and ocean sounds on the

NEUHAUS
Times Square

other. A similar recording serves as the soundtrack to his film *Hard Core* in which he and fellow Land artist Michael Heizer enact an Old West cowboy gun duel while the camera does endless 360 degree pans over the Nevada desert landscape.[19] De Maria also did Young the good turn of introducing him to Heiner Friedrich, who would go on to found Dia Art Foundation and become the leading sponsor of both artists. In this respect, De Maria's *New York Earth Room*, a gallery space filled with two feet of dirt, first realized in Friedrich's gallery in Munich and then at Dia in New York, could be compared to Young's *Dream House* as a "sound room," although visitors could not walk around in the dirt the way they could walk among the sound waves in Young's environment. Still, the similarities in the aesthetic cannot have been lost on Friedrich.

Other quasi-Earthwork/sound art pieces include Walter Marchetti's *Chamber Music #19* played by walking around a gallery floor that is covered with 20,000 pounds of salt, and Bill Fontana's *Earth Tones* (loudspeakers buried in the ground in a California ranch with low frequency sounds from the Pacific Ocean piped in which caused the earth to vibrate with sound). Bruce Nauman's *Untitled Piece* from 1970 instructed drilling a hole a mile into the earth and placing a microphone inside, which would feed into an amplifier and speaker in an empty room. His *Amplified Tree Piece* called for a similar setup by drilling a hole into a large tree and putting a microphone inside.[20] The translocation of Smithson's nonsites is felt particularly in Fontana and Maryanne Amacher's works but also in Hildegard Westerkamp's *India Sound Journal* (which considers, as she puts it, "the deeper implications of transferring environmental sounds from another culture into the North American and European context of contemporary music, electroacoustic composition, and audio art"[21]) and Leif Brush's *Gibbs Fjord: Hexagram Wind Monitors* which beamed wind sounds from Bafffin Island in Canada to DeDeolen Hall in Holland via satellite. The reference to Smithson's works is also clear in George Brecht's 1970 multimedia event

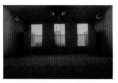

YOUNG AND
ZAZEELA
*Dream House: Seven
+ Eight Years of
Sound and Light*

DE MARIA
*The New York
Earth Room*

Journey of the Isle of Wight Westwards by Iceberg to Tokyo—inspired by an article about the possibilities of translocating land masses by harnessing them to icebergs—which featured a performance by the Scratch Orchestra and the making of a graphic score in reaction to their playing.[22] Around the same time there was even a global musical event called Earthworks organized by the New Zealand chapter of the Scratch Orchestra, headed by Philip Dadson, in which different associates around the world recorded local conditions during the September equinox of 1971.[23]

Trevor Wishart's sound work *Viking Museum* (that re-creates a lost Viking language), Hans Peter Kuhn's installation at the closed steelworks Volklinger Hutte (of sounds recorded when it was still in operation), or Ron Kuivila's Mass MoCA installation (re-creating sounds of the factory it once housed) are reminiscent of Alan Sonfist's *Time Landscape* (1965), which took an abandoned lot at Houston and La Guardia Streets in New York City and planted indigenous, forested plants, and re-created rock and soil formations from centuries before.

Smithson used rocks instead of representing rocks; in an interview he pointed out that he and his colleagues were not:

> dealing with matter in terms of a back to nature movement. For me the world is a museum. Photography makes nature obsolete. My thinking in terms of the site and the nonsite makes me feel there's no need to refer to nature anymore. I'm totally concerned with making art and this is mainly an act of viewing, a mental activity that zeroes in on discrete sites.[24]

Likewise sound artists, in a post–Pierre Schaefferian way, are concerned with sound divorced from its source, as an aesthetic end in itself. Even field recordings are perhaps better than classical music's attempts at replicating nature. Consider Wassily Kandinsky's critique:

OPPENHEIM
Gallery Transplant

ANT FARM
COLLECTIVE
Cadillac Ranch

Imitations of frogs croaking, of farmyards . . . are worthy of the
variety stage and may be very amusing as a form of entertainment.
In serious music, however, such excesses remain valuable examples
of the failure of attempts to "imitate nature." Nature has its own
language, which affects us with its inexorable power. This language
cannot be imitated.[25]

David Dunn is one sound artist whose work is concerned with
presenting natural sound in situ, rather than abstracting it for use in concert
or gallery presentation, or introducing electronic sound into a natural
habitat. In the piece *Mimus Polyglottos,* inspired by the mockingbird's
mimetic skills, he recorded electronic tones in the range and rhythm of
a mockingbird's song, then played it for a mockingbird, which reacted as
if it had heard another bird's song. In *Entertainments 1* he played a single
oscillator tone in a forest, which initially drew ire from a bluejay. Dunn
recorded the bird's response then replayed the recording back into the
woods and rerecorded that and played it back, repeating the process over a
series of months. Eventually the sound attracted wildlife who would stop to
listen to the sounds. Of course, whether his and his equipment's presence is
actually welcome in the creatures' natural habitat is open to debate; but this
attempt to recast sound as an interspecies phenomenon, on a one-to-one
level, is significant.

Earthworks and sound art share another concern: the question of how
to sell Earthworks could also be applied to sound installations, which have
yet to find a market among collectors. Compare sculptor/painter/architect
Tony Smith's famous quote on highway landscapes as art—"There is no way
you can frame it, you just have to experience it"—which was prompted after
driving on the unfinished New Jersey turnpike with this quote from Michael
J. Schumacher, proprietor of the Diaspason sound art gallery in Manhattan:
"Sound is experience, so there's no point in trying to make it into an object as

AMACHER
The Music Rooms:
A Six Part
Mini-Sound Series

OPPENHEIM
Accumulation
Cut

a collector's piece. So I'm trying to create situations where people come to it as experience, and value that."[26]

So, if noise is, or can be listened to, as "music," what is, well, noise? Edgard Varèse said "noise is any sound one doesn't like." Cage's answer is, "Silence is all of the sound we don't intend," and he professed to welcome street noise in his city home:

> I wouldn't dream of getting double glass because I love all the sounds. The traffic never stops, night and day ... At first I thought I couldn't sleep through it. Then I found a way of transporting the sounds into images so that they entered into my dreams without waking me up. A burglar alarm lasting several hours resembled a Brancusi.[27]

During a discussion with Young about his love for the hum of transformers at a power plant growing up, interviewer Edward Strickland complained that the one for his doorbell drives him nuts. Young replied "If you can walk up to it, listen, and leave, it's one thing. If you've got it as an annoyance in your house and you can't get rid of it, then it's a headache."[28]

In December 2005 I attended a concert of Morton Feldman's piece *Patterns in a Chromatic Field* by cellist Charles Curtis and pianist Aleck Karis at the Doubleknot Rug Gallery in TriBeCa in New York City. It was a small space with high ceilings, with rugs displayed on the walls. Although the piece is not as sparse as much of Feldman's work, it was still quiet and demanded concentration from both the performers and the listeners. For the first ten or fifteen minutes the occasional cry or words from a baby in the back of the room were heard. This was clearly disturbing the enjoyment of the piece, and finally the family left the concert. Later, the heating pipes started clanging loudly—another extraneous noise, but one whose steady pulse made for an interesting counter rhythm to the one happening in the piece at the time.

JULIUS
*Music For a
Frozen Lake*

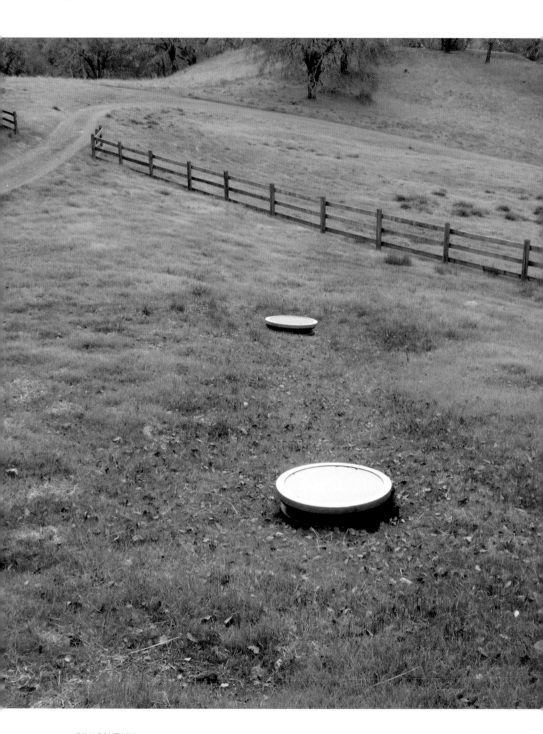

BILL FONTANA
Earth Tones, 1992. Installation of six low frequency sound speakers buried in
the earth at Oliver Ranch, Sonoma County, California. Steven Oliver Collection.
Courtesy the artist

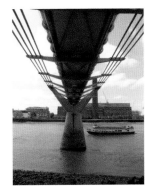

BILL FONTANA
Harmonic Bridge, 2006. Sounds from the vibrations of the Millennium Bridge, outside the Tate Modern, London, were transmitted into both Turbine Hall at the Tate and the main concourse of the Southwark station of the London Underground. Courtesy the artist

MICHAEL SNOW AND JOYCE WIELAND
Still from *Dripping Water*, 1969. 16 mm. 12 minutes.
A documentation of the filmmakers' dripping kitchen
faucet, originally realized as a sound recording.

MAX NEUHAUS

People listening to his *Water Whistle III*, 1972, at the St. Paul YMCA, Minnesota. Work exhibited in association with the Walker Art Center, Minneapolis. Sound was "piped" into the pool and was only audible when the listener's ears were submerged under water.

BILL AND MARY BUCHEN
Harmonic Compass, 1983. Galvanized
steel poles and resonator with stainless
wires. Installation in Lexington, New York.

Parabolic Bench, 1992. Concrete and stainless
steel. Installation at P.S. 23, Bronx, New York.
© Paul Warchol

GORDON MONAHAN AND THADDEUS HOLOWNIA
Long Aeolian Piano, 1984–86. Photo by Thaddeus Holownia. For
this work, the artists set up sixty-foot-long piano strings attached to
sound boards on a farm in Canada.

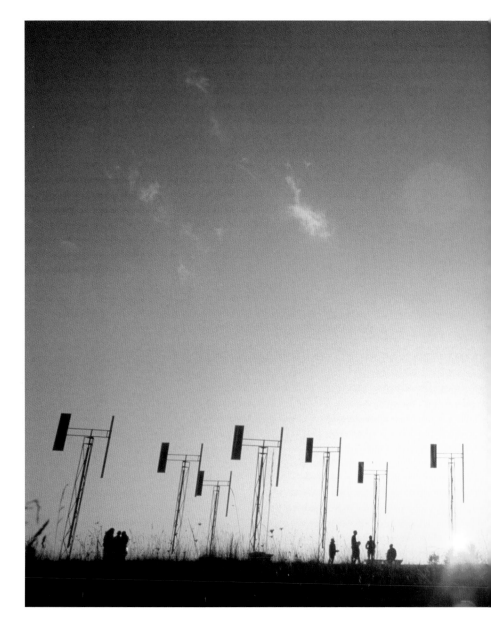

DOUG HOLLIS
Sound Garden, c. 1993. Installation in Magnuson
Park, Seattle, Washington. © Mike Zens/CORBIS

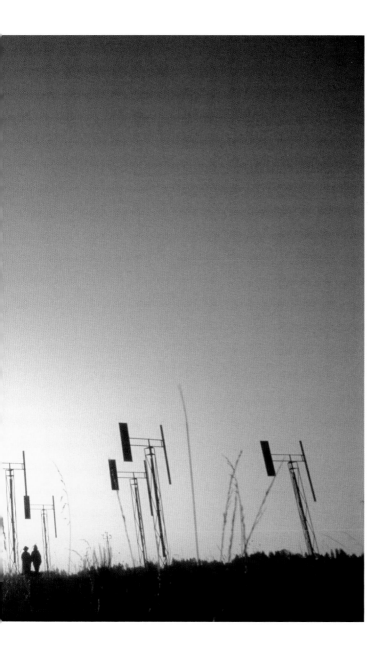

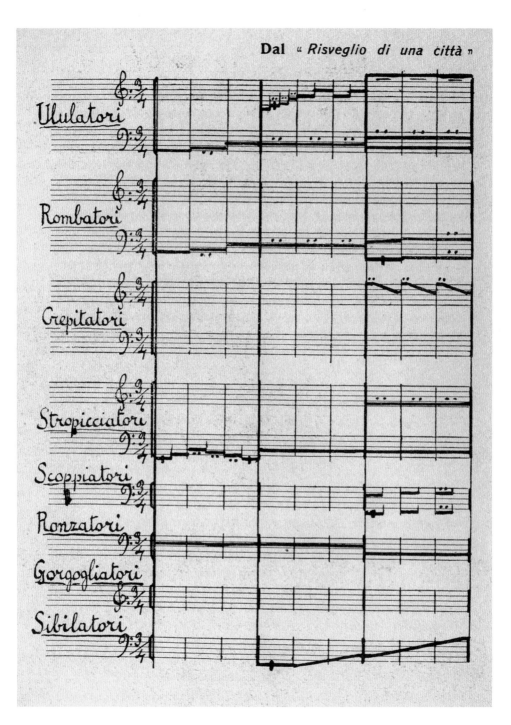

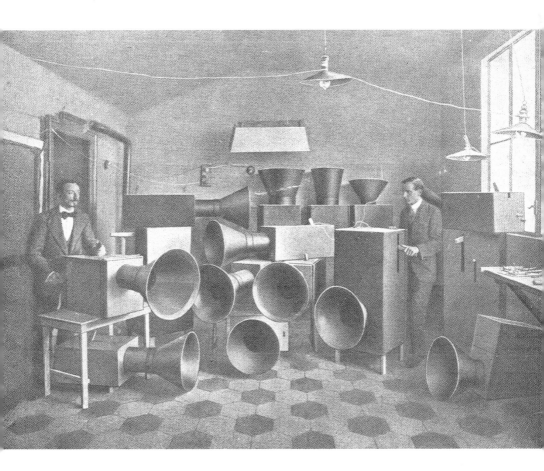

LUIGI RUSSOLO
The artist (left) and his assistant Ugo Piatti with their *intonarumori*,
1913. Courtesy Valerio Saggini

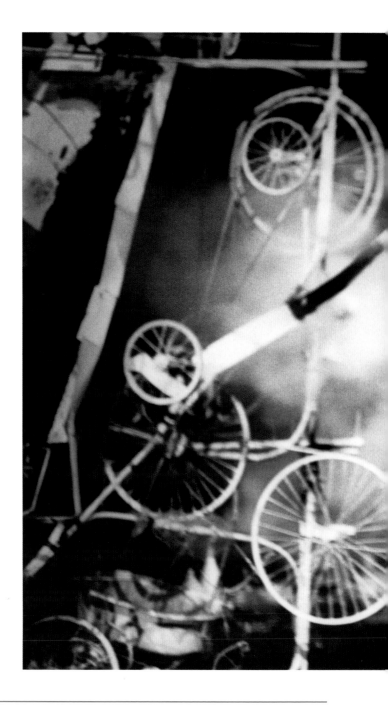

JEAN TINGUELY
Shown with his work *Homage to New York* as it was set in motion and destroyed in the Abby Aldrich
Rockefeller Sculpture Garden at the Museum of Modern Art, New York City, March 17, 1960. Digital Image
© The Museum of Modern Art/Licensed by SCALA/Art Resource, NY

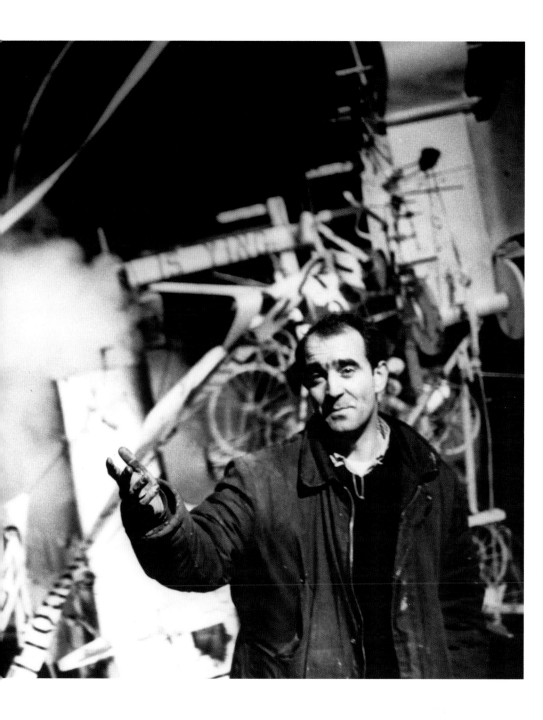

YASUNAO TONE
The artist (wearing a white jacket) with his sound installation *Volkswagen*, 1965.
Courtesy the artist. The location is a Volkswagon showroom in Tokyo and the
sounds are intended to interact with the audience.

ROBERT RAUSCHENBERG
Dirt Painting for John Cage, 1952–53. Dirt and mold in wood frame.
15 ½ x 16 ½ x 2 ½ inches. © Untitled Press, Inc. Art © Robert
Rauschenberg/Licensed by VAGA, New York, NY

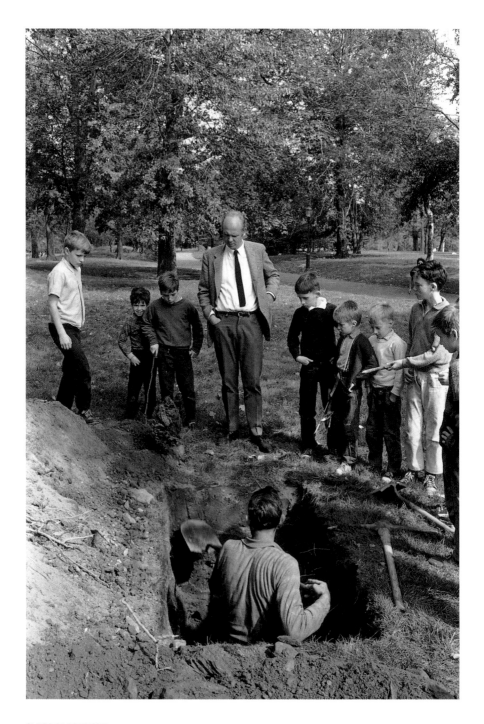

CLAES OLDENBURG
The artist at the site of *Placid Civic Monument*, 1967, in
Central Park, New York City. Photo by Fred McDarrah

MAX NEUHAUS
Installation of Neuhaus's work *Times
Square*, 1977, New York City.

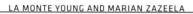

LA MONTE YOUNG AND MARIAN ZAZEELA
Dream House: Seven + Eight Years of Sound and Light, c. 1993. Photo and art © 1993 by Marian Zazeela.
MELA Foundation. A sound and light environment, described by the artists as "a time installation measured
by a setting of continuous frequencies in sound and light."

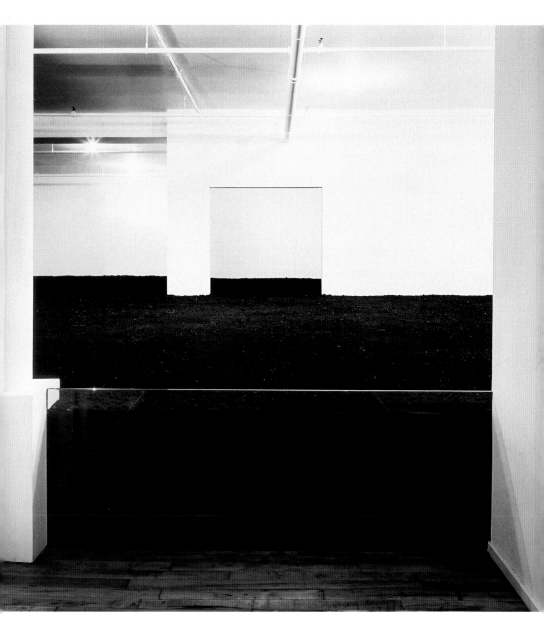

WALTER DE MARIA
The New York Earth Room, 1977. Two-hundred and fifty cubic yards of soil in 3,600 square feet of floor space; soil is 22 inches deep. Long-term installation at Dia Art Foundation, 141 Wooster Street, New York City. Photo by John Cliett. © Dia Art Foundation

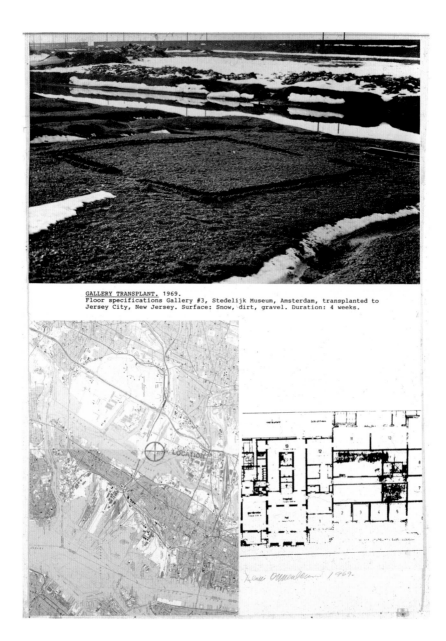

GALLERY TRANSPLANT. 1969.
Floor specifications Gallery #3, Stedelijk Museum, Amsterdam, transplanted to
Jersey City, New Jersey. Surface: Snow, dirt, gravel. Duration: 4 weeks.

DENNIS OPPENHEIM
Gallery Transplant, 1969. Floor specifications of Gallery 3 at Stedelijk Museum,
Amsterdam, transplanted to Jersey City, New Jersey. Surface: snow, dirt, gravel.
Duration: 4 weeks. Courtesy the artist

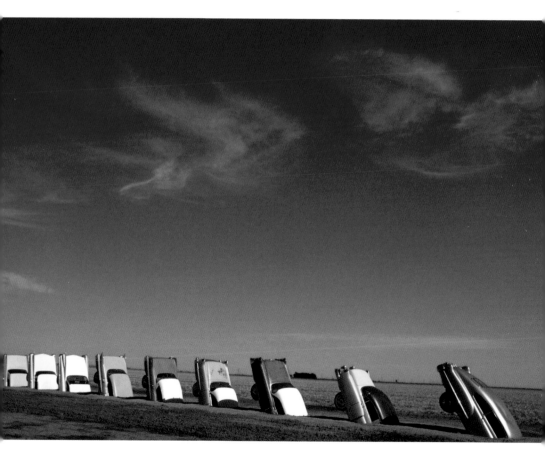

ANT FARM COLLECTIVE
Featuring Chip Lord, Hudson Marquez, and Doug Michaels, *Cadillac Ranch*, 1974. A public artwork of ten Cadillacs buried nose-down along Route 66. University of Berkeley, California, Berkeley Art Museum. Purchase made possible through a gift from Therese Bonney, by exchange, a partial gift of Chip Lord and Curtis Schreier, and gifts from an anonymous donor and Harrison Fraker. Photo by Bud Lee. © Ant Farm, 1974

MARYANNE AMACHER
Installation view of *The Music Rooms: A Four Part Mini-Sound Series,* 1987. Mixed media, projection of video image. The installation incorporated sound and well-worn props from the warehouse of the German Opera and newsprint murals created from pop music press. Photo by the artist

MARYANNE AMACHER
Installation detail and view of set created for *Sound House: A Six Part Mini-Sound Series*, 1985. Mixed media, couch (after Freud), architectural projections. Capp Street Gallery, San Francisco. A project in the tradition of television "mini-series," this sound work was experienced as sequenced performances by audiences over a period of weeks as opposed to a single evening concert or a continuous installation.

MARYANNE AMACHER
The artist installing a microphone and telelink transmission at Budget Rent-a-Car
for her work *No More Miles (an acoustic twin) Telelink Work No. 7*, 1974, from the
"City Links" series. Photo by Scott Fisher

MICHAEL J. SCHUMACHER
Diapason Gallery for Sound Art, New
York City, c. 2001. Courtesy Michael J.
Schumacher

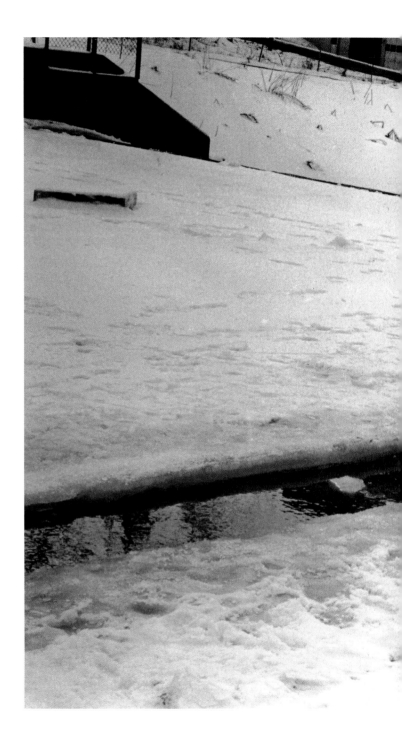

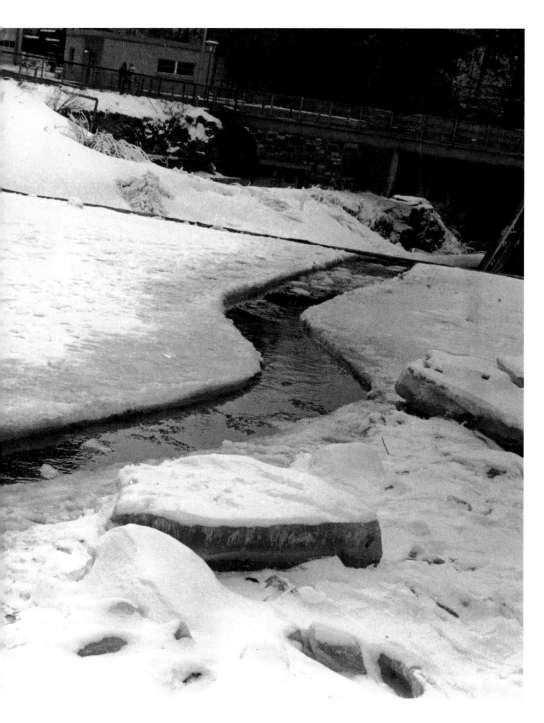

DENNIS OPPENHEIM

Accumulation Cut, 1969. Performance in Ithaca, New York. 4 x 100 foot-cuts made perpendicular to frozen waterfall using a gasoline powered chain saw, which required twenty-four hours to refreeze. Courtesy the artist

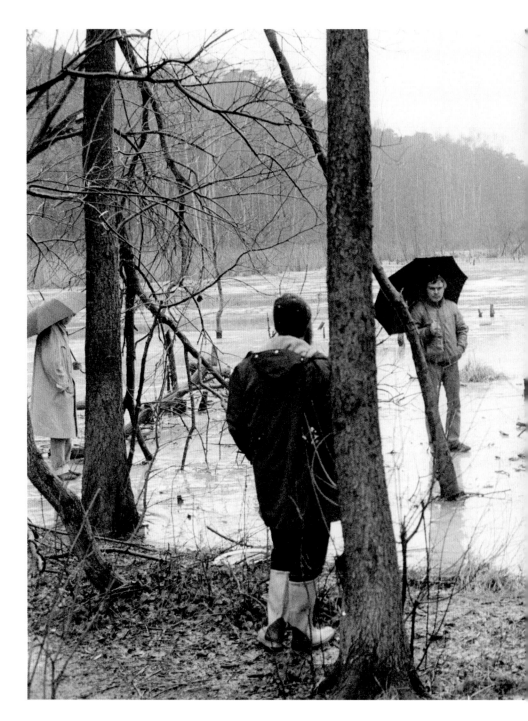

ROLF JULIUS
Music For a Frozen Lake, January 1982. Performance in which piano sounds were
played next to a frozen lake. Part of the Berlin Concert Series. Courtesy the artist

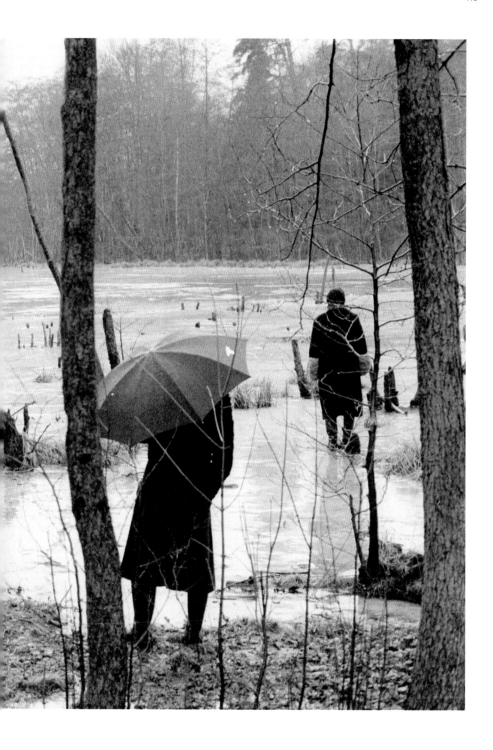

An anecdote from Glenn Gould may also illuminate the variable appeal
of unwanted noise:

> I happened to be practicing at the piano one day—I clearly recall, not
> that it matters, that it was a fugue by Mozart, *K.394* ... and suddenly a
> vacuum player started up just beside the instrument. Well, the result
> was that in the louder passages, this luminously diatonic music in which
> Mozart deliberately imitates the technique of Sebastian Bach became
> surrounded with a halo of vibrato, rather the effect you might get if you
> sang in the bathtub with both ears full of water and shook your head
> from side to side all at once. And in the softer passages I couldn't hear
> any sound that I was making at all. I could feel, of course—I could sense
> the tactile relation with the keyboard, which is replete with its own kind
> of acoustical associations, and I could imagine what I was doing, but
> I couldn't actually hear it. But the strange thing was that all of it sud-
> denly sounded better than it had without the vacuum cleaner, and those
> parts which I couldn't actually hear sounded best of all. Well, for years
> thereafter, and still today, if I am in a great hurry to acquire an imprint of
> some new score on my mind, I simulate the effect of the vacuum cleaner
> by placing some totally contrary noises as close to the instrument as I
> can. It doesn't matter what noise, really—TV westerns, Beatles records,
> anything loud will suffice—because what I managed to learn through the
> accidental coming together of Mozart and the vacuum cleaner was that
> the inner ear of the imagination is very much more powerful a stimulant
> than is any amount of outward observation.[29]

The point is, sound art comes from the appreciation of the total
environment of sounds, both wanted and unwanted. Of course, the dilemma
is that its presentation should, in theory, strive to prevent extraneous
sounds from entering the space. Michael J. Schumacher has pointed out

SCHUMACHER
Diapason Gallery
for Sound Art

that art galleries make no attempt to make sure other sounds are not heard (telephones ringing, etc.) but Diapason does. Similarly, sound art pieces are best experienced in solo shows; group exhibitions can either yield cacophony (such as one show I participated in in 1996, *Constriction,* which had a variety of sound pieces triggered by motion detectors in what appeared to be an empty gallery in Brooklyn's Pierogi 2000 space) or are real-time public compilation albums, which are annoyingly time-based (I can remember sitting in a room at the 2002 Whitney Biennial and in Charlie Morrow's *Sound Cube* at the Kitchen, an alternative space in New York, wishing I had a fast-forward button to get to certain pieces). There have been a few experiments with "sonic houses" and this perhaps is the future of sound art—a building with several rooms, each occupied by a different sound piece, perhaps all by the same artist or by several different ones. Young conceived his *Dream House* of continuous sound in 1962; Stockhausen had a 1968 piece called *Music for a House,* made as an extension of one of his seminars at Darmstadt, but this was a collective effort with different instrumentalists in trios and other formations, although at the end of the performance, tapes of the previous day's rehearsal were played in two rooms. Audiences still wandered through the house looking for the musicians (who had already left). [30] Maryanne Amacher took over an empty house in St. Paul during the New Music America festival in 1980 and filled it with electronic sound. Dia commissioned a full-scale *Dream House* in 1975, which became a reality at 6 Harrison Street in New York City in 1979. There were several sound environments running at once in different rooms in the six-story building, with chords mixing in hallways and alcoves as well. This lasted until 1985, when funding ran out.

Brian Eno has a more adaptive approach to sound installations, inspecting the given space and then trying to "make a piece which completely sinks into that environment somewhere. So that many of the sounds are indistinguishable from the traffic outside, the general hum of the city."[31]

Hans Haacke has stated:

> A sculpture that physically reacts to its environment is no longer to be
> regarded as an object. The range of outside factors affecting it, as well as its
> own radius of action, reaches beyond the space it materially occupies. It
> thus merges with the environment in a relationship that is better under-
> stood as a "system" of interdependent processes.[32]

Even more diplomatic are Bruce Odland and Sam Auinger, who have
created several installations that turn the sounds of an urban environment into
music. Using a "tuning tube," they filter real-time sounds from the location
into harmonics, often fed into an interior listening space as well as back out
into the environment, in effect, juxtaposing the inner harmonic activity of
the area with the raw material of its ambience, to allow listening in tandem.
They call it "music of the human hive," a reflection of human activity, and the
musical results are melodious and pretty, but they are anti-Russolo, and maybe
even anti-Cage; that the sounds themselves have to be scrubbed down to
reveal a musical essence, rather than being appreciated as "noise" prima facie.
Nevertheless, it does make for a more artful alternative to the finger-wagging
acoustic ecology of R. Murray Schafer, who opposes the high decibel noise
pollution of the past several decades.

In Europe another, non-site-specific alternative to the concert hall has
become radio, which exists in a broadcast space. As Michael J. Schumacher said:

> the European equivalent of the American alternative space, how the gal-
> lery became a venue for alternative music. In Europe, because the concert
> hall was much more flexible and open to new music, new music stayed in
> a very narrative form that's suitable to the concert hall. Radio became the
> center for what we would call radical experimentation forms. The facili-
> ties were there . . . the format of an hour radio program gave composers

the freedom, and a different way of thinking about time. A concert hall requires ten-to-fifteen-minute pieces.[33]

Radio art is also a phenomenon that has sometimes been discussed as sound art, although the movement's founder, Canadian Ian Murray, has stipulated that "radio art is not sound art—nor is it music. Radio art is radio ... radio by artists."[34] Murray had broadcasted tape loops in between normal programming and also taped the silences between programs and broadcast that as well. He has also said "Radio happens in the place it is heard and not in the production studio," which is what differentiates it from the European radio work noted above (and from fellow Canadian pianist and composer Gould's series of radio compositions, *The Idea of North, The Latecomers,* and *The Quiet in the Land*). While radio art could be considered sound by visual artists (and another radio artist, Hank Bull, has compared it to sculpture), the fact that its "sited" in inummerable locations (the space occupied by whoever's tuning in) makes it closer to street theater.

However, radio does play a role in certain sound installations. The earliest example may be Max Neuhaus's *Drive In Music* (1962–68), where he installed radio transmitters along a stretch of road that set up a number of sounds, heard through an AM radio in the car, which change as one drives along (Neuhaus was apparently arrested several times during one realization of the piece in Buffalo). More recently, Thomas Kubli and Sven Mann's *Determinal Verschweifungen* (2004) used a wireless FM transmitter system in a gallery installation. Visitors to the gallery were encouraged to use their own radios or those located in the gallery to interfere with predetermined loops and ambient recordings broadcast via the transmitter system.

The Elimination of Time

Dancer Yvonne Rainer, in discussing her 1961 solo work *The Bells,* has said that dance "was at a disadvantage in relation to sculpture in that the

spectator could spend as much time as he required to examine a sculpture, walk around it, and so forth—but a dance movement—because it happened in time—vanished as soon as it was executed." Her solution was to repeat seven movements, in varied sequence, direction, and parts of the room, over seven minutes—"in a sense allowing the spectator to 'walk around it.'"[35] There is no fixed time/duration it takes to appreciate a visual art object; however, for a sound installation, even if it's seemingly static and fixed, it may take an extended period of time to fully understand everything the piece has to offer and to absorb the structure the sound artist has intended.[36] A visual artwork manages to freeze a moment in time as an image; installations that use loops or drones are an attempt to sustain a sonic moment long enough to examine detail (as you would with a work of art).[37] Bill Fontana has written "Sounds that repeat, that are continuous and that have long duration defy the natural acoustic mortality of becoming silent."[38] This shows that using these techniques not only demonstrates the aspiration towards stopping time but also the predilection for the avoidance of "uncomfortable" silences. You can only hold a note vocally for a short period of time until you *run out of breath;* psychologically, I believe this to be part of the equation of silence with death. The use of echo and delay to elongate a sound's time duration is a basic technique to serve this dual purpose of time extension and opposing silence (and lengthening life itself, on a subliminal level).[39] In an interview, Bernhard Leitner notes:

> The Taj Mahal contains a huge empty domed space above the crypt. The mass, the weight of the walls, the shape and dimensions of the dome (twenty meters in diameter, twenty-six meters in height), and the extremely hard and polished surfaces (the interior of the dome is entirely made of marble) sustain a tone for up to twenty-eight seconds. In this space, a simple melody played on a flute will interweave with itself, going on and on to become an almost timeless sound. The

LEITNER
Sound Cube

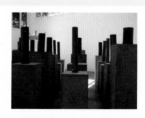

SUZUKI
From One Bamboo

room never ends. Even without sound, time is inherent in this space. The silence is tension-filled. The space finds its meaning in an unearthly, infinite silence.[40]

Because of sound art's investigation of extended time duration and repetition, there's also a transformative element to it that most likely would not occur in the contemplation of a visual piece (unless it was a film or video loop, which has similar aspirations).[41] La Monte Young's *X (any integer) for Henry Flynt* (1960) is a classic piece of repetition. Most often performed as repeated piano clusters, in one performance a frying pan was banged against the stage hundreds of times; a performance I witnessed in the early '90s found a percussionist striking a large bullet shell casing over one thousand times. A pioneering work in this respect is Erik Satie's *Vexations* (1893), a piano which reiterates the same melody, with two different harmonizations, 840 times[42]; a performance of the piece organized by John Cage in 1963 at the Pocket Theater in New York lasted eighteen hours and forty minutes and another performance in conjunction with the exhibition *Soundings* at SUNY Purchase in 1981 also lasted eighteen hours. Richard Toop's performance at Arts Lab in London in 1967 lasted twenty-four hours. Toop remarked "the piano was in the outer foyer, where there was an art exhibition, so that the music became a real 'musique d'ameublement.' People walked round the piano, talked, sometimes stopped and listened."[43] Feldman's *Rothko Chapel* (1971) points in this direction—"I envisioned an immobile procession not unlike the friezes on Greek temples," while noting that "stasis, as it is utilized in painting, is not traditionally part of the apparatus of music." His six hour *String Quartet No. 2* (1983) became a kind of installation at a 1999 performance at Cooper Union by Flux String Quartet, as people were encouraged to move about freely during the epic performance (but more the way they might during a long airplane flight or train ride than in a gallery space). Young's *Well-Tuned Piano* also became a

YOUNG /
THEATER OF
ETERNAL
MUSIC
*The Tortoise,
His Dreams
and Journeys,
"7"*

YOUNG
*Dream House: The
Well-Tuned Piano in
the Magenta Lights*

kind of installation as a performance, since it lasted over six hours by the
time of its last performance to date in 1987. Perhaps Young would have
frowned on people walking in and out, but I'm sure people did just that;
and he's always played the piece in a series of consecutive dates, which
gives the connotation of an exhibition. This is borne out in his more
recent exhibiting of a DVD of the final performance in 1987 as a video
installation in Europe.

SCALE

Sound installations represent a dramatic extension of music's sense of
scale, as time duration has been the way that music has approximated other
arts' sense of scale, certainly as much as volume or orchestration has. This
goes back to Wagner's *Ring Cycle,* and also finds counterparts in Robert
Wilson's epic theater works of the late '60s and '70s. (Interestingly, he pro-
nounced his play *Deafman Glance* to be a "silent opera"; and to go back to
sound/image dissociations, Pierre Schaeffer and Pierre Henry's first major
musique concrete work, *Symphonie Pour Un Homme Seul,* was termed "an
opera for the blind.") The six-hour running times of Young's *Well-Tuned
Piano* and Feldman's *String Quartet No. 2* show an avant-garde chamber
music contribution to that tradition. The use of amplification is in part
a counterpart to photography's magnification of image and also reflects
Surrealism's shifts of scale. Stockhausen elucidates this in an interview
with Jonathan Cott:

> I like to change the ordinary perspective. When the *Marseillaise in
> Hymnen* is heard eight times slower, it sounds like funeral music. And
> it's like putting in the same landscape painting a tree next to a man
> with the same height so that the dimensions don't seem right anymore
> ... this reveals the fact that *size* is a musical parameter.[44]

An installation like *Phase Difference Between Two Windows by Using Line Vibrations* (2001) by the Japanese sound art collective WrK, is another way of working with scale—it amplifies the vibrations of two windows in a gallery space outfitted with contact mics, making a sound otherwise barely audible into something at listenable volume (and becomes a sound art equivalent to Robert Irwin's practice of utilizing a bare gallery space as an art object). Pitches are made up of harmonics; the accentuation and amplification of harmonics (which are naturally soft) in music by Young, Tony Conrad, Arnold Dreyblatt, Phill Niblock, and others are other examples of changes in scale. In Hans Peter Kuhn's installation *Completely Birdland* he pushes the sound of a tongue hitting the inside of a mouth to a high volume, while a frenzied cello cadenza is reduced to a murmur. Playback volume on a home stereo is an everyday way that scale is shifted in music, as a concert that may have been upwards of one hundred decibels in a performance can be played back at nearly inaudible levels as a recording, if one so desires (and likewise an acapella 45 could theoretically be played back louder, or softer, than its singers would be in real life). This is also true in films, where sound can be given the equivalent of a close-up, but not necessarily in tandem with what's onscreen; Walter Murch notes that in *The Godfather* there's a loud screech of a subway during a dinner scene—the viewer doesn't see the train and accepts that it's outside, but "for a sound that loud, the camera should be lying on the train tracks."[45] The heavy-handed Dolby surround sound approach also plays with scale, in the unintentionally Surrealist amplification of the quietest sound—a footstep in the forest in *Lord of the Rings* (2000), for example, sounds like a thunderclap.

Bill Fontana has written of "the idea of being able to hear as far as you could normally see" in relation to some of his sound artworks.[46] This not only speaks to the ear's relationship to the eye but to these issues of scale as well, and reaffirms the emphasis on environment in works of sound art. Sound art takes its cue from Cage's assertion to listen to all sounds,

natural and man-made, and in doing so eventually shifted the stage to the environment itself rather than the concert hall. Conceptual artist Les Levine has written "environmental art can have no beginnings or endings"[47] and likewise the sound artists sought the elimination of time. That the first generation of sound artists (Annea Lockwood, Bill Fontana, La Monte Young, Maryanne Amacher, Bernhard Leitner, Max Neuhaus) emerged in the '60s and early '70s at the same time as the Earthworks and Land artists cannot simply be coincidental. While Descartes may have thought that sound originates in the human ear, the invention of microphones and tape recorders proved, through the recording signal transferred to tape, that sound was most certainly an external phenomenon, as well as a universal and elemental force, like earth, light, water, or air.

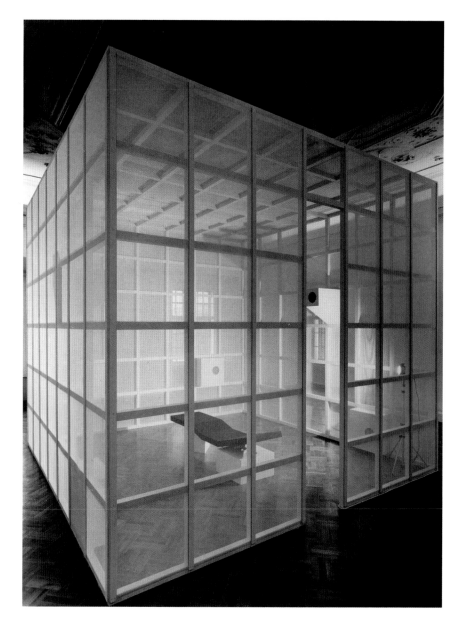

<u>BERNHARD LEITNER</u>

Sound Cube, 1980. In the work, a set of speakers on six walls create sounds that travel through space, "drawing" invisible lines, circles, and planes.

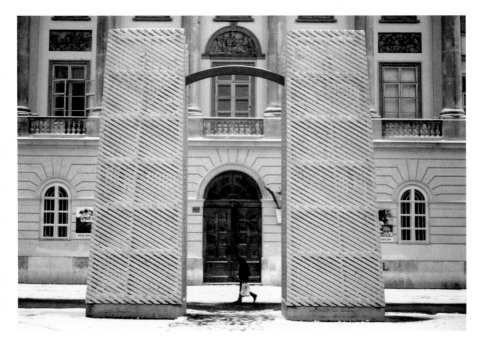

BERNHARD LEITNER
Sound Gate, 1990. Installed in Vienna. Courtesy the
artist

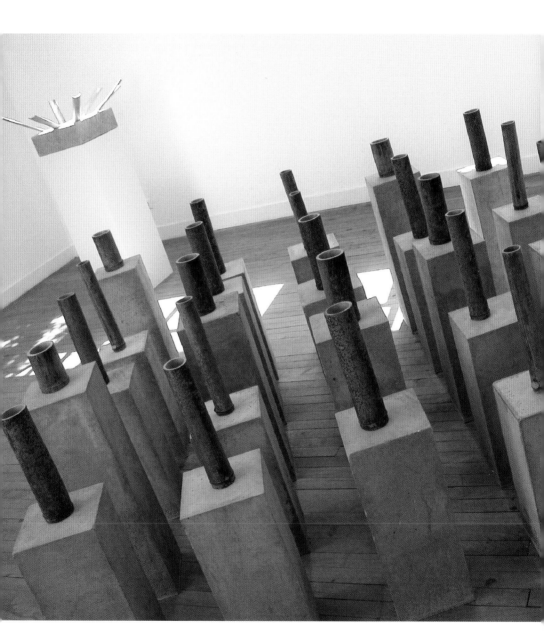

AKIO SUZUKI
From One Bamboo, 2004. From an exhibition of his work at Zadkine
Museum, Paris. Suzuki used this sculpture as a musical instrument
for the exhibition's opening. Photo by Keiko Yoshida

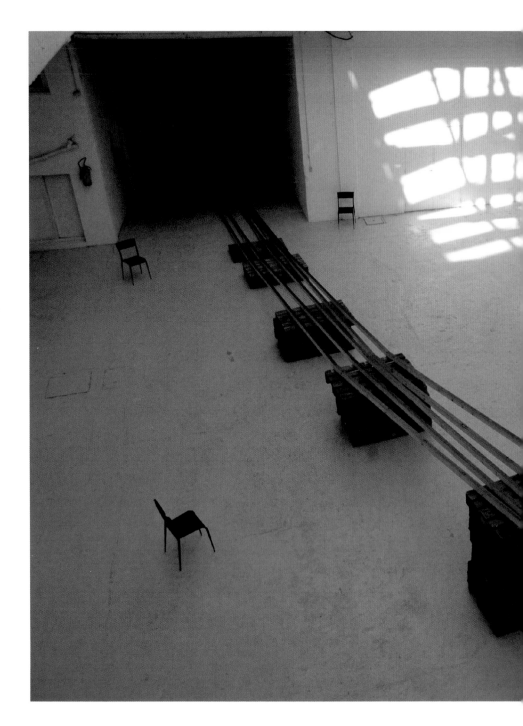

AKIO SUZUKI

Economical Music, 2006. Recycled materials including wood (from previous exhibition) and 12 chairs. The chairs are intended for people to sit in to listen to the space's inherent sounds. Centre d'art Passerelle, Brest, France. Courtesy Keiko Yoshida

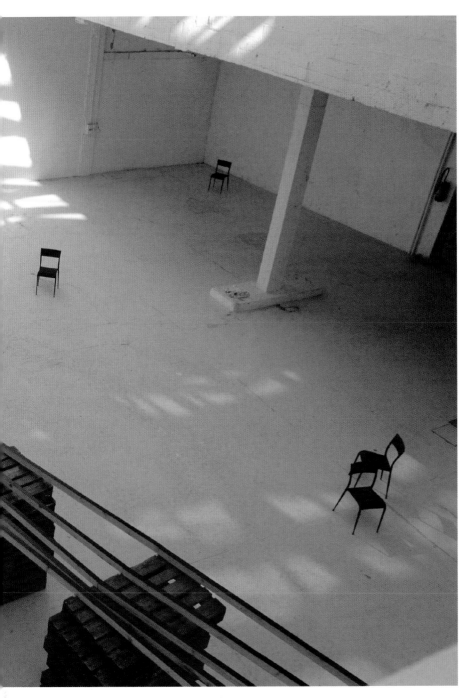

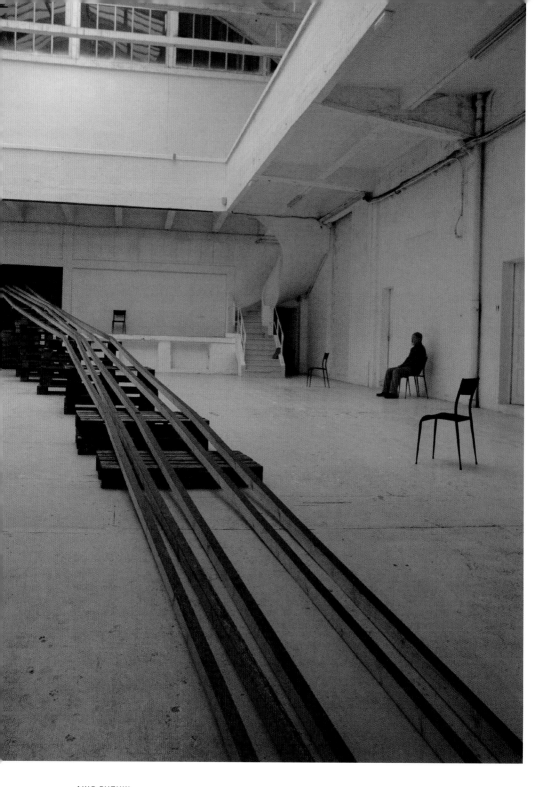

AKIO SUZUKI
Economical Music

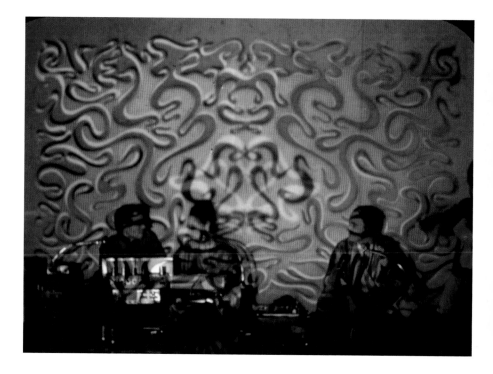

LA MONTE YOUNG

The Tortoise, His Dreams and Journeys, "7," February 6, 1966. Performance at The Four Heavens (Larry Poons's studio) of The Theater of Eternal Music, including the voices of La Monte Young, Marian Zazeela, Terry Riley, and Tony Conrad on violin. Light design by Marian Zazeela. Copyright © 1966, 1990 Marian Zazeela

LA MONTE YOUNG AND MARIAN ZAZEELA
Dream House: The Well-Tuned Piano in the Magenta Lights, 2001–present. Installation and DVD projection.
Kunst im Regenbogenstadl, Polling, Germany. Photo and art © 2001 Marian Zazeela. Young is standing in
front of his DVD image on the large screen.

LA MONTE YOUNG AND MARIAN ZAZEELA
Dream House: The Well-Tuned Piano in The Magenta Lights, May–September, 2000. Installation and DVD projection, St. Joseph Chapel, Avignon, France. Photo and art © 2000 Marian Zazeela

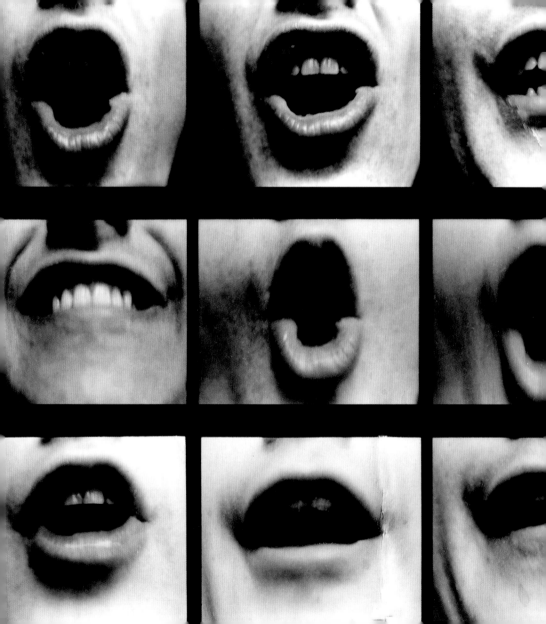

Sound and The Art World

MUSIC VERSUS PAINTING

Music and painting have always existed side by side, but it is with the deconstruction of painting into formal elements in the early twentieth century that makes possible the breakdown of music into pure sound. As a result, painters and musicians began to take further interest in what each other were doing, starting with Kandinsky's fascination with Arnold Schoenberg, which

resulted in a correspondence (as it turned out, Schoenberg was also a painter, and Kandinsky was also a cellist). If music had previously existed as one of "the arts," music/sound began to take on a new identity as another medium to be used by artists, starting with Marcel Duchamp's and Jean Dubuffet's forays into composition and free improvisation, respectively. Andy Warhol's positioning of the Velvet Underground in his Pop take on the au currant Happenings of the mid-'60s was similar to his silk screens as a once-removed artistic gesture. It wasn't so much the music world meeting the art world as it was Warhol's interest in expanding out of the art world into the entertainment world: the film business (his movies), the publishing business (*Interview* magazine), and television (a short-lived cable show, *Andy Warhol's TV*). The legacy of the Velvet Underground, though, has turned out to be the punk and No Wave movements of the mid-to-late '70s, which led would-be poets, painters, and experimental theater types to consider rock as an alternate medium and the urban rock club as a viable art space with an exciting immediacy that the gallery system lacked. It may not be sound art, per se, but it provides a necessary context for how sound has become part of the art world.

Morton Feldman asked his friend Brian O'Doherty to comment on the difference between painting and composition and got this reply:

> The composer's surface is an *illusion* into which he puts something real—sound. The painter's surface is something *real* from which he then creates an illusion ... A music that has a surface *constructs* with time. A music that doesn't have a surface *submits* to time and becomes a rhythmic progression.[1]

Still, music has always produced equivalents to painting; the way classical composers mixed instrumental timbres in orchestras is really equivalent to a painter mixing colors. Feldman traced the history of correspondences between the two in his own inimitable way:

Music and painting, as far as construction is concerned, parallel each
other until the early years of the twentieth century. Thus, Byzantine art,
at least in its uncluttered flatness, was not unlike the Gregorian chant or
plainsong. The beginning of a more complex and rhythmic organization
of material in the early fifteenth century with the music of [Guillaume
de] Machaut was akin to Giotto. Music also introduced "illusionistic" ele-
ments during the early Renaissance by way of inaugurating passages of
both loud and soft sounds. The miraculous blending or fusing of the reg-
isters into a homogeneous entity, as in the choral music of Josquin [des
Pres], could also be said of the painting of that era. What characterized
the Baroque was the interdependence of all the parts and its subsequent
organization by means of a varied and subtle harmonic palette. With the
nineteenth century, philosophy took over—or to be more precise, the
spectre of Hegel's dialectic took over. The "unification of opposites" not
only explains Karl Marx, but equally explains the long era that includes
both Beethoven and Manet.

 In the early years of the twentieth century we have (thank heaven!)
the last significant organizational idea in both painting and music—
Picasso's analytical Cubism, and a decade later, Schoenberg's principle of
composing with twelve tones. (Webern is even more related to Cubism
in its formal fragmentation.) [2]

The New York School of modern classical music of the early '50s (Cage,
Feldman, Earle Brown, Christian Wolff) had a tremendous crossover with
the New York art scene of the time. Feldman went to the Cedar Bar (a well-
known hangout for artists) with Cage every day for five years, and names Bar-
nett Newman, Mark Rothko, Larry Rivers, Jasper Johns, Willem de Kooning,
Robert Motherwell, Robert Rauschenberg, Franz Kline, Jackson Pollock, and
Philip Guston as personal acquaintances and influences (he even collected
work by Pollock, Guston, and Rauschenberg). He also made the soundtrack

to the important Hans Namuth/Paul Falkenberg film of Pollock and has said "what resembled Pollock was my 'all-over' approach to the time canvas. Rather than the usual left to right passage across the page, the horizontal squares of the graph paper represented the tempo—with each box equal to a preestablished ictus; and the vertical squares were the instrumentation of the composition."[3] This is reminiscent of Cage's statement "Observe that the enjoyment of a modern painting carries one's attention not to a center of interest but all over the canvas and not following any particular path. Each point on the canvas may be used as a beginning, continuing, or an ending of one's observation of it."

Robert Rauschenberg's Combines have exerted a supreme influence on postmodernism that is certainly felt in the genre slice-and-dice of free improvisations of AMM (a British group who would improvise noisy soundscapes on top of loops of Beach Boys' songs) or Christian Marclay (whose ability to careen from lounge music to classical to Jimi Hendrix on his multiple turntables in turn influenced composer John Zorn). But Rauschenberg also exerted a major influence on many auteurs in the music world of the '40s and '50s. Rauschenberg's white paintings were particularly influential on Cage's 4'33": "When I saw those I said 'Oh yes, I must; otherwise I'm lagging, music is lagging.'" Douglas Kahn elaborates:

> He [Cage], noticed how, on a canvas of nearly nothing, notably absent of the expressive outpourings characteristic of the time, another plenitude replaced the effusiveness in the complex and changing play of light and shadow and the presence of dust. Correspondingly, environmental sounds rushed in to fill the absence of music sound in 4' 33".[4]

Karlheinz Stockhausen also cites the unifying found objects in Rauschenberg's Combines as an influence on his *Kontakte* and *Gesang der Junglinge*. Rauschenberg was an influence on Feldman's later piece *The Viola in My Life*— "My intention was to think of melody and motivic fragments," he wrote,

"somewhat the way Robert Rauschenberg uses photographs in his painting—and superimpose this on a static sound world more characteristic of my music."[5] And Steve Reich's determination to break with musique concrete and present taped sounds as they were, unprocessed, recalls Rauschenberg's postmodernist decision to leave imagery recognizable in his collages (although Reich's integration of African music into his composition would be more comparable to the influence of African tribal art on Picasso). Indeed Rauschenberg's famous quote about operating in the gap between life and art becomes increasingly influential even five decades later and is certainly responsible for the acceptance of daily environment sounds into an installation situation.[6]

Another important composer of the period, Earle Brown, cites Pollock as an influence but singles out Alexander Calder as a more direct one:

> In Calder, the construction of units and their placement in a flexible situation that subjects the original relationships to constant and virtually unpredictable, but inherent, change (the movement of the units as well as the movement of the viewer) led me to construct units of rhythmic groups (with assigned intensities but "open" timbre possibilities subject to an independent timbral-density plan), modify them according to [...] "generative" techniques, and assemble them rather arbitrarily—accepting the fact that all possible assemblages were inherently possible and valid.[7]

This in turn led to graphic scores to realize notation of the pieces in 1952 and 1953, which he called "mobile compositions," and ultimately to his 1963 *Calder Piece,* in which an actual Calder mobile is placed in the center of the performance space as a kind of "conductor" with four percussionists situated in each corner of the room reacting to its movements and even using it as another percussion instrument. He further affirmed that by eliminating stasis from visual art, Calder's work created "a vital relationship to the 'time arts'—theater, music."[8]

There was a certain aesthetic jealousy of these composers to visual artists, particularly of the painter's hand as opposed to the composer's score, which only provides a sketch for the performer. Feldman provides an example:

> Someone suggested that since Mondrian used areas of all one color, why not use a spray instead of painting these areas? Mondrian was very interested, and immediately tried it. Not only did the picture not have the feel of a Mondrian, it didn't even have the look of a Mondrian. No one who has not experienced something of this will understand it ... The word that comes closest is perhaps touch. For me, at least, this seems to be the answer, even if it is nothing more than the ephemeral feel of the pencil in my hand when I work. I'm sure if I dictated my music, even if I dictated it exactly, it would never be the same.[9]

(In this passage, written in 1965, Feldman is speaking before the rise of composers/performers like Philip Glass, Terry Riley, Steve Reich, and La Monte Young who are arriving at composition from a jazz background.) Electronic composer Richard Maxfield, who took over Cage's class at the New School, also scorned scores, complaining that "artists don't publish directions for painting their paintings or sculpting their sculptures except in the form of children's coloring books or toys." There was also a practical consideration, as Douglas Kahn has pointed out:

> Unlike writers or painters, who needed relatively affordable technologies (pen and paper, brush, paints, canvas, and the like) to complete their art, composers were closely linked to string quartets or symphony orchestras to hear common forms of their practice realized ... To gain access to their technologies, composers were required to circulate in the upper reaches of society, participate within the formal rites of high musical culture, and speak through the discourses attending these scenes.[10]

Laszlo Moholy-Nagy called for gramophones to be used as sound producers rather than reproducers: "The composer can himself create his composition, ready for reproduction, on the record; therefore, he is not dependent upon the absolute skill of the interpreter. Until now the interpreter in most cases succeeded in smuggling his own heart and soul into the tone of the written composition."[11] He also prophesized "independence from large-scale orchestral enterprises; enormous distribution of the original creations by simple means." This is comparable to the freedom of the first super 8mm, the Bolex for filmmaking, and ultimately the Sony Portapak and camcorder for video as opposed to large-scale studio filmmaking—the accessibility of production has always led to artmaking (video art, sound art, etc.).

Edgard Varèse called for a "sound producing machine (not a sound reproducing one)" where a score would be transferred directly—"music exactly as the composer wrote it—exactly like opening a book." (One of Varèse's followers, Iannis Xenakis, comes close to this with his computer music in the 1970s in which the music is created by drawing a graphic score directly into the computer.) Feldman also longs to escape from instruments: "In music it is instruments that produce the color. And for me, that instrumental color robs the *sound* of its immediacy. The instrument has become for me a stencil, the deceptive *likeness* of a sound ..."[12] He calls for music without instruments; presumably, sound, made somehow without instruments, would assume an identity much like that of a pure color. He continues: "There is an old proverb: 'Man makes plans, God laughs.' The composer makes plans, music laughs."[13]

SOUND BY VISUAL ARTISTS

Most sound by visual artists isn't classifiable as sound art—it's too performance oriented. Nonetheless, it's an important facet of its mise-en-scène inasmuch as it shows a tradition of artists looking to sound or music as a form

of expression and continuation of their visual aesthetic, and galleries function-
ing either as a venue or as a label producing albums as a kind of artist's multiple
edition, or as a more economical means of documenting artist's performances
than video.

In the Dada era, both Marcel Duchamp and Kurt Schwitters turned to
sound as an additional forum for their creative work. Beyond the Readymades,
Duchamp's championing of ideas over technical mastery of drawing or paint-
ing echoes in untrained musical expression by artists over the last decades.
Duchamp's famous dictum "No more masterpieces" lives on in his three com-
posed works, produced in 1913.

Erratum Musical is scored for three voices. Each performer is given one
of three sets of twenty-five cards and one note is indicated per card. The cards
were originally thrown in a hat by Duchamp, picked out one at a time at ran-
dom, and then written down. *The Bride Stripped Bare by her Bachelors, Even*
is an unfinished work for "player piano, mechanical organs, or other new
instruments for which the virtuoso intermediary is suppressed." Numbered
balls are dropped through a funnel into open-ended cars, again representing
note values. Finally, *Sculpture Musicale* merely consists of a note on a small
piece of paper.[14]

Upon hearing Raoul Hausmann's sound poem "fmsbw" in 1921 (the form
was invented by Hugo Ball in 1916), Schwitters began including it in his lec-
tures, and eventually developed his own piece, *Sonate in Urlauten,* which grew
to four movements, including an introduction, cadenza, and a finale. He per-
formed the piece himself ("Listening to the sonata is better than reading it. This
is why I like to perform my sonata in public") and gave minimal instructions to
other potential performers ("You yourself will certainly feel the rhythm, slack
or strong, high or low, taut or loose. To explain in detail the variations and com-
positions of the themes would be tiresome in the end and detrimental to the
pleasure of reading and listening, and after all I'm not a professor"). No pitches,
tempi, or dynamics are indicated, just phrases like "Lanke trr gll."

DUCHAMP
*To Have the
Apprentice
in the Sun*

Sound poetry "made by and for the tape recorder," as Henri Chopin put it, really comes of age in the late '50s and early '60s, and was documented extensively in Chopin's *Revue Ou* periodical, which included recordings by the form's major figures, including Lettrists Francis Dufrene and Gil Wolman, Bernard Heidsieck, Swedes Ake Hodell and Sten Hanson, Mimmo Rotella, Bob Cobbing, Brion Gysin, Charles Amirkahanian, and Chopin himself. At the same time, Yves Klein "finishes" his *Symphony of Monotone-Silence 1949–1961*, which sustains one chord and a silence for an equal length of time. This musical equivalent to his monochrome paintings, in its final version, was performed as nude models bathed in blue paint created body prints on the floor while a tuxedoed Klein conducted a twenty-two-piece ensemble with twenty singers. Jean Dubuffet also begins carrying his Art Brut aesthetic into the aural realm, beginning with improvisations with Asger Jorn in late 1960. Despite some previous musical experience, "we were intending to use instruments in such a way as to obtain new sounds from them. Besides a piano (not a very good one) our instruments were a violin, a cello, a trumpet, a recorder, a Saharan flute, a guitar, and a tambourine," and the pair later added a hurdy gurdy, horns, xylophone, zither, cabrette (Auvergnat bagpipes), and bombarde (a kind of oboe)—"things we came upon by chance." Dubuffet was not conversant with Cage or aleatory trends in modern classical composition, and he soon took to overdubbing all the instruments himself. The resulting recordings are a bracing, early example of modulated cacophony.

Dubuffet's experiments set a precedent for nonmusician visual artists creating "noise" music. In 1962 the Artists Jazz Band starts in Toronto. Comprised of painters Graham Coughtry, Harvey Cowan, Terry Forster, Jim Jones, Nobuo Kubota, Robert Markle, Gerald McAdam, Gordon Rayner, and later joined by Michael Snow, the group was inspired by free jazz and produced a social outlet for the artists as well. (Coughtry has said "Music has always been the messenger since some of us Toronto painters discovered it was one of the most empathetic forms of communication between us, and the always expanding

KLEIN
Symphony of Monotone-Silence, 1949–1961

DUBUFFET
Jouant de la trompette chinoise

Artists Jazz Band came into existence.") The Isaacs Gallery released a double album in 1973 that came with a limited edition set of prints, one by each artist. A little south of Toronto in London, Ontario, artists Greg Curnoe, John Boyle, and Murray Favro start the Nihilist Spasm Band in 1965, similarly in homage to free jazz improvisation and psychedelic rock, although unlike the Artists Jazz Band they and their compatriots have no musical training ("Even if we wanted to play *Melancholy Baby*, we couldn't," reads the liner note to their album *Vol. 2*). Armed with homemade electric kazoos, guitars (some made by Favro), drums, vocals, violin, and electronics, they've played every Monday night in London for the past forty years and despite the deaths of Curnoe and long-time bassist Hugh McIntyre, they show no sign of stopping.

Fluxus's musical excursions, mostly "noise," were made by a mix of trained and untrained musicians. La Monte Young presented a proto-Fluxus concert series at Yoko Ono's loft starting in December 1960, once a month until June 1961, which included Terry Jennings, Toshi Ichiyanagi, Henry Flynt, Joseph Byrd, Jackson MacLow, Richard Maxfield, Simone Forti, Robert Morris, and Dennis Lindberg. This was followed by another series at Fluxus CEO George Maciunas's A/G Gallery in the spring of 1961 which gave nights to Maxfield, John Cage, Storm de Hirsch, Ichiyanagi, MacLow, Byrd, Young, Flynt, Walter De Maria, and Ray Johnson, plus a painting show by Ono. There was also a similar lineup at the Living Theater concert in 1960 featuring pieces by Allan Kaprow, George Brecht, Ray Johnson, Richard Maxfield, Cage, Al Hansen, and Rauschenberg. Maciunas continued to do Fluxus concerts, including one at Carnegie Hall in 1965 by the Fluxus Symphony Orchestra, but as a self-described "combination of Spike Jones, vaudeville, gags, children's games, and Duchamp," Fluxus music is still in the tradition of Dada performance, strongly influenced by Cage's concert-hall antics.[15] As Fluxus created its own everyday objects (tickets, toys, furniture, etc.) as well as films, books, prints, poetry, and paintings, it was inevitable that music would be another one of its by-products.

Cage and Post-Cage

In his general recognition of everyday sounds as potential compositional material, Cage is often considered to be the music world's answer to Duchamp, a debt he acknowledges first in the 1947 *Music for Marcel Duchamp* (originally written for Duchamp's sequence in Hans Richter's film *Dreams That Money Can Buy*) and in titling pieces *The Bride Stripped Bare* and *Not Wanting to Say Anything About Marcel*. *Living Room Music* (1940) shows the influence of the Readymade in particular—the instrumentation is "objects to be found in a living room." It also demonstrates his once-controversial championing of Erik Satie in his call for "A music which is like furniture ... which will be part of the noises of the environment, that will take them into consideration."[16] Cage was also doubtless aware of Satie's friendship with sculptor Constantin Brancusi and his collaboration with Pablo Picasso, Jean Cocteau, and Leonide Marsine on the ballet *Parade* as a precedent for his own cultivation of acquaintances in the art world.

Cage's inroads in upending traditional modes of composing and presenting music publicly have laid the groundwork for sound art. His *Musicircus* or Happenings like *HPSCHD* or *Roaratorio* could, I suppose, be experienced like a short-term art exhibition, although the incorporation of dancers suggests an outgrowth of his collaborations with Merce Cunningham, and the performance element is still unique to multimedia events rather than exhibitions. As time went on, Cage became more politically engaged and began to see his ideas in terms of human nature and behavior. As Feldman wrote, "Cage's idea, summed up years later as 'Everything is music,' has led him more and more towards a social point of view, less and less towards an artistic one ... Cage gave up art to bring it together with society."[17]

There is also a split between what becomes Happenings and Fluxus and what becomes sound art in the early '60s, as members of Cage's New School class (George Brecht, Jackson MacLow, Allan Kaprow, Al Hansen, Dick Higgins), begin creating Neo-Dada music pieces. Brecht's pieces like *Solo for Violin*

HIGGINS
Symphony No. 48

(in which the performer polishes the instrument) and *String Quartet* (in which the performers simply shake hands) follow Cage in the upending of concert performance expectations and etiquette, while *Drip Music* and *Comb Music* likewise follow up on Cage's "all sounds are music" philosophy. Kaprow also talks about Pollock paintings as an almost performance/Happening:

> a kind of spatial extension ... the entire painting comes out at us (we are participants rather than observers) right out into the room ... By being inundated in his swirls of paint and by an enormous format which he could not assess in any one glance, he finally put the whole affair on the floor and stood in the middle of it. He created a quasi-environment in which reiterated pulsations of flung and dragged paint seemed to cause a trance-like, almost ritual loss of self, first in himself and, later, in the observer. This is not painting anymore.[18]

However, the physicality of creating the painting is what Kaprow responds to in creating his own Happenings. Cage considered Happenings theater. Young is involved with Maciunas, Brecht, MacLow, et al., before the term Fluxus is created and the movement shifts to Europe, at which point he becomes disinterested. Yet he retroactively calls his group performances with Tony Conrad and John Cale in the early and mid-'60s the Theater of Eternal Music, indicating some theatrical bent to the proceedings (which may only reference Marian Zazeela's slide projections and lighting, or to differentiate live performances from his more permanent *Eternal Music/ Dream House* concepts).

Like the cabaret Voltaire and other Dada-era performances, Fluxus pieces did not require musical training to perform, and most of Cage's New York students were painters. Yet several Fluxus participants have musical backgrounds.

Nam June Paik studied music, wrote a thesis on Schoenberg, and worked in the electronic music studio at WDR. He gave various Cage-inspired piano

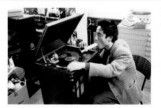

PAIK
*Listening to Music
Through the Mouth*

performances between 1959 and 1963, and his first major exhibition with the TV sets he was to become known for was entitled *Exposition of Music-Electronic Television,* which signaled his departure from music making as his primary activity. (The exhibition also included prepared piano, mechanical sound objects, *Schallplatten Schaschlik*—a record-playing sculpture which suspended several records in air—a free-floating tone arm that allowed switching back and forth playing any record and *Random Access Music,* in which the viewer could run a detached tapehead across tape attached to the wall.[19]) He had a long-standing collaboration with cellist Charlotte Moorman and gave occasional music performances, either solo or in collaboration with Joseph Beuys, Takis, and others.

Philip Corner studied music with Henry Cowell and Olivier Messiaen. While doing his share of graphic scores and text instruction pieces, Corner has also composed over four hundred works for gamelan and numerous piano pieces, as well as creating much poetry, calligraphy, and visual art. MacLow had studied composition and several instruments extensively by the time he arrived in Cage's class; although perhaps best known for his poetry (he served as Fluxus's literary director) he made numerous music compositions, both deterministic and aleatory, as well as text/sound pieces and sound poetry.

Takehisa Kosugi studied musicology in college, although he had no formal training on the violin, his chosen instrument. Kosugi was intrigued with improvisation and chance methods in the very early '60s, and unaware of Cage, formed a free-improvisation group, Group Ongaku, in Tokyo in 1960 (which predates the Cage-influenced free improvisation scene in Europe by a half-dozen years).[20] His subsequent exposure to Cage's work, seeing a Cage/Tudor performance in Tokyo in 1962, confirmed his interests and led to his involvement with Fluxus through composer Toshi Ichiyanagi; ultimately he replaced Cage as the musical director of the Merce Cunningham Dance Company. While Kosugi has done sound installations, his music is still primarily performance and improvisation based, in line with the Fluxus tradition; his

FOX
Isolation Unit

TUDOR
Performance of John
Cage's *Variations II*

own comparison of his "catch wave" electronic performances, where he sets up a system to "catch" electronic sounds to catching fish in a river and terming his music as "sound cuisine," better describes his work than "sound art."

Joseph Beuys was a sometime Fluxus participant and had a background in violin and cello. His *Siberian Symphony* (1963) was his first Fluxus performance in Dusseldorf; there was a piano solo, then a Satie piece was played as Beuys hung a dead hare on a blackboard, stuffed the piano with clay and branches, and finally removed the hare's heart. He also collaborated extensively with composer Henning Christiansen, who was affiliated with Fluxus, and created a series of music-oriented sculptures—*The Noiseless Blackboard Eraser, Bone Gramophone, Tape in Stacked Felt,* and *Infiltration-Homogen for Grand Piano.*

Wolf Vostell's "de/collage music" focused on "all noises which are propagated when a form is destroyed," claiming that all that is left of the form in the wake of the destruction is the sound. Indeed, he did a version of Satie's *Furniture Music* in which he smashed the furniture; and in the piece *Kleenex* he smashed one hundred lightbulbs. "When the lightbulb is smashed," he has said, "it no longer produces light, but sound." (True, but the sound only lasts a second, and then you have all that broken glass to look at.) Vostell's other hijinks included a piece involving opening and closing a car door 750 times and having instrumentalists play torn up scores of classical pieces or "play" silences for every written note in a score.

It is two of Cage's frequent performers—David Tudor and Max Neuhaus—who take Cage's ideas into sound art as opposed to Cage himself. Neuhaus began doing installations in the mid-'60s. In the music for the 1968 dance piece *Rainforest,* Tudor fed electronic sounds into inanimate objects to make them resonate, including a wine barrel, bed springs, a sprinkler, a tennis racket, a picnic basket, and the audience was welcome to walk around them—a masterpiece of sound sculpture and installation.

Another follower of Cage's, Italian composer Walter Marchetti, also takes

NEUHAUS
Fan Music

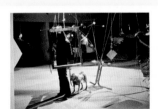

TUDOR
Rainforest IV

certain of his ideas into the realm of sound art (beyond modern composition). He calls his work "visible music." In one of his *Chamber Music* pieces (which number nearly three hundred), he lies asleep on a gallery floor, in essence taking Cage's "silent piece" (*4′ 33″*) into an art world context rather than the classical world context of the concert hall, and turning it into an installation rather than a five-minute performance. Marchetti's more recent compositions for eight orchestras or eight instrumental ensembles or eight organs are an interesting and surprisingly rare example of conceptual sound art, in that it's unlikely that the piece can be realized due to technical limitations, much like many examples of early '70s conceptual art.

- - -

In 1972 artist Dieter Roth, poet and playwright Gerhard Ruhm, and writer Oswald Wiener, began playing music together at home and subsequently performed concerts under the name Selten Gehorte Musik. Occasionally joined by Vienna Actionists Hermann Nitsch, Günter Brus, and Arnulf Rainer, these concerts were documented by Roth on a series of gallery edition LP box sets. Roth had been developing a sound alphabet since the '60s and went on to give riotous solo concerts on multiple instruments. He also issued a twenty-four cassette collection of dogs barking, and later made assemblages using keyboard instruments. Wiener had been a jazz musician; Ruhm, for his part, had been doing sound poetry and "one-tone music" on piano as early as 1952, and has also done "pencil music" (recording the sound of drawing). Meanwhile, over in the American midwest (Detroit, to be precise) young artists Mike Kelley, Jim Shaw, Niagra, and Cary Laren banded together as Destroy All Monsters, a similarly untutored foray into electronic noise.[21]

Sound was also utilized by the conceptual artists of the period. Joseph Beuys made the hour-long 1968 recording *Ja Ja Ja Ne Ne Ne* of himself saying "yes, yes, yes, no, no, no" over and over, an audio manifestation of what is a conceptual piece. The 1969 album *Art By Telephone* was essentially the catalog for an exhibition at MoCA in Chicago that never happened. *Art by*

MARCHETTI
*Chamber Music
No. 293*

SELTEN GEHORTE
MUSIK
*Munchner Konzert
Mai 1974*

Telephone focused on voice as a medium for relaying conceptual art projects; the artists (including John Baldessari, James Lee Byars, Hans Haacke, Richard Hamilton, Ed Kienholz, Les Levine, Sol LeWitt, Robert Morris, Bruce Nauman, Claes Oldenburg, Dennis Oppenheim, Richard Serra, Robert Smithson, and Willam Wegman) were not permitted to make drawings or written instructions for the pieces. The museum apparently recorded the instructions for the pieces as relayed to them over the phone by the artists themselves, then failed to ever execute any of them due to technical difficulties.

Vito Acconci made tape pieces in the late '60s at the same time as he was leaving poetry and investigating performance and video. *Running Tape*, made in Central Park in 1969, is a sound document of an endurance piece, termed a "tape situation" by Acconci. However, most of his audio work is concerned with language rather than sounds or noises—not surprising as he was originally doing poetry readings. Acconci seems more interested in music than in sound per se; he's said that music exists in time and not space, not exactly the sentiments of a sound artist. As he stops his performance activities, Acconci turns to installations that always include an audio component. In *Other Voices for a Second Sight* (1974) Acconci adapts the role of a DJ and in its plot he lets a narrative unfold indefinitely, and in *Where Are We Now (Who Are We Anyway?)* (1976) he creates a fictional community meeting. Later installations like *Gangster Sister from Chicago* (1977), *Tonight We Escape from New York* (1977), *The People Machine* (1979), and *Another Candy Bar from GI Joe* are more visual, using swings, colored lights, and wood panels, alongside more spoken audio.

Likewise, another conceptual artist of the period, Lawrence Weiner, has made a number of recordings, some in collaboration with musicians like Richard Landry (of the Philip Glass Ensemble), and composers Peter Gordon and Ned Sublette, but he is similarly concerned mainly with oration rather than sound per se. Weiner also produced a radio work, *Need to Know,* in the late '70s, with a forum provided to him and other artists via a radio show hosted by artist James Umland on New York station WBAI.

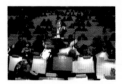

NITSCH
122 Aktion

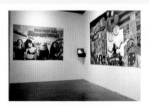

DESTROY ALL MONSTERS COLLECTIVE
Installation view

Two examples of artists of the time who moved from performance into installations involving sound are Dennis Oppenheim and Rebecca Horn. Oppenheim did one untitled performance (in the summer of 1971) in which he placed a dead dog on top of an electric organ, which would theoretically produce sound by holding the keys down with its weight until its body deteriorated into nothing. Oppenheim's *Attempt to Raise Hell* has a marionette bang its metal head into a bell (drawn by magnets) over and over, creating a clanging sound, while *Theme for a Major Hit* has another puppet, also controlled by magnets, move to a pop song written and performed by Oppenheim. Horn's installations often incorporate sound or musical instruments. *Concert for Buchenwald Part 1* (1999) has guitars and violins strewn across a gallery floor, while *El Rio de la Lune* has violins secured to the walls (and bedroom furniture), although her choice of musical materials seems almost arbitrary.[22]

Art and Pop Envy

In early 1977, Tom Johnson reviewed a gallery show by Laurie Anderson in which she installed a jukebox with twenty-four singles of her music on it, alongside pencil-written texts accompanied by single photos. (Anderson, trained as a classical violinist, received a degree in art history; later she completed an MFA in sculpture and wrote art criticism.) She was exhibiting "sound sculptures," little boxes containing tape loops placed on stilts, as early as 1970. Admitting Johnson was slightly aware of her reputation as a performance artist but had never seen her perform, he was coming to the show cold. He noted that most of the singles had vocals on them (hers) and were produced "quite professionally." He concluded with "one basic question: Is the gallery situation necessary to the music?" He contends that:

> if it is necessary, then the music should only be discussed as an element in a multimedia exhibit, and it certainly should not be issued on an ordinary LP, as it apparently will before long. On the other hand, if the music

ANDERSON
For Instants

has it's own integrity, then why bother to put it in a gallery situation? Why not just present it as music?

One can't generalize about such things because so many works do function in more than one medium. Ballet scores become pure orchestral pieces, operas become record albums, books become movies, sculptures become theater sets, and there is no reason why a gallery exhibit shouldn't occasionally become a recording. Usually, however, works have to undergo a great deal of translating, revising, and adapting before they really come alive in a second medium. In Anderson's case I sensed a bit of opportunism, an attempt to have it both ways, and I sense a bit of cynicism in my response. I just can't stop suspecting that maybe the exhibition was a covert publicity stunt, an attempt to con us into noticing some music that we probably wouldn't have paid much attention to in a more conventional presentation.[23]

In a sense Johnson is correct in pointing out the show's self-promotional nature. However, it did make a certain statement that the same music that worked in the Kitchen (New York's premiere New Music venue at the time) should work in an art gallery. This doesn't make it sound art, but it does allow the idea of a gallery space as a listening space to germinate. For what it's worth, artist Jack Goldstein had already made and exhibited his own 45s of sound effects the year before (not to mention Ben Vautier's found 45s with his own labels, made in the mid-'60s). Additionally, Philip Glass, who had already used work by Alan Saret and Sol LeWitt on his album covers in the early '70s, ran a label, Chatham Square, with gallerist Klaus Kertess, while Sonnabend Gallery had issued Charlemagne Palestine's first album *Four Manifestations of Six Elements* and Steve Reich had worked with John Gibson Multiples to produce an early 2LP edition of his piece *Drumming* in 1971. If galleries could release records, why not exhibit them? Indeed, the first exhibition of records in relation to the art world, *The Record As Artwork: From*

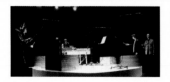

REICH
*Pendulum
Music*

MENTHOL
WARS
Performing at
Tier 3

Futurism to Conceptual Art, opened in 1977 at the Fort Worth Art Museum and later traveled.[24]

The double album *Airwaves,* featuring artists' recordings, was released the same year, and includes Anderson's down-home/calypso pop number *It's Not the Bullet that Kills You, It's the Hole,* including virtuoso harmonica playing and guitar by composer Scott Johnson (and inspired by Chris Burden's *Shoot Piece*). However, it also includes Vito Acconci crooning a tango, one of Meredith Monk's more plaintive vocal/piano songs, and Jim Burton's country-western instrumental *High Country Helium*—so Anderson clearly wasn't the only artist intrigued by pop songs.[25] Anderson, of course, went on to land a recording contract with Warner Brothers, and while she has only scored one cult hit (*O Superman*) she nevertheless remains a major label recording artist and crossover signifier.

Also in 1977 came No Wave, largely comprised of former students of experimental theater (Mark Cunningham and Lucy Hamilton of Mars, Arto Lindsay of DNA, Glenn Branca of Theoretical Girls), painters (Sumner Crane and Nancy Arlen of Mars), and former art student (James Chance). The scene lived up to the punk myth of people forming bands despite having no knowledge of how to play instruments, à la Dubuffet, and was discovered by Brian Eno at a festival of bands at Artists Space in spring 1978. Eno subsequently documented four of the bands (the aforementioned Mars and DNA, James Chance and the Contortions, and Teenage Jesus and the Jerks) on the now-classic *No New York* LP. Eno's attraction is understandable, as he performed with the Scratch Orchestra in the late '60s (an ensemble made up of both musicians and nonmusicians—DNA, in particular, sounds like a rock power-trio version of the Scratch Orchestra).[26] Robert Longo was also on the scene, playing guitar alongside Branca in one version of Rhys Chatham's group Meltdown, and providing album cover art for Chatham and Branca.

Thurston Moore organized the Noise Fest three years later at White Columns gallery in New York as a kind of post–No Wave update, which

NOISEFEST
Poster

BASQUIAT
Cover for Rammell-zee's *Beat Bop LP*

showcased some of the original set like Branca and Cunningham and a variety
of newer noise bands including his own nascent Sonic Youth (with Kim
Gordon, then working at Anina Nosei's gallery). (Sonic Youth would go on
to make extensive use of their album covers as a kind of gallery space over the
next quarter century, utilizing work by James Welling, Dan Graham, Gerhard
Richter, Raymond Pettibon, Mike Kelley, Joe Brainard, Richard Prince, and
Christopher Wool.) White Columns director Josh Baer went on to found
Neutral Records with Branca, recalling composer Philip Glass and gallerist
Klaus Kertess's Chatham Square label, that released early records by Sonic
Youth and the Swans, as well as efforts by Barbara Ess's band Y Pants, Eric
Bogosian, Paul McMahon, and a six-10" record set by Jack Goldstein.

Curator Diego Cortez helped found the Mudd Club, for which Eno
designed the sound system and presented rock bands alongside art events
(Nan Goldin did her early slide shows there). He then organized the epochal
exhibition *New York/New Wave* at P.S. 1 in 1981, which included work by
Chris Stein, Vega, and David Byrne alongside the Neo-Pop contingent of
Keith Haring, Kenny Scharf, Kiki Smith, and Jean-Michel Basquiat. Basquiat
briefly performed in the self-described "art-noise band" Gray, playing bell,
synthesizer, clarinet, or sometimes he "just raked a comb across a guitar."[27]
They played at rock venues like the Mudd Club, Hurrah's, TR3, and even Leo
Castelli's birthday party. Basquiat also produced an early hip hop 12 inch,
Beat Bop, for graffiti artist Rammellzee and provided the cover art. Another
'80s artist, David Wojnarowicz, performed in a punk band called 3 Teens Kill
4, playing tapes of found sounds using a hand-held tape recorder.

Some of the more recent New York art/noise/rock/band activity in
the last ten years has been centered around Jutta Koether and Rita Acker-
mann, who once collaborated on a series of paintings with Kim Gordon.
Ackermann had a group with Koether on keyboards called Diadal, as well as
a more heavy metal-inspired outfit called Angelblood with Lizzi Bougatsos
(who was working at American Federation for the Arts). Koether joined

GRAY
Photo of
the band

3 TEENS KILL 4
Photo of the band

forces with the late Steven Parrino's high-volume bass guitar noise project
Electrophilia, and the two organized an exhibition of their black paintings
called *Black Bonds* at New York City's Swiss Institute, which also featured
performances by Merzbow (a Japanese noise artist whose name derives from
Kurt Schwitter's room-size work called *Merzbau*), Christian Marclay, and
Black Dice. Koether and Gordon organized a series at Kenny Schachter's gal-
lery near the West Side Highway called Club in the Shadow which featured
bands like Angelblood and Double Leopards (whose members met while
working at an art/poetry bookstore, Bound and Unbound). Vito Acconci
designed the club in the fashion of '80s clubs like Danceteria where different
floors had different media.

In Rhode Island in the mid-'90s, an art collective/house called Fort
Thunder played host to a number of bands and comic artists from Rhode Island
School of Design (RISD) who have since achieved considerable notice. Force-
field, the project of Mat Brinkman, has released albums of analog synthesizer
soundscapes as well as created an installation at the 2002 Whitney Biennial.
Brinkman is also a prolific cartoonist, as is Brian Chippendale, who formed the
bass drums duo Lightning Bolt with Brian Gibson, an animator. Like Force-
field, the two wear costumes in performance, but Lightning Bolt plays Philip
Glass–style arpeggios at thrash metal speeds and volume. They also travel with
their own sound system and set up on the floor as opposed to the stage (if there
is one; I've seen them play in an alley during a music festival in Brooklyn), giv-
ing their shows a site-specific quality. Black Dice also originated at RISD but
relocated to Brooklyn at the end of the '90s. They started as a hardcore punk/
noise unit, began to shift focus to electronics, and then to a more industrial-
ized New Age sound. The art world caught on to them early on, and they were
frequently asked to play at openings.

Of course, some artists are not content to make noise—there is a long his-
tory of British art students turned rock stars, not necessarily as an extension
of their visual art sensibilities (Keith Richards, John Lennon, Pete Townshend,

ELECTROPHILIA
Performing at the
Swiss Institute

FORCEFIELD
Installation view

MARCEL DUCHAMP
To Have the Apprentice in the Sun, 1914. India ink
and pencil on music paper. 10 ⅝ x 6 ¹¹⁄₁₆ inches.
© Philadelphia Museum of Art/CORBIS

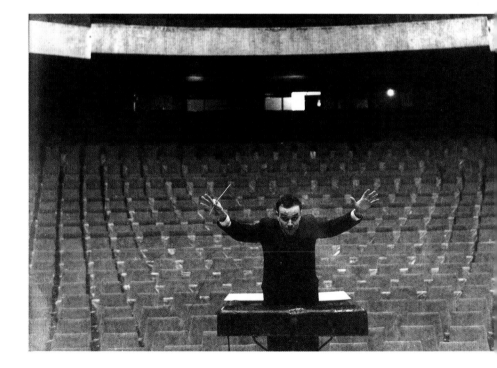

YVES KLEIN
Performing *Symphony of Monotone-
Silence* at the Opéra-théâtre de Gelsen-
kirchen, Germany, 1959. © Charles Wilp

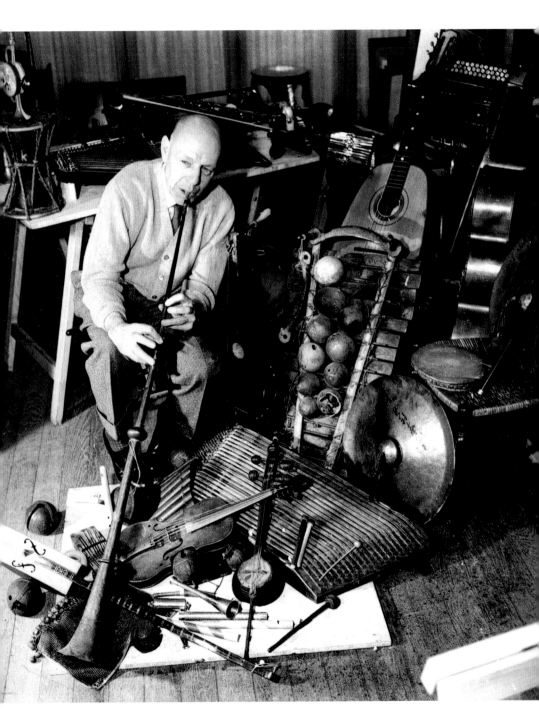

JEAN DUBUFFET
Jouant de la trompette chinoise (Playing the Chinese
trumpet), Paris, 1961. Courtesy Archives Fondation
Dubuffet, Paris. Photo by Jean Weber

DICK HIGGINS
Symphony No. 48, 1969. Paint (discharged
from a gun) on music paper. Gelbe Musik,
Berlin

NAM JUNE PAIK
Performing *Listening to Music Through the Mouth* from his *Exposition of Music-Electronic Television*, Galerie Parnass, Wuppertal, Germany, March 1963. Photo by Manfred Mantwe

TERRY FOX
Collage of photo documentation from a performance called *Isolation Unit* with Joseph Beuys, 1970. Collage was featured in Fox's *Linkages* catalog/LP, Kunstmuseum Luzern, Switzerland, 1982. Courtesy the artist

DAVID TUDOR
Performance of John Cage's *Variations II*, June 20 1961, American Embassy, Paris. Pictured from left to right: Robert Rauschenberg, Niki de Saint-Phalle, an unindentified man, and Jasper Johns. The artists contributed works that served as a changing backdrop to Tudor's performance. Photo by Harry Shunk

WALTER MARCHETTI
Chamber Music No. 293, performed February 4, 1999. Courtesy of the
Morris and Helen Belkin Art Gallery, University of British Columbia.
Photo by Howard Ursuliak

SELTEN GEHÖRTE MUSIK
Munchen Konzert Mai 1974. LP cover featuring Günter Brus, Hermann Nitsch,
Dieter Roth, Gerhard Ruhm, and Oswald Wiener. 3 LP box set issued by Edition
Hansjörg Mayer. Photos by Karin Mack

HERMANN NITSCH
122 Aktion, 2005. Burgtheater, Vienna. Photo ©
the artist

HERMANN NITSCH
122 Aktion

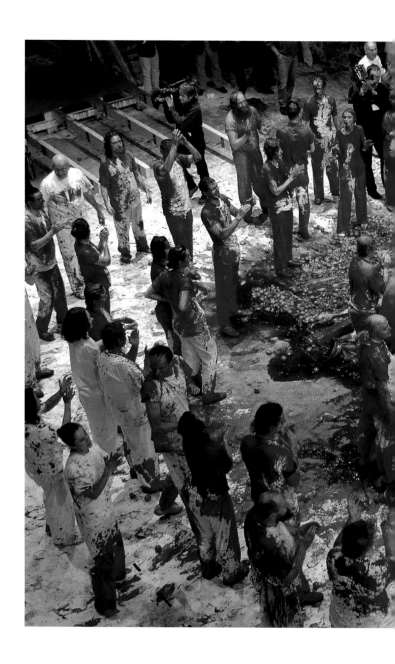

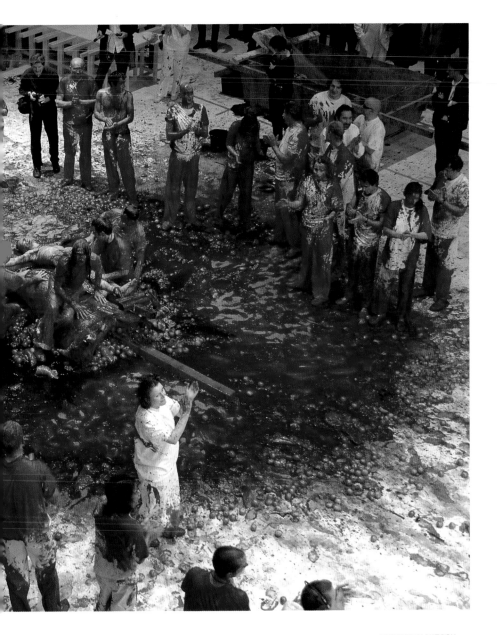

HERMANN NITSCH
122 Aktion

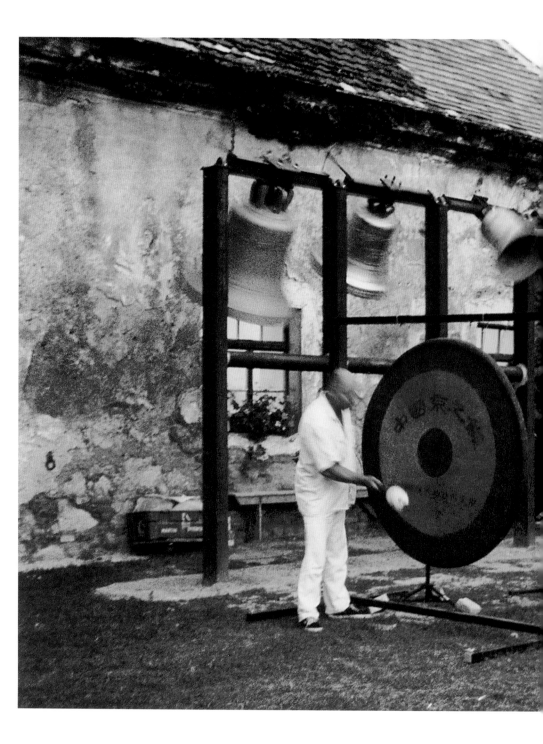

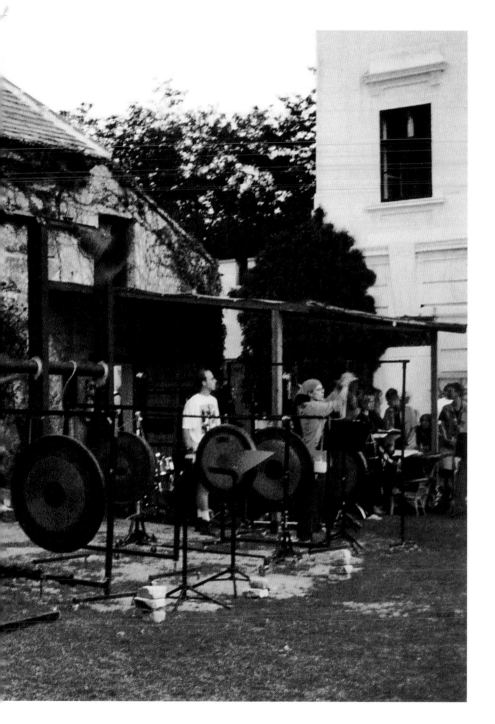

HERMANN NITSCH
6 Day Play, August 3–9, 1998. Prinzendorf,
Austria

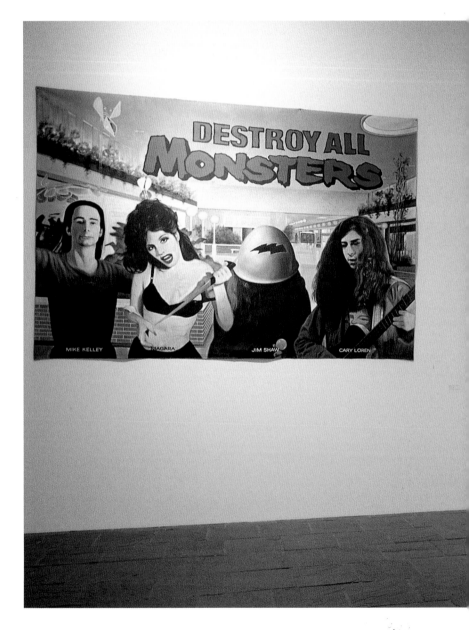

DESTROY ALL MONSTERS COLLECTIVE
Installation view of 2002 Whitney Biennial showing left to right: *Mall Culture*,
2000; *Strange Fruit: Rock Apocrypha*, 2000; and *Greetings from Detroit*, 2000.
Photo by Jerry L. Thompson

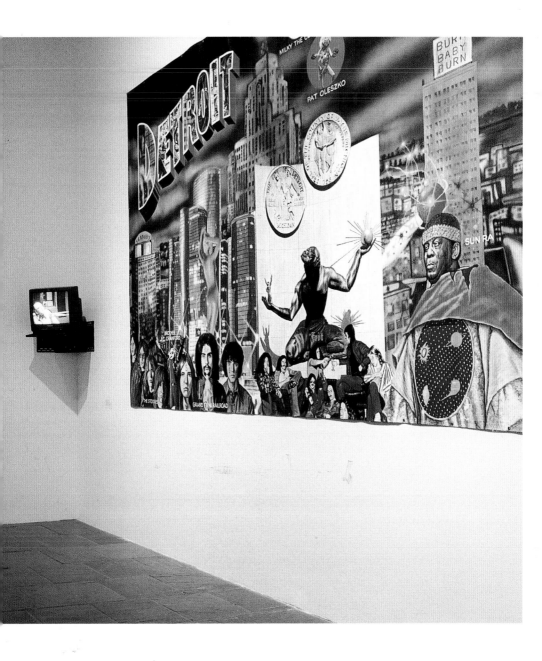

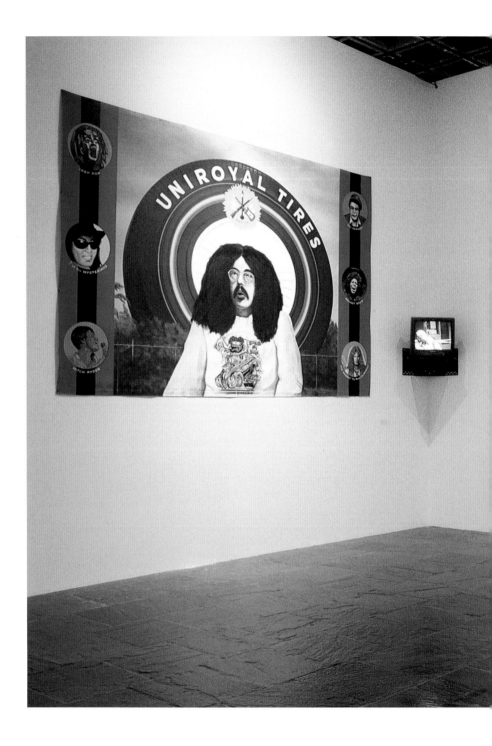

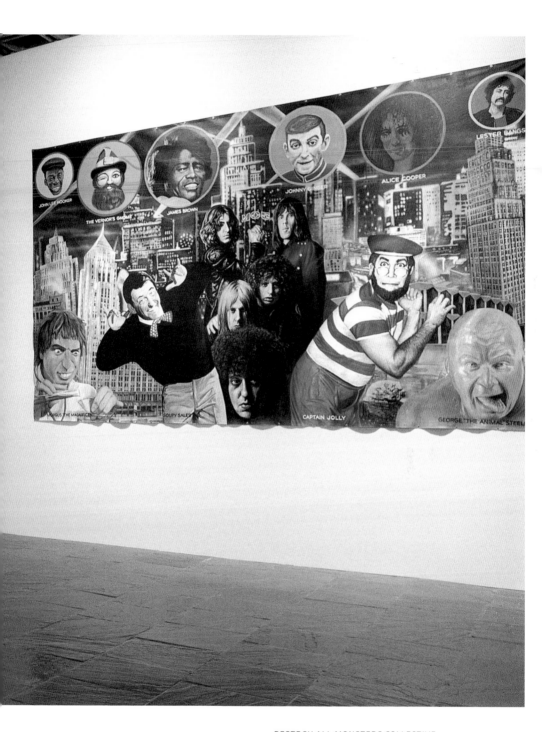

DESTROY ALL MONSTERS COLLECTIVE
Installation view of 2002 Whitney Biennial showing: *Amazin Freaks of the Motor City*, 2000; *Strange Fruit: Rock Apocrypha*, 2000; and *The Heart of Detroit by Moonlight* 2000. Photo by Jerry L. Thompson

The c
padd
dina

The

The o
which
durin
by th
a pie

LAURIE ANDERSON
For Instants, 1976. Courtesy Sean Kelly Gallery, New York City. Anderson performs
on a violonograph, a turntable mounted on a violin played with a needle embed-
ded in the bow. The record is of Anderson singing.

DRUMMING

for

EIGHT SMALL TUNED DRUMS
THREE MARIMBAS THREE GLOCKENSPIELS
MALE AND FEMALE VOICES
WHISTLING AND PICCOLO

are stand mounted and played with dowel sticks. One end of the stick is covered with felt, or some other make the soft stick, while the uncovered wood end is the hard stick. The drums are tuned and for the drummers, who stand while playing, as shown below.

bas and glockenspiels are set end to end with players arranged around them as shown below.

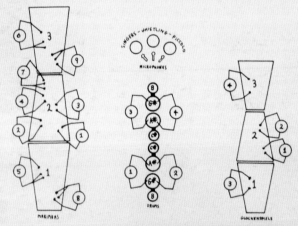

illustrates the maximum number, and suggested position, of players during the first three sections of the piece n drums and male voice, marimbas and female voices, and then glockenspiels, whistling and piccolo. Only fourth and last section are the drums, marimbas, and glockenspiels played simultaneously, and then only ers on each instrumental group, for a total of nine musicians. Together with two or three singers, and player a minimum of twelve or thirteen performers are needed.

Steve Reich 1971

STEVE REICH
Drumming, 1972. 2 LP set. Originally issued as a multiple by John Gibson Gallery, New York City.

STEVE REICH
Pendulum Music, performance at the Whitney Museum of American
Art, May 27, 1969. Pictured left to right: Richard Serra, James Tenney,
Steve Reich, Bruce Nauman, and Michael Snow. Photo by Richard Landry

MENTHOL WARS
The band at Tier 3, 1980. Pictured left to right:
Richard Prince, Joe Hannan, David Linton, Robert
Longo, and Jeffrey Glenn. Photo © Paula Court

"Let's face it, a lot of music has just become noise."
—ex-Hurrah co-owner R. Boykin on the club's demise
(Soho Weekly 5/13/81)

NOISE FEST

Tuesday, June 16
DOG EAT DOG, OFF BEACH, AVANT SQUARES

Wednesday, June 17
UT, MARK CUNNINGHAM-DON KING-DANTAS LINS,
AVOIDANCE BEHAVIOR

Thursday, June 18
RHYS CHATHAM, SONIC YOUTH, SMOKING SECTION
CHINESE PUZZLE

Friday, June 19
Y PANTS, DARK DAY, AD HOC ROCK

Saturday, June 20
GLENN BRANCA, RUDOLPH GREY,
JEFFREY LOHN, JOHN REHBERGER

Sunday, June 21
JULES BAPTISTE RED DECADE, KHMER ROUGE, IMA

Monday, June 22
MOFUNGO, THE PROBLEM, EQ'D

Tuesday, June 23
NNB, THE PRIMITIVES, BARBETOMAGUS

Wednesday, June 24
BUILT ON GUILT, GLORIOUS STRANGERS, RADIO FIREFIGHT

9:30 pm **$4**

Gallery Exhibition in Conjunction with Noise Fest
June 16-24, 3:00 - 6:00 p.m. daily

IKUE MORI (DNA); ROBERT LONGO (Built on Guilt); ALAN VEGA (Suicide);
ROBIN CRUTCHFIELD (Dark Day); NANCY HEIDEL (The Problem); ANDY BLINX (IMA);
DAVID ROSENBLOOM (Chinese Puzzle); WHARTON TIERS (Glorious Strangers);
LEE RENALDO (Avoidance Behavior); RICHARD McGUIRE (Liquid Liquid); JEFF McGOVERN (Mofungo);
SOODY CISCO (Dog Eat Dog); NINA CANAL (Ut); KIM GORDON (Sonic Youth); MIRANDA (Tar);
LINDA PITT (Dog Eat Dog); JULES BAPTISTE (Red Decade); DAN WITZ (EQ'd);
Barbara Ess (Y PANTS); KURT HOFFMAN (Off Beach); SUE HANEL (Tar);
ANN DEMARINIS (Sonic Youth); GAIL VACHON (Y Pants); FRITZ VAN ORDEN (Red Decade);
MARTHA FISHKIN (Dog Eat Dog); JACK TEXAS: 1. Rudolph Grey (Blue Humans), 2. Sumner Crane,
3. anonymous; JEFFREY LOHN JOHN REHBERGER, RANDY LUDACER, GLENN BRANCA,
DANTAS LINS, JOHN KING, BILLY KOMOSKI

WHITE COLUMNS 325 SPRING ST.

NOISE FEST
Poster for music festival curated by Thurston Moore
in 1981 at White Columns, New York City. Courtesy
White Columns

WHITE COLUMNS
325 SPRING STREET
NEW YORK CITY 10013
(212) 924-4212

Music	6/16 - 6/24	9:30 p.m.	$4.00
Gallery	6/16 - 6/24	3:00-6:00 p.m.	FREE

6/16: DOG EAT DOG, OFF BEACH, AVANT SQUARES
6/17: UT, MARK CUNNINGHAM-DON KING-DANTAS LINS, MUSIQUE MANIQUE
6/18: RHYS CHATHAM, SONIC-YOUTH, SMOKING SECTION
6/19: Y PANTS, INFORMATION, ~~THE~~ Ad Hoc Rock
6/20: GLENN BRANCA, RUDOLPH GREY, JEFFREY LOHN, JOHN REHBERGER
6/21: JULES BAPTISTE RED DECADE, ~~AD HOC~~, KHMER ROUGE, IMA
6/22: MOFUNGO, THE PROBLEM, EQ'D
6/23: NNB, THE PRIMITIVES, TAR
6/24: BUILT ON GUILT, GLORIOUS STRANGERS, A CHINESE PUZZLE, RADIO
 FIREFIGHT

"Let's face it, a lot of music has just become noise." ex-Hurrah
co-owner R. Boykin on the clubs demise. (Soho Weekly 5-13-81)
 Noise Fest is a reaction to false claims made by the majority
of rock/disco club owners and the overground music press. The com-
mercial, 'successful' sound of the 'Big Beat' British band has se-
duced club owners and has diminished the range of music presented in
the video/lounge circuit. The fact is there are more young, new, ex-
perimental rock musicians than ever before. The number of bands and
their necessary progress is essential to Noise Fest and its main pro-
jection: to unite. For music information contact - Thurston Moore
226-5258.

F
O
R

I
M
M
E
D
I
A
T
E

R
E
L
E
A
S
E

IN CONJUNCTION WITH
NOISE FEST

MIRANDA (Tar), ROBERT LONGO (Built on Guilt), VIRGINIA PIERSOL (Y
Pants), ALAN VEGA (Suicide), ROBIN CRUTCHFIELD (Dark Day), NANCY
HEIDEL (The Problem), ANDY BLINX (IMA), DAVID ROSENBLOOM (A Chinese
Puzzle), LEE RENALDO (Plus Instruments), RICHARD McGUIRE (Liquid
Liquid), JEFF McGOVERN (Mofungo), SOODY CISCO (Dog Eat Dog), IKUE
MORI (DNA), NINA CANAL (Ut), KIM GORDON (Sonic Youth), LINDA PITT
(Dog Eat Dog), JULES BAPTISTE (Red Decade), DAN WITZ (EQ'd), BARBARA
ESS (Y Pants), KURT HOFFMAN (Off Beach), SUE HANEL (Tar), ANN De-
MARINIS (Sonic Youth), WHARTON TIERS (Glorious Strangers), GAIL
VACHON (Y Pants), FRITZ VAN ORDEN (Red Decade), MARTHA FISHKIN (Dog
Eat Dog), JACK TEXAS 1. (Rudolph Grey) 2. (Sumner Crane) 3. (anony-
mous), JEFFREY LOHN, JOHN REHBERGER, RANDY LUDACER, GLENN BRANCA,
JOHN KING, BILLY KOMOSKI, DANTAS LINS

Much attention has been given to recent art movements. This work some-
how parallels or derives its energy from current movements in music
(Punk, New Wave, Energist, Retro-Chic). The artists in the exhibition
at WHITE COLUMNS are all musicians - whether or not the work has any
relationship to music remains open. For information regarding exhib-
ition contact: Kim Gordon 226-5258, Barbara Ess 966-0626.

JEAN-MICHEL BASQUIAT
Front and back cover for *Beat Bop*. 12-inch LP
by Rammellzee Vs. K-Rob, Tartown Records, 1983.
Courtesy the author

GRAY
The band featuring (from left to right): Vincent Gallo,
Wayne Clifford, Jean-Michel Basquiat (lying on floor),
Nick Taylor, and Michael Holman. Photo by Marina D

3 TEENS KILL 4
Photo of the band in 1982, featuring (from left to right): Brian Butterick, Julie Hair, Jesse Hultberg, David Wojnarowicz, and Doug Bressler. Photo by Mark C

ELECTROPHILIA
Performing at the Swiss Institute of Contemporary Art (above and opposite), New York City, during the *Black Bonds* exhibition/concert series, 2002. Pictured above (from left to right): Steven Parrino, Jutta Koether, and Lizzi Bougatsos. Pictured opposite (from left to right): Steven Parrino and Jutta Koether.

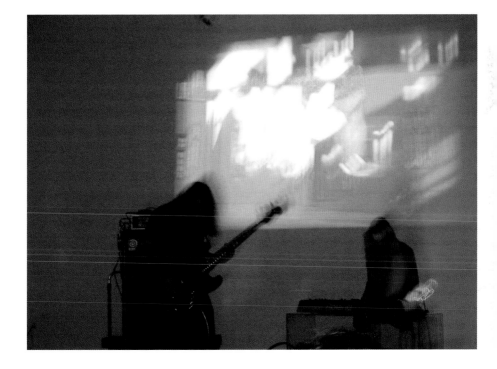

FORCEFIELD
Installation view from the 2002 Whitney Biennial
showing *Third Annual Roggabogga*, 2002. Photo by
Jerry L. Thompson

Ray Davies, Jimmy Page). Roxy Music was founded by a student of Richard Hamilton's, Bryan Ferry; song titles like *Editions of You* and *Virginia Plain* (originally the title of one of Ferry's Pop art paintings, named after a brand of cigarette) are subtle references to his art background. Brian Eno bridged the gap between the art and music worlds as an art student/nonmusician who nonetheless found pop fame as Roxy Music's synthesizer player. He went on to produce both the Talking Heads (who studied with conceptualist and musician Alan Sondheim at RISD) and Devo, who carried art school conceits into a rock-band format, and then a hit singles band format, more successfully than anyone before or since. Another pre-punk example is Captain Beefheart, a.k.a. Don van Vliet, who was a sculptor as a child and became a full-time painter after nearly twenty years as a curiosity in the rock scene best known for his cult double album *Trout Mask Replica*, produced by Frank Zappa; one of his erstwhile guitarists, Zoot Horn Rollo, once termed the music "collage-ish, polyrhythmic, polytonal sound sculptures."[28]

Yoko Ono also straddles the sensibilities here. She studied music at Sarah Lawrence, and has a variety of instruction pieces collected in her book *Grapefruit*. Most of them date from late 1961 to 1963, but *Secret Piece* ("Decide on one note that you want to play. Play it with the following accompaniment: The woods from 5 AM to 8 AM in summer") was written in the summer of 1953. Most also involve listening to natural phenomena ("listen to the wind," "listen to a heartbeat") and show a bit of one-upmanship with Young's 1960 compositions. However, she was more prolific than Young, and her performance pieces like *Cut Piece*, where members of the audience were asked to come up and cut pieces of her clothing off, were far more sociopolitically engaged. She retains a conceptual bent in her early collaborations with John Lennon (for example, *Radio Play*, nano-second snippets of radio broken by long silences), and, in retrospect, her emphasis on extended technique for the voice (i.e., screaming and guttural noises), was fairly radical in the context of rock and even the art world of the time—it was one thing for Dick Higgins to emit a single scream as

a piece, but Ono developed a lexicon out of it. On the 1970 Yoko Ono *Plastic Ono Band* LP she's wailing over a heavy proto-punk riff-mantra by Lennon's band; by the time of her *Fly* album she has begun singing songs (although one side is given over to a collaboration with Joe Jones's music machines and another is her and Lennon still in noise mode for the soundtrack to the film *Fly*). Thereafter, on her own records and those with Lennon she becomes an outré pop singer. Her disco 12 inch *Walking on Thin Ice,* released after Lennon's death, is one of the most compelling dance tracks ever waxed. Ono has never had a pop hit, and the rock world remains wary of her efforts despite her influence on everyone from the B-52's to Sonic Youth, but nonetheless she remains the prototypical art crossover pop artist.

Another figure who seems to have embraced both strains is Mayo Thompson. A one-time art history major, Thompson formed the band Red Krayola with soon-to-be avant literary figure Rick Barthelme in mid-'60s Houston. Their first LP, *Parable of Arable Land,* featured psych-punk numbers like *War Sucks* and *Hurricane Fighter Plane* alongside *Free-form Freakouts* by The Familiar Ugly, an ad-hoc assemblage of friends essentially making noise. A second album, *God Bless the Red Krayola and All Who Sail With It,* was more song-oriented though still experimental and postliterate; a third LP, *Coconut Hotel,* unreleased until the mid-'90s, was a series of experimental pieces using one instrument at a time. Live tapes of Red Krayola's appearance at the Angry Arts festival in Berkeley, California, show them using extreme feedback à la Max Neuhaus's realizations of Cage's *Fontana Mix.* Thompson cut one classic, tuneful album of songs *Corky's Debt to His Father* in 1970, and then went on to work with British art collective Art & Language in the '70s, allowing their Marxist political tracts to collide with his ditties, with detrimentally postliterate results. He ultimately reformed the Red Krayola several times, finding a receptive environment for his off-key vocals and jagged song forms in postpunk late '70s England, recruiting members of the bands the Raincoats and Swell Maps to play with him and cutting two records with Art & Language

still in tow in the early '80s. The '90s incarnations included everyone from Chicago indie-rockers David Grubbs, John McEntire, and Jim O'Rourke to artists Stephen Prina, Werner Buttner, and Albert Oehlen. Much of the later work attempts to deconstruct pop forms in a theory-conscious way. In recent years Thompson has been teaching art and running a gallery in Los Angeles, but still performs with Red Krayola.

Oehlen has done a couple of noisy rock records with his brother Markus as Van Oehlen (a play on heavy-metal band Van Halen, which also includes two brothers) and runs the label Leiterwagen. Oehlen also played music with the late Martin Kippenberger, recording several singles as a duo and one under the name The Alma Band (both Oehlens and Kippenberger alongside a variety of other German artists, appear on a 1984 album called *Die Rache der Erinnerung*). Kippenberger also recorded a single with Christine Hahn (formerly one-third of the Static with Branca and Ess) and Eric Mitchell (No Wave cinema actor) as Luxus. Kippenberger was the manager of a legendary underground music club in Berlin, S.O. 36, which hosted the German post-punk scene of the early '80s as well as film and art events. Dietrich Dietrichsen's Cologne-based magazine *Spex* captured the flux between the music and art worlds in Germany at the time, and Jutta Koether contributed a column as well as interviewing many artists and musicians.

Also in Berlin at the time was the project Die Todliche Doris (the Deadly Doris), conceived by nonmusician art students Wolfgang Mueller and Nicholaus Utermohlen (later joined by Kathe Kruse in 1982). Originally releasing several cassettes of rickety, noisy songs, they later developed a kitschier sound informed by Muzak, industrial film soundtracks, toy instruments, and language instruction records (one release packaged a set of eight dolls' voice records with a miniature record player usually found in a doll house). The group was nothing if not diverse, creating 8mm films, videos, sculpture, painting, radio plays, and books and appearing at avant-garde music festivals, S.O. 36, and Documenta. They eventually began touring with just a live recording from the first date of

the tour, which would be played back and rerecorded at each subsequent date until there was as much audience noise on the tape as there was music (a perfect art/punk translation of Alvin Lucier's *I Am Sitting in a Room*).

More recently Julian Schnabel released a curious Leonard Cohen–style album of songs, *Every Silver Lining Has a Cloud*, on Island in 1995, and video artist Rodney Graham, who was once in a Vancouver New Wave band with photographer Jeff Wall called UJ3RK5, has been doing the singer/songwriter thing of late, accompanying himself on acoustic guitar and releasing five albums since 1999. He's also done several sound installations based on loops from classical pieces, and two of his videos incorporate his own music, *How I Became a Ramblin' Man* (1999) and the lovely *The Photokinetoscope* (2001), in which the viewer must play a record of the soundtrack, inherently varying its accompaniment to the visuals. Artist Stephen Prina has said "For me, those are the only two things that exist: drones and love songs," and he went on to prove it with a 1999 Burt Bacharach/Steely Dan-ish pop LP *Push Comes to Love*, released by the indie-rock label Drag City.

Thinking about where this discussion began, with Laurie Anderson, it seems her only true successor may be Fischerspooner. Originally a duo of Warren Fischer and Casey Spooner who met at the Art Institute of Chicago, their ranks soon ballooned up to twenty with dancers and guest vocalists. Their over-the-top electro-pop performances in galleries caused a sensation in the art world in the early part of this decade. They had a hit in Europe with *Emerge* and have since signed to Capitol; subsequent albums have charted high on Billboard's electronic charts, but not in the top 200.

WHAT IS SOUND SCULPTURE?

In some ways sound sculpture, which is not instrument-making but sculpture that is made with an inherent sound-producing facility in mind or a machine made for the same purpose, is the oldest form of sound art. Think of

GRAHAM
Getting It Together in the Country LP

lithophones—Chinese stone chimes, in which stones vibrate after being hit
with a mallet to create sound; China's ancient classical music also uses stone
slabs. The science fiction writer Philip K. Dick, in one of his final interviews,
told the story of Pythagoras walking past a blacksmith's shop:

> he noticed that the anvils, when hit with a hammer, the smaller the anvil,
> the higher pitched the sound. So the bigger anvils make a low-pitched
> sound and the little ones make a high-pitched sound ... Wait a minute,
> he says. The sound the anvil emits when struck is a musical sound. There
> is no difference between an anvil being hit with a hammer and a musical
> instrument.[29]

Of course, this led Pythagoras to deduce the mathematical relation-
ships in music, not to a sideline in sound sculpture, but nonetheless this
offers some grounding, of a sort, for our topic. Dadaism is again a modern
source, with Duchamp's *A Bruit Secret* (1916; a ball of yarn with a mysterious
object inside that creates a sound when shaken) and Man Ray's *Indestructible
Object* (1923/1958), a metronome with a picture of an eye attached to it.[30]
Cage began thinking of objects' sonic properties when he used anvils in *First
Construction in Metal* (1939), and he had begun contemplating the inherent
sound properties of objects from conversations with experimental filmmaker
Oskar Fischinger as early as 1936. Cage has said:

> When I was introduced to him, he began to talk with me about the
> spirit which is inside each of the objects of the world. So, he told me,
> all we need to do to liberate that spirit is to brush past the object, and
> to draw forth its sound ... in all the many years which followed ... I
> never stopped touching things, making them sound and resound, to
> discover what sounds they could produce. Wherever I went, I always
> listened to objects.[31]

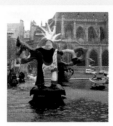

DE SAINT-PHALLE
AND TINGUELY
Stravinsky Fountain

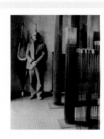

BERTOIA
In his sound studio

The major figures of contemporary sound sculpture are Jean Tinguely, Harry Bertoia, and the Baschet brothers all of whom started working in the mid-'50s and early '60s. Tinguely's use of motors, in particular, follows through on Luigi Russolo's manifesto. Subsequent sound machines include Joe Jones's *Music Machines,* Remko Scha's machine guitars (electric guitars played with various mechanized contraptions), John Driscoll's *Second Mesa* (spinning robotized loudspeakers that react specifically to the acoustics of a space), and Felix Hess's sound creatures (automatons based on studying the croaks of frogs, which "listen" with microphones and respond with electronic sounds).[32] Three of Tinguely's fellow kinetic sculptors—Len Lye, Nicolas Schoffer, and Takis—have also worked with sound. Lye created several sounding sculptures starting in the early '60s, around the same time as Bertoia. *Blade* (from the early '70s) is a six-foot-tall steel blade that bounces against a cork ball; the results sound like a saw being rapidly shaken. *Storm King* (1997) and *Twisters* (1977) are more violent, erupting suddenly into hurricanes of sound from silence, but the majority of his works have the swishing sound of motion itself. Schoffer actually took up piano, but began doing computer music programming at IRCAM in the early '80s. Takis produced his first sounding sculptures, *Signals,* in the '50s. Piano wires vibrated as they were knocked into each other by the wind. His 1963 collaboration with composer Earle Brown, *Sound of the Void,* showed him applying his interest in using magnets in sculptural works to sound, using a magnet to make a needle strike a string to produce repetitive sounds. Fifteen years later he produced his "electro musicals" putting several needle-and-string works in a room (with the string stretched across canvases and amplified). He also performed with Nam June Paik (which was documented on the album *Duet*) and Charlemagne Palestine.

Another sound sculptor of note is Robert Rutman, an Abstract Expressionist painter who constructed the *Steel Cello* and *Bow Chime* in the late '60s for the exhibition *Space Mass.* The original *Steel Cello* was an eight-by-four-foot piece of steel that would vibrate when an attached string was bowed. *Bow*

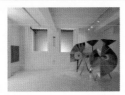

BASCHET
BROTHERS
Sculpture Sonore

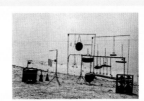

JONES
*Mechanical
Fluxorchestra*

Chime is a horizontal steel sheet that also vibrates, when attached steel rods
are bowed. Besides producing the inevitable overtones and washes of white
noise, the instruments are also capable of producing subsonic frequencies.
Rutman has worked with Merce Cunningham and Robert Wilson, and the
industrial band Einsturzende Neubaten had Rutman's Steel Cello Ensemble
open a 1998 tour.

Stephan von Heune and Martin Riches are two of the more widely exhib-
ited sound sculptors, both working with automated music machines since the
'70s; the cutesy sounds they generate are, as they say, fun for all ages.

Yoshi Wada was associated with Fluxus and also studied with Pandit
Pran Nath. In the early '70s he started experimenting with plumbing pipes,
fittings, and copper tubes as horn instruments. This led to his adapted bag-
pipes, huge constructions (often room size) made from a long pipe with a
canvas bag and an air compressor attached. David Jacobs had made a similar
device called *Wah Wah's* in 1967, using tubes and rubber, then reconfigured
them as *Hanging Pieces* "capable of producing as many as 5,000 partials,
beats, secondary beats, and other musical and psychoacoustic effects."[33]
Another artist fascinated by organ pipes, Andreas Oldorp, has been active
since the late '80s. He has mostly worked with pipes of his own construction
and has experimented with various methods of putting air into them continu-
ously, often with gas flames and glass pipes.

Richard Lerman made a classic work in the '70s, *Travelon Gamelan,* in
which he amplified the sounds in a bicycle's frame with microphones on the
bike's axles. It's scored both as a concert work and as an event, where a number
of bicyclists ride with a speaker mounted on their bikes. Voice Crack, the Swiss
duo of Norbert Moslang and Andy Guhl active from the late '70s (when they
were still free improvising instrumentalists) until the late '90s, has made sim-
ilar discoveries about latent sounds with electronic gadgets. "Electronic tools
are not merely useful black boxes producing a predefined effect," Moslang has
written, "they are rather flexible units that in most cases contain far more (hid-

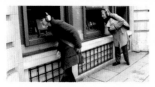

KUBISCH
Electrical Walks

den) functions than they were originally designed for."[34] He cites the remote control of a model car as an example of something that can emit sounds that it was not designed to make. The pair also would convert light waves into sound waves—a blinking LED bicycle light, for instance, although Moslang is quick to note that "the original—visual—function of the tool is irrelevant." Voice Crack's performances were nonetheless visually arresting and their sonic stew was one of the better noise experiences of the '80s and '90s.

Artists like Peter Vogel, Walter Giers, and Howard Jones have created wall pieces that use speakers and other media, and are generally interactive, triggered by a viewer's presence. These are effective works that pave the way for Christina Kubisch's later full-scale installations.

What Sound Sculpture is Not

A 1970 exhibition at the Museum of Contemporary Art in San Francisco, organized by its founder Tom Marioni called *Sound Sculpture Is* was misleading—it featured mostly conceptual performance pieces like pissing in a bucket, melting ice, and a phone ringing off the hook.[35] (Though Marioni later did "drum brush drawings" by drumming with steel wires on large sheets of sandpaper that would leave marks, an interesting intermedia work.)

A case is often made for musique concrete as sound sculpture, since tape made visual the duration of sounds—one second of reel-to-reel tape is fifteen inches. In this sense it was only a matter of time before artists would regard sound (and later, records themselves) as physical material to be used. Brian Eno has referred to tape as "malleable, mutable, and cutable." Writer and sound artist Robin Minard has cited Pierre Schaeffer as one with whom "sound turned into sculptural material. Sound material was first collected and then it was manipulated. It was cut into pieces, played forward and backward, transposed, and looped."[36] Tape music certainly turned sound into physical material, yet his processes have more to do with the experiments in film editing, than with sculpture. In film editing, the recorded material can be manipulated in any

MARCLAY
Recycled Records

number of ways, played backwards, juxtaposed with other images to create certain effects, double exposed, etc. Paul D. Miller has also argued that sampling is a form of sculpture; but it depends on what kind of sampling. In terms of sampling any audible sound, maybe; sampling records may be using found material, but it's material that was originally intended to be listened to, and doesn't have the same effect as Rauschenberg putting a car tire in a Combine.

Records themselves are another matter. Duchamp had made *Rotoreliefs* (6 "optical discs" with drawings on them, to be rotated on turntables at 33 1/3 revolutions per minute) in 1935, and Cage had incorporated turntables into his pieces *Imaginary Landscape* (1939) and *33 1/3* (1969); but more to the point, Milan Knizak made his "broken music" sculptures of two different records broken and glued together in the '60s; Christian Marclay did the same with his "recycled records" in the late '70s and '80s. Both actively played the records at various speeds and incorporating various degrees of abuse.

VIDEO ART AND FILM SOUND DESIGN

Just as music broke from the concert hall setting towards the end of the twentieth century, single-channel video installations likewise took the moving image, which before had to be experienced in a theater setting at a specific time, and made it a continuous attraction, that could be dropped in on at any time during gallery hours. Like Earthworks (and sound art), it was an art movement that had difficulty attracting collectors. Also, as many sound artists do not have a background in music, many video artists do not have a background in film. In fact, Nam June Paik, Bill Viola, Bruce Nauman, Charlemagne Palestine, Tony Oursler, Gary Hill, Steina Vasulka, Paul McCarthy, and Mike Kelley all worked in sound and/or visual arts before turning to video; Arnold Dreyblatt started in video and then worked with sound and then intermedia.[37]

This is not surprising, as Bill Viola's analysis of video and sound delineates their structural kinship:

PALESTINE
Overtone Study for Voice

HILL
Soundings

the video image is a standing wave pattern of electrical energy, a vibrat-
ing system composed of specific frequencies as one would expect to find
in any resonating object ... Technologically, video has evolved
out of sound (the electromagnetic), and its close association with cinema
is misleading since film and its grandparent, the photographic process,
are members of a completely different branch of the genealogical tree
(the mechanical/chemical). The video camera, as an electronic trans-
ducer of physical energy into electrical impulses, bears a closer original
relation to the microphone than to the film camera.[38]

Viola also notes that "musically speaking, the physics of a broadcast is
a type of drone. The video image perpetually repeats itself without rest at
the same set of frequencies."[39] That dovetails with the use of drones and/or
repetitions in sound works and installations emerging at the same time as
video art—Viola relates it to the increased familiarity of drone-based Indian
music in the West.

Viola was originally working with electronic music, studying Moog
synthesizer, and building his own sound-producing electronic circuits,
while also studying video and experimenting with techniques like feedback
and using oscillators to create video interference. He worked extensively
with David Tudor on a production of *Rainforest IV*, making field recordings
and assisting the setup. He cites the ability to project an image as a factor in
his shift to video from music in that it "freed the image from the monitor
box and expanded it to the architectural scale of both the room, and more
importantly, of the human body."[40] Viola was aware of Lucier's *I Am Sitting
in a Room* and he'd made sound installations like *Hallway Nodes* which acti-
vated the space in a similar way, but obviously when video caught up to this
it was more accommodating to his emerging aesthetic. Nevertheless, sound
plays an important role in many of his video works, such as *A Non Dairy
Creamer* (1975)—in which the soundtrack emphasizes "every minute noise

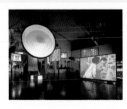

KELLEY
Day is Done

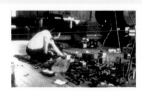

VIOLA
Setting up David
Tudor's *Rainforest*

connected to human presence and activity"; *A Million Other Things* (1975) is described as "The direct recording of different sounds and situations of light articulates the otherwise fixed framing of a man near a warehouse overlooking a lake"; and, in *The Space Between the Teeth* (1976), "the movement of the camera describes the close physical relationship between architectural space and the sound that periodically invades it" as a man shouts at the end of a corridor. Viola also embarked on a project to record ambient sounds of various Florence cathedrals in 1981.

Bruce Nauman was originally a jazz bass player and a classical guitarist before setting music aside because it required too much practice.[41] Nonetheless, he made the record *Record* of himself sawing away on the violin (an instrument he was untrained in), and, in *Playing a Note on the Violin While I Walk around the Studio* (1967-68), he employed a familiar strategy of using disjunctive sound as the image of himself playing violin is out of sync with his playing on the soundtrack.[42] Another disjunctive piece was *Lip Sync* (1969), in which the soundtrack of Nauman saying the words "lip sync" goes in and out of sync with the image of his lips pronouncing them. One of his earliest exhibitions was titled *Six Sound Problems* (1968) and featured the violin video as well as videos of him bouncing a ball.[43] In 1969's *Separate Touch and Sound* (also known as *Touch Piece*) he created two false walls, one outfitted with mics that would pick up the sounds of the viewer touching it, the other located forty feet away with speakers that transmit the sound, creating a delay in hearing the amplified touching sounds. In *Sound Breaking Wall* from the same year, a wall with hidden speakers emitted sounds of exhaling, pounding, and laughing. Like many other conceptual artists, much of Nauman's sound work dealt with language; 1968's *Get Out of My Mind, Get Out of This Room* confronted the visitor with Nauman's voice speaking the title from a hidden loudspeaker in an empty room. In 2004 he had a sound installation at Turbine Hall in the Tate Modern, *Raw Materials*, consisting of twenty-two spoken texts culled from the last four decades as well as soundtrack material from his videos. Walking through the long hallway,

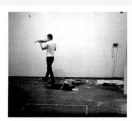

NAUMAN
Playing a Note on the Violin While I Walk Around the Studio

the visitor would encounter each text, which would fall out of earshot and be replaced by another (some were very short loops, others longer).

Bruce Nauman did two early '80s installations that should be classified as sound sculpture. In *Diamond Africa with Chair Tuned D.E.A.D.* (1981), he "tuned" the chair by throwing a dime at it and listening to the ring ("the whole chair has a really good ring... I worked for two weeks with a tuning fork trying to find out what all the different notes were").[44] This piece was silent, but the other one, *Musical Chairs* (1983), had a hanging chair and two suspended steel bars in an X position that swung and banged into each other to "actually make noise—make music."[45]

Gary Hill worked with sonic properties of steel welding rods when still a sculptor, and began experimenting with feedback and tape loops (which would prove influential in his video installations, e.g., *Hole in the Wall*). In *Sums and Differences* (1978) Hill switches around the sounds and images of different musical instruments. In his video *Soundings* (1979) a person moves a variety of loudspeakers around—"a series of reflections on the relationships between 'the images of sounds and the sounds of images.'"[46] In *Meditations* (1979–86) sand falls on a loudspeaker that begins to muffle the spoken sounds it's emitting, then piles up and the vibrations begin to create patterns in the sand, much like Alvin Lucier's *Queen of the South* or Takehisa Kosgui's 1980 installation *Interspersions,* and in *Full Circle* (1978) a circular image is created by Hill's voice. This sort of interaction seems inevitable given the relationship between sound and video described by Viola (and dates back to Nam June Paik's mid-to-late '60s *Kuba TV* and *Participation TV,* which hooked up a TV to a tape recorder and a microphone respectively and converted the sounds into visuals).

At the same time as video art came into being, film sound design began to come of age in commercial cinema, particularly in Walter Murch's early '70s work on Francis Ford Coppola's *The Conversation* (a kind of remake of Michelangelo Antonioni's *Blowup* but centered around sound instead of

LUCIER
*The Queen of
the South*

photography, and echoed in Brian De Palma's 1981 *Blow Out*) and George
Lucas's *THX 1138* (1971). Murch is an especially interesting case as he heard
musique concrete as a child and had experimented with tape recorders and
sound sculpture (taking pieces of metal and striking or rubbing them with a
microphone attached).[47] As he put it, by "taking humble sounds out of their
normal context you could make people pay attention and discover the musi-
cal elements in them ... editing images had emotionally the same impact for
me as editing sound."[48] While up to the time of *THX 1138* a soundtrack would
consist of dialogue, incidental music, and sound effects, in that film Murch
and director/cowriter George Lucas decided "the music would operate like
sound effects and the sound effects would operate like music." In Lucas's
subsequent feature *American Graffiti,* the '50s rock-and-roll songs on the
soundtrack were used as a sound effect, part of the mise-en-scène throughout
the entire film (as the characters are shown listening to a continuous radio
broadcast by DJ Wolfman Jack throughout) as opposed to incidental music
or a particular scene in which someone was listening to the radio or a record
player.[49] The radio track was recorded all the way through, then played back
and rerecorded in various locations so it would fit the ambience in each set-
ting in the film (e.g., car interiors, the street, the radio studio).[50]

Murch, in fact, was the first person to be credited as a sound designer
in film (for *The Conversation)*, because he wasn't in the union and therefore
could not be credited as a sound editor.[51] Coppola has also described the
film—which concerns a sound surveillance expert (a "private ear") who
discovers a murder plot while reviewing tapes he's made of a couple having a
conversation in a city plaza—as a "sound composition ... sound was the core
element in it."[52] The repetition of the tape of the conversation throughout the
film resonates with the use of repetition in the work of Nauman, La Monte
Young, Philip Glass, and Steve Reich of the same period (not to mention the
endless replays of the President Kennedy assassination footage)—in fact, the
tape could be said to have a costarring role.[53]

Sound had played a key role in Coppola's previous film *The Godfather*, on which Murch also worked. The murder scenes were accompanied by sound effects rather than drowned out by music (the customary technique). In the scene where the horse's head is found in a bed, Murch took the incidental music by Nino Rota, which didn't adequately convey the horror of the situation, split it in three parts, and put it through a musique concrete process of layering the three parts on top of each for the climactic moment. This proved so effective that studio executive Robert Evans, upon seeing it for the first time, called up another executive and played the scene for him over the phone![54] Such was the newfound power of sound in the film medium.

It had been a long time coming. The experiments in spatialization in the concert hall had also taken place in the cinemas: In 1953 Fox introduced CinemaScope, which originally was not only a new chapter in cinematography but also a sound process in which four sound tracks played on three speakers behind the screen (for onscreen sound) and one "surround" speaker (for off-screen sounds and/or voice-over narration). Todd AO sound, introduced in 1955 with *Oklahoma* (the same year that Stockhausen premiered *Gruppen*), utilized six tracks on five speakers, and as many as nineteen "surround" speakers spread throughout the theater. However, after the '50s, theater sound declined drastically, and as Stephen Handzo has written, "By the early 1970s there was a better sound system in the average American teenager's bedroom than in the neighborhood theater." In the late '70s, the increased popularity of home stereo, and larger sound systems at concerts or in discos, had made it necessary for film to keep up; the Dolby sound system was introduced, and used on films that became blockbuster hits (*Star Wars* and *Grease,* for example). Director Michael Cimino, who was an early proponent of Dolby, once said, "What Dolby does is to give you the ability to create a density of detail of sound—a richness so you can demolish the wall separating the viewer from the film. You can come close to demolishing the screen." In other words, with the new attention to sound, film could operate in the gap between art and life.

BETWEEN CATEGORIES

Morton Feldman, after a discussion with Brian O'Doherty, concluded:

> My obsession with surface is the subject of my music. In that sense my
> compositions are not really "compositions" at all. One might call them
> time canvases in which I more or less prime the canvas with an overall
> hue of the music ... I prefer to think of my work as between categories.
> Between time and space. Between painting and music. Between the
> music's construction, and its surface.[55]

Between categories is a defining characteristic of sound art, its creators
historically coming to the form from different disciplines and often continu-
ing to work in music and/or different media. But in the last decade sound
art's identity between categories has intensified, particularly as the term itself
has spread. Eno's ideal sound installation is "a place poised between a club,
a gallery, a church, a square, and a park, and sharing aspects of all of these."[56]
In fact, the same could be said of much installation art in recent years, and
many of the people included in exhibitions like *Sonic Boom, Bitstreams,* or
Sonic Process exemplify this, as "the gap between art and life" seems to nar-
row with every passing year, as technology increases the replicability of daily
life, whether it's high definition video or 5.1 surround sound. The sense of
interconnectivity in the modern world, heightened by the internet, and its
one-stop shopping mentality has increased the loosening of boundaries to
accept more and more kinds of media, including sound, into the art world. In
addition it seems like rather than finding an equivalent in Earthworks, cur-
rent sound art is more like landscape architecture, and increasingly focused
on digital culture.

Ryoji Ikeda, Carsten Nicolai, and Richard Chartier have been work-
ing with digital detritus—buzzes, clicks, and glitches—to produce quiet

IKEDA
data.spectra

soundscapes for the laptop generation (although some of them use analog equipment, they are still referencing digital sounds). They also attach sleek but bare visual components to their work, either by joining their electronic music with their paintings or sculpture in installations or in CD packaging, and can also be found DJing in techno clubs. Sonically there seems to be little difference between them and many of their ambient electronica peers, but by "playing the art card," they're sometimes discussed and curated as sound art more frequently than Oval or Pole, for example. Nicolai himself admits his work has more references to science and mathematics than to art history; his background in landscape design clues one in to the obvious attention he's devoted to the design of his work (and why his installations recall a freshly trimmed suburban lawn rather than one of Hans Haacke's grass Earthworks). His hybrid aesthetic identity reflects the interconnectivity of the post-McLuhan cybernetic zeitgeist rather than a cross-disciplinary artistic vision.

Chartier is a trained graphic designer and once told the *Baltimore City Paper* "I'm not a musician ... but I work with sound. I guess I'm a composer." (He then steps back and offers that he's somewhere in between a composer and designer, which is more on track.) He, too, reflects the rise of computers as why he'd stopped doing music until he discovered a software program in 1995 that allowed him to work with silence and near silent sounds. Bernhard Gunter preceded him in this, and on his best work, the 1993 CD *un peu de neige salie* Gunter constructed a Sisyphean listening experience where if you turn the volume up to hear it the clicks and pops threaten to blow your speakers—turn it down and you can't hear it at all. However his work radiates a Zen-like simplicity rather than a digital sterility, and his background was more musical, in modern instrumental composition and playing rock and jazz, than his successors.

Ikeda's CD +- came out not long after Gunter's and took the movement to the next step, an early combination of high-pitched sine tones and glitches which tended to turn home listening rooms into sound fields. Ikeda sometimes

collaborates with Nicolai and places a similar emphasis on clean, sparse, mostly black-and-white accompanying visuals and intermedia installations (or "performance/installations"). While he's also collaborated with architect Toyo Ito, art collective Dumb Type, and photographer Hiroshi Sugimoto, his overall aesthetic reflects a data intensive, rather than a sound or image-intensive society—even as its cool surface implies avoiding being overwhelmed by it all. Christoph Cox has posited both Nicolai and Ikeda as Neo-Modernists, aligning them with the Minimalism of Donald Judd or Agnes Martin, but the Experiments in Art and Technology (E.A.T.) movement of the late '60s, which worked towards the integration of new technologies in the arts, seems to me to be a more direct antecedent; stylistically I also see a parallel in the gleaming blacks and whites of the costumes and sets in Lucas's dystopian futuristic vision *THX 1138*.

Cox also asserts that Ikeda, along with Francisco López, "offer up the experience of sound-in-itself," citing López's standard procedure of blind-folding the audience before his concerts, and the requirement of a "totally darkened anoechic room" for Ikeda's work *Matrix*; yet it seems to me that the lack of image *is* the image, which both continue to use on their consis-tently austere CD packages. After all, they go in someone's collection where they will be compared with other CD boxes or cases—to really keep their music free from all associations, they would have to leave it unpackaged (and unreleased). Wearing a blindfold does help focus concentration on the sound alone during López's concerts, but in and of itself it can trigger associations ranging from pin the tail on the donkey to the 1979 Iranian hostage crisis; it *dramatizes* López's pursuit of "absolute" music as much as it furthers it. The icily minimalist CD artwork is as readily identifiable for this movement as record covers of the Blue Note or Windham Hill record labels as an identify-ing visual equivalent to the music within.

For some, sound can simply be one link in a chain in a nongallery, archi-tectural site-specific installation, and is often used in this context to make a

statement on social forms. The interest in sound in relation to architecture goes hand in hand with the social aspect, as architecture is designed by and for human beings. It's also a twist on the idea of "furniture music," that is, sounds placed in a room as furniture would be, specifically at humans' disposal. In Achim Wollscheid's *Intersite* and *Redlighthaze* (both 2004) LED lights mounted on the outside of a building change patterns based on quotidian sound input (flow of traffic, noises by passersby), while some of his other works simply use motion detectors to affect other lighting setups in buildings. In a project with architects Gabi Seifert and Goetz Stoeckmann, he outfitted a private home with microphones and loudspeakers fitted inside and outside, piping the interior sounds to the outside world and vice versa after turning each into tones via computer. In this case, sound is used as conduit to raise the issue of privacy.

Brandon LaBelle is also interested in architecture: he's edited anthologies concerned with site specificity (*Surface Tension: Problematics of Site*) and the relationship of sound to architecture and sculpture (*Site of Sound: Of Architecture and the Ear*) and has stated that "sound is never a private affair" and that "sound occurs among bodies."[57] LaBelle's *Learning from Seedbed* revisits Vito Acconci's infamous performance piece where he masturbated under a ramp in a gallery space hidden from view. In LaBelle's version, contact mics are placed on the ramp to record visitors' movements and comments. The piece is not so much about sound as about performance as a social dialogue. But like the Wollscheid piece, it's also about surveillance. Sound art's beginnings in the late '60s and early '70s may coincide with Earthworks/Land art, light art, video art, and performance art, but it also coincides with the Watergate tapes. Andy Warhol remembers that in the late '60s "everyone, absolutely everyone [he knew], was tape recording everyone else," and he would tape all of his phone calls, as would his friends (though he notes that other people would be paranoid if they knew they were being taped). In Nauman's *Empty Room/Public Room,* TV cameras and monitors show a room that is

inaccessible; the viewer is observed by another oscillating camera and shown on yet another monitor.[58] At the end of the film *The Conversation*, the sound recordist ends up receiving a phone call letting him know that he's being sonically watched as the person on the other end plays back the sound of him playing his saxophone just before the phone rang. He then rips his apartment apart trying to find the bug his surveillant is using (the last shot uses oscillating camerawork to specifically reference a surveillance camera). The idea that a room has been wired for sound not only reflects Watergate but also resonates with sound installations that do not seek to spy on other people, necessarily, but on other areas or situations.

In works by Stuart Marshall around this same time, the sounds of a corridor are picked up by microphones and fed into an adjacent room. Two decades later, in a piece titled *Recorded Delivery,* Janek Schaefer recorded the first seventy-two minutes of a package's journey through the postal system—the package was a sound-activated Dictaphone machine. In a sense he was spying on the package.[59] In his early work (from the mid-'90s), Scanner (Robin Rimbaud) created controversy by scanning cell phone conversations and using them, unbeknownst to the callers, in his electronic music concerts.

Rimbaud and LaBelle are also part of a generation who bounce between writing critical/cultural theory, sound-making, and curating; between the avant-garde music world, the electronica/dance music world, and the art world, putting their critical/cultural theory into practice, leading by example. Rimbaud and Paul D. Miller, a.k.a. DJ Spooky, are high profile examples of this, both one-man worldwide webs that (in Miller's case) connect everything from Gilles Deleuze to Afrika Bambaata to dub to D.W. Griffith in essays and records alike. The fact that they have done sound installations is just part of an overriding (and at times overreaching) intermedia C.V.

In the '90s, experimental DJing (which Miller rapidly became synonymous with) could mean either manipulating records by scratching or looping or creating ambient soundscapes for techno chill out rooms. Unlike an exhibi-

tion or a sound installation, those things were parties, and a drag unless they were well attended, with the sounds used as incentive to attract participants. But they prepared people, especially the art world, to investigate sound art.

New York's Soundlab moved from space to space, including the Frying Pan (a boat rescued from the bottom of the Hudson River) and David Linton's eighth-floor Chinatown loft, attracting a mix of the art crowd and club kids, downtown experimental music vets, and laptop electronic newcomers. Locations like the Brooklyn Anchorage, a huge space located at the base of the Brooklyn Bridge, allowed for a sound-installation-like experience where the listener could sense the difference in acoustics as he moved around. These sorts of experiences are what started people thinking about sound art more and more by the late '90s. "People start using spaces differently and that means listening to them in a different way," Soundlab cofounder Beth Coleman told Philadelphia's *City Paper* in 1997.[60] "Since I've been DJing, I don't hear the city the way I used to. I have a friend who lives on the East Side near a big power plant. One morning she was walking home from one of our shows, and she heard the hum of that plant and it sounded like music to her."[61] Miller exhibited frequently in art galleries at the same time, which raised the profile of sound in the art world but also created a lot of misconceptions about sound art (hence all those electronic musicians in museum sound shows).

Soundlab usually boasted simultaneous DJ sets, performances, and even sound-making from the audience, so they're more related to Happenings than sound art per se. Like the chill out rooms, they are also another kind of urban atrium, promising a soothing respite from the hustle bustle of the street but also demonstrating an up-to-date technological mentality. DJ Olive, for one, complained when people actually started watching the DJ, concert-style:

> If the DJ is on a stage it's like: here I am, sit down, listen to me and decide whether you like it or not. It's like walking into a gallery, looking at the art and deciding if you like it or not. That's a crisis in representation, you

know what I mean? You don't walk into a garden and look at the tree and
decide if you like it or not. You go into a garden and chill out and think
about what's happening.[62]

This sentiment points to sound art as the ultimate destination for the
removal of the performer/audience relationship. The person experiencing
sound art already comes to it as an expert in as much as he or she has been
hearing and listening every day of their lives. Michael J. Schumacher points
out that certain people walk in off the street and are surprised by what they
hear in his gallery Diapason, but I suspect that they're simply not accustomed
to sound's presentation in an art space as opposed to swirling around them in
daily life.

As sound is increasingly prevalent in intermedia installations, it suggests
that sound art is simply another art movement to be signified. Helen Mirra's
2002 installation at the Whitney Museum, *Declining Interval Lands,* con-
sisted of green military blankets lying on the floor, a bench fashioned from
shipping pallets, texts on the wall, and an ambient sound work playing on
speakers. Meant to evoke the disappearance of the elm tree in the U.S. during
the twentieth century, the sound component, suggesting the outdoors, is a
reference to sound art, just as the blankets are a reference to Minimalist sculp-
ture, rather than an example of sound art itself. Sound is a contributor to an
environment (a symbolized atrium, really) rather than the environment itself.

While Bill and Mary Buchen have designed several sound playgrounds
with sound sculptures for children as well as sound-sculpture parks, there is
even now sound art as theme park: As part of the 2006 Grenzelos (Without
Borders) ISCM World New Music festival, Killesberg, an amusement park
near the festival site in Stuttgart, Germany, was used for several sound works:
a viewing tower transformed into a kind of antenna by Andres Bosshard that
broadcasted the festival's concerts to the outside world; a "lake sound field";
a "wall of sound" with an interactive installation near a playground (all by

Erwin Staches), and a sound field by Andreas Oldorp.

Germany, in particular, has become a world center of sound art activity, boasting a monthlong, city-wide (Berlin) festival of sound art, Sonambiente (held in 1996 and again in 2006); a gallery devoted completely to sound art (Singhur in Berlin, also founded in 1996) as well as others that often show-case sound works (Galerie Rachel Haferkamp, Stadtgalerie Saarbrucken); a venue that hosts music performances as well as intermedia and sound art events (Mex in Dortmund, run by composer and sound artist Jens Brand); a store devoted to artists' recordings (Gelbe Musik in Berlin, run by Ursula Block who curated the exhibition *Broken Music* of artists' records in 1988); an Institute for Sound Art in Hamburg (founded by Andreas Oldoerp); an online magazine, *Moderne Klangkunst*; and an audio magazine of sound art, *Because Tomorrow Comes.*[63]

Someone like Connie Beckley, a vocalist who gives semitheatrical per-formances surrounded by sculpture or other visual props, is creating situa-tions not unlike the book collaborations between poets and painters where the parties fabricate a dialogue through juxtaposition (if not necessarily illus-tration) of the forms.[64] This also applies to several exhibitions where an artist has asked a musician to make a "soundtrack" to go along with it (Mimmo Paladino and Brian Eno, Charles Long and Stereolab, Doug Aitken and Sigur Ros). In this sense everyone from Vito Acconci to Carsten Nicolai, by creating installations that employ visual and audio elements, could be compared to Alfred Jarry or Henri Michaux, who illustrated their own books of poetry. The versatility of someone like Ed Tomney, who's played in bands (The Nec-essaries with Arthur Russell and Ernie Brooks in the early '80s, alternative pop band Rage to Live in the mid-'80s); made radio art; has created sound installations in public areas (elevators, stairwells); collaborated with Jonathan Borofsky on sound installations and one album of Islamic inspired music; made videos, paintings, and scores for theater and film (Todd Haynes's *Safe*, *Caged Heat 3000*); and done live electronics performances (a duo with Ron

Kuivila called Sophisticated Filters) must ultimately be considered a professional musician rather than a sound artist, despite his links to the art world. "Sound art" is simply another activity in a busy creative life, and the sound works (as opposed to the music) are highly reminiscent of other sound art achievements (Tomney's Industrial Orchester, of machine/computer played guitars brings to mind both Remko Scha and Trimpin, for example).

Sound art, like its godfather experimental music, is indeed between categories, perhaps because its effect on the listener is between categories. It's not emotional nor is it necessarily intellectual. Music either stimulates, reinforces, or touches on emotional experiences either directly (through lyrics) or indirectly (through melody and harmony). Even electronic and experimental music, which is often thought of as unemotional or intellectualized, still deals with human thought process, technology, and behavior. Cage's love of nature and all sounds still frames them either as a natural resource to be harnessed by a composer, or as humanist aural spillover from civilization. Music speaks to a listener as a human being, with all of the complexity that entails, but sound art, unless it's employing speech, speaks to the listener as a living denizen of the planet, reacting to sound and environment as any animal would (with all the complexity *that* entails). This sounds dehumanizing, but this appeal to a primal common denominator may, in fact, show human gesture at its most benevolent and least aggrandizing. By taking sound not as a distraction or currency but as something elemental, it can potentially point to the kind of cosmic consciousness that so much art aspires to.

RODNEY GRAHAM
Getting It Together in the Country, 2000.
LP cover. Front cover by Shannon
Oksanen. Courtesy Donald Young Gallery

NIKI DE SAINT-PHALLE AND JEAN TINGUELY
Stravinsky Fountain, 1983, Paris. Vanni/Art Resource. © 2007 Artists
Rights Society (ARS), New York/ADAGP, Paris

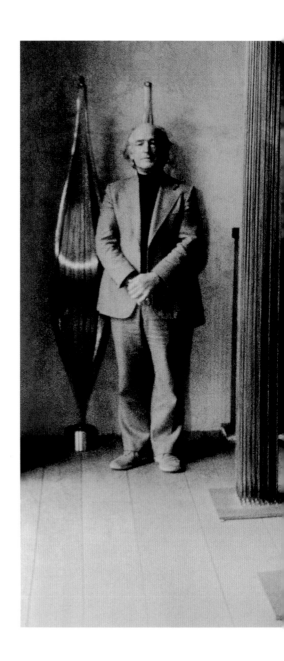

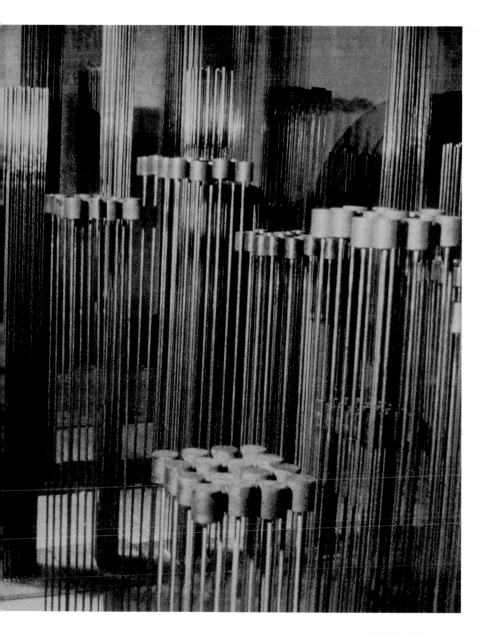

HARRY BERTOIA
In his sound studio c. 1976. Photo by
Clifford West. © 2007 Estate of Harry
Bertoia/Artists Rights Society (ARS)

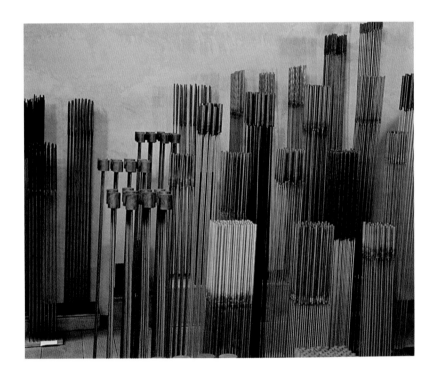

HARRY BERTOIA
Two views of the Sonambient® sound studio with
sounding sculpture. © 2007 Estate of Harry Bertoia/
Artists Rights Society (ARS)

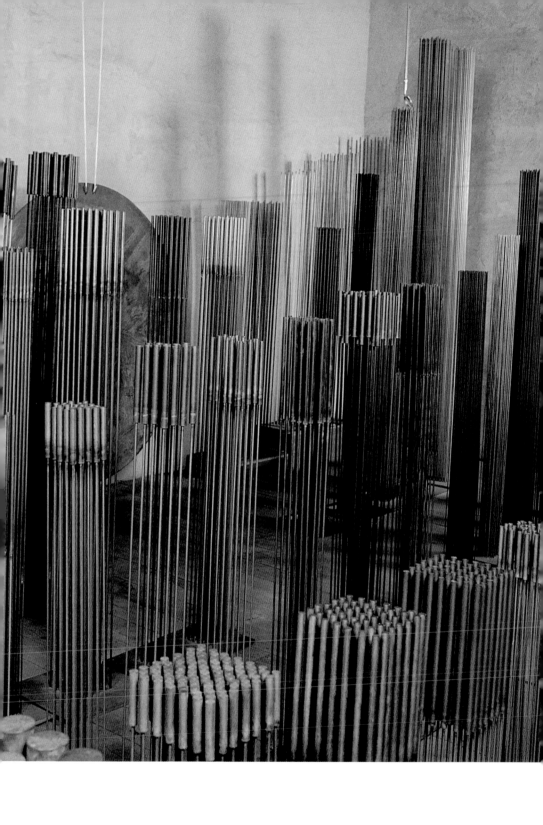

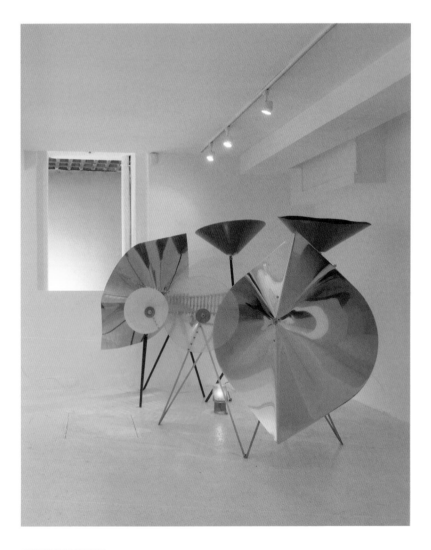

BASCHET BROTHERS
Sculpture Sonore, 2007 (original sculptures created 1958). Metal rods, glass
rods, steel foil, metal bars, and cardboard cones. Photo by Stephen White.
Art © Francois Baschet/Licensed by VAGA, New York, NY

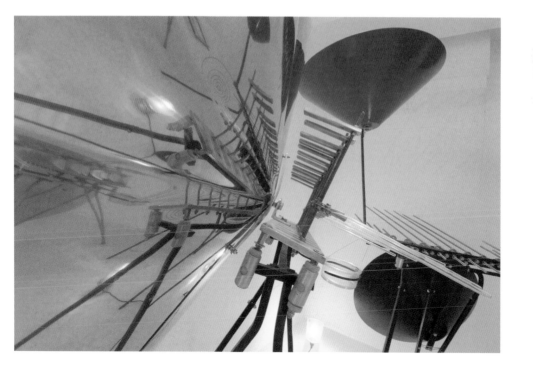

BASCHET BROTHERS
Sculpture Sonore (detail)

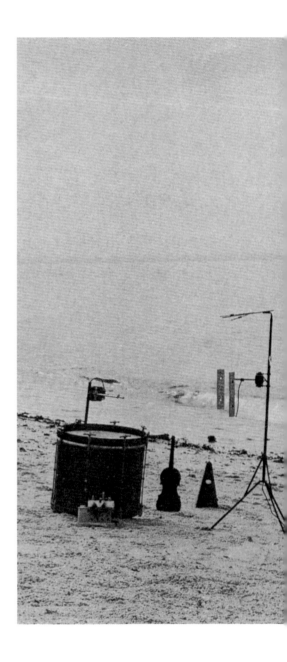

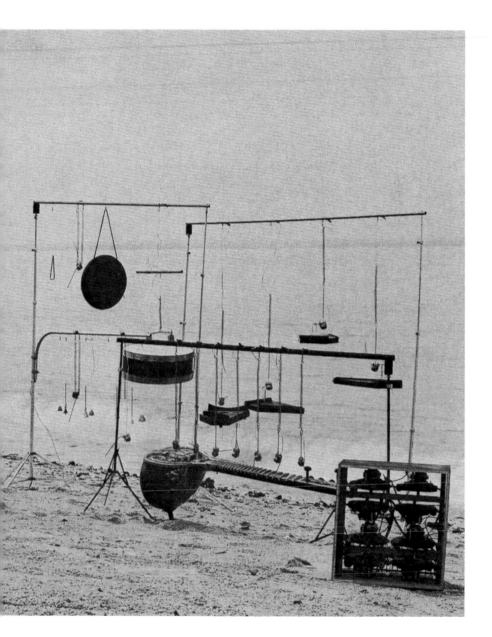

JOE JONES
Mechanical Fluxorchestra. This photo was used in a collage by George Maciunas on Yoko Ono's *Fly* LP.

CHRISTINA KUBISCH
Electrical Walks, 2006, (top) in Birmingham, England; photo courtesy IKON Gallery, Birmingham, and
Electrical Walks, 2005, (above) in Oxford, England. Photo by Janine Charles. Wearing electromagnetic
headphones, participants listen to ordinarily inaudible electrical currents.

CHRISTIAN MARCLAY
Boneyard, 1990. 750 hydrostone casts of
phone receivers. Dimensions variable.
Courtesy Paula Cooper Gallery, New York City

CHRISTIAN MARCLAY
Recycled Records, 1981. Collaged vinyl record.
12 inches. Courtesy Paula Cooper Gallery, New York
City. Photo by Adam Reich

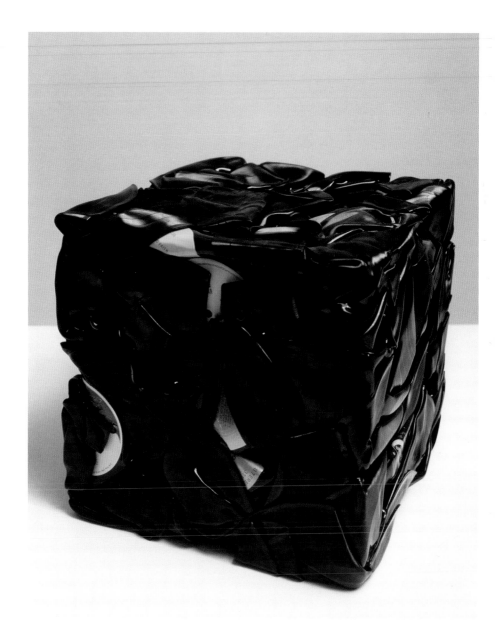

CHRISTIAN MARCLAY
Cube, 1989. Melted LP records. 12 x 12 x
12 inches. Courtesy Paula Cooper Gallery,
New York City

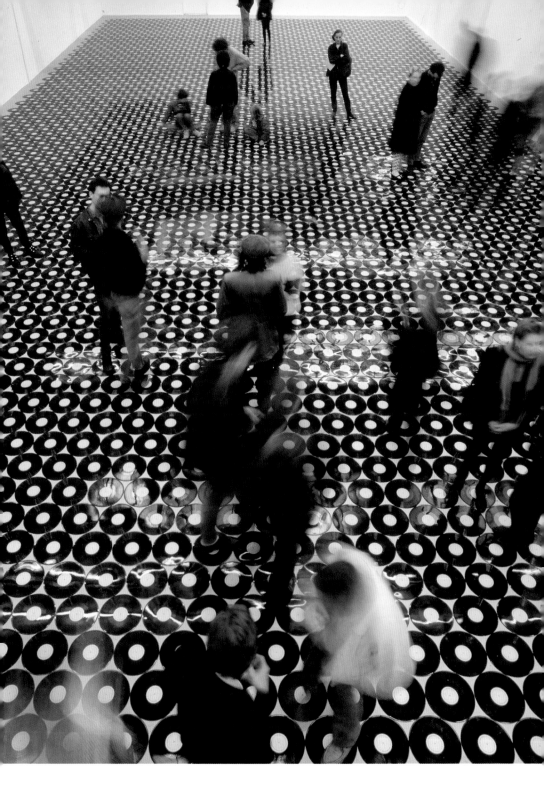

CHRISTIAN MARCLAY
Footsteps, 1989. Installation view in Shedhalle,
Zurich. Courtesy Paula Cooper Gallery, New York City

GARY HILL
Soundings, 1979. Courtesy Electronic Arts Intermix (EAI), New York.
In this video Hill puts a found loudspeaker through a number of
physical changes.

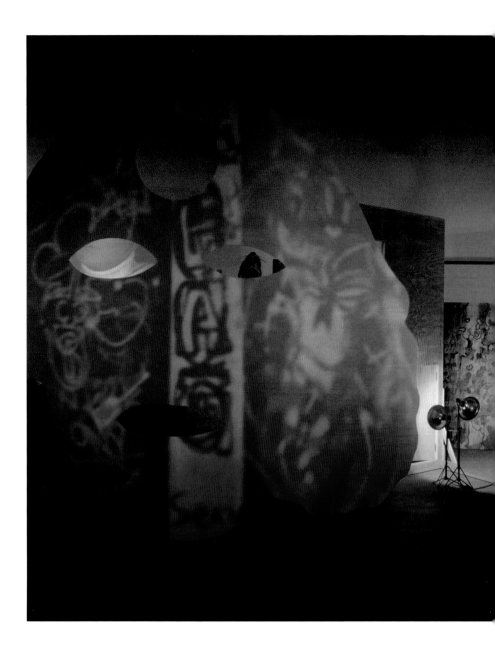

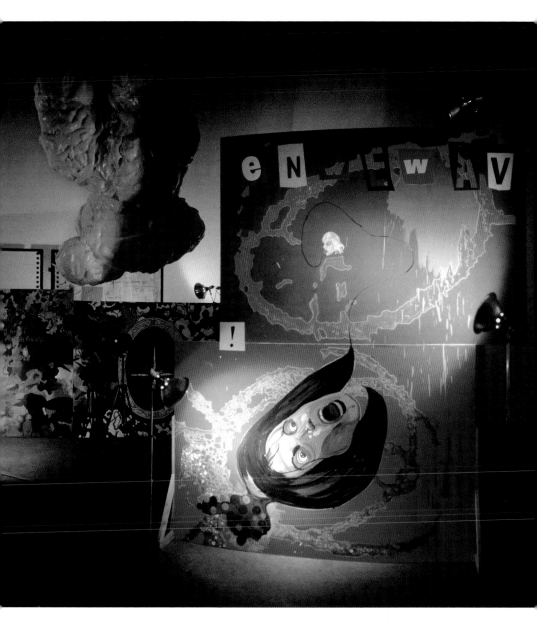

MIKE KELLEY AND TONY OURSLER
The Poetics Project: 1977–1997, 1997.
Installation view at Documenta X, Kassel,
Germany.

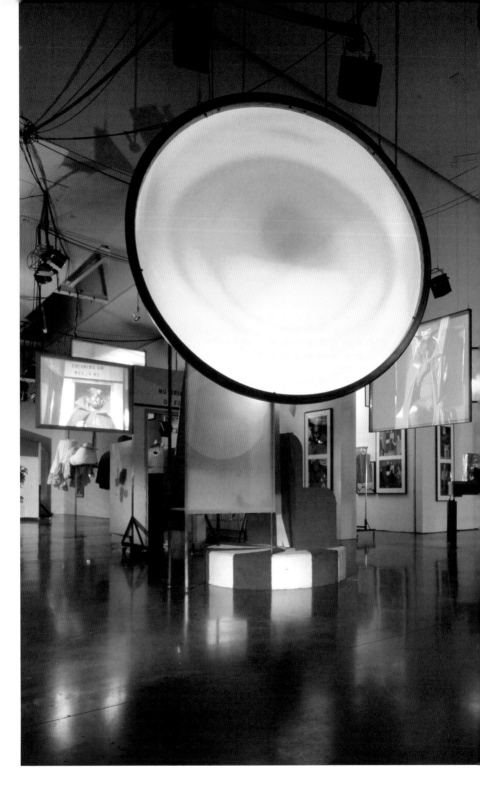

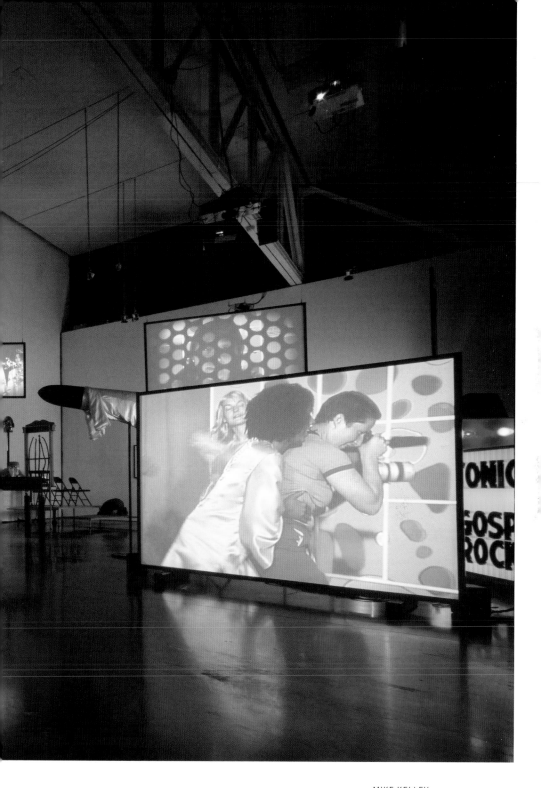

MIKE KELLEY
Day is Done, 2005. Installation view at
Gagosian Gallery, New York City.

<u>BILL VIOLA</u>
The artist setting up for the first performance of
Rainforest by David Tudor's workshop participants
in a barn.

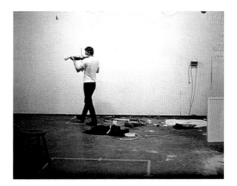

BRUCE NAUMAN
Playing a Note on the Violin While I Walk Around the Studio,
1967–68. Courtesy Electronic Arts Intermix (EAI), New York. © 2007
Bruce Nauman/Artists Rights Society

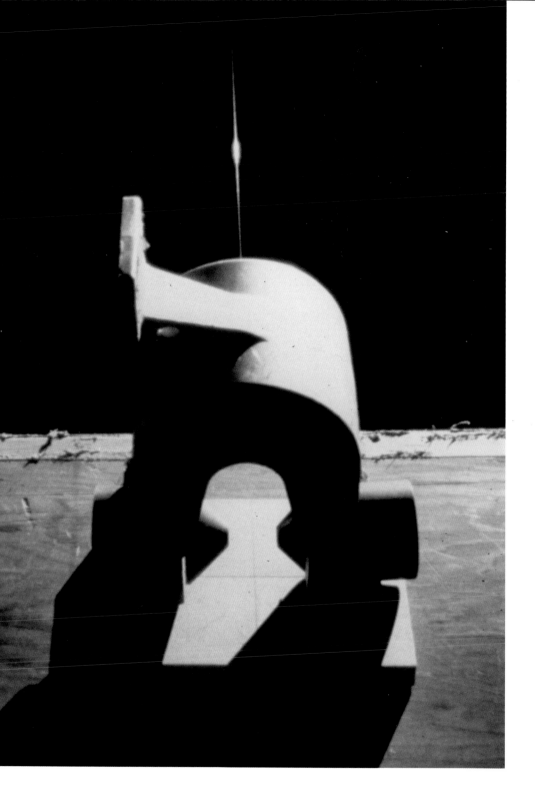

ALVIN LUCIER
Music on a Long Thin Wire, 1977. Ezra and Cecile Zilkha Gallery, Wesleyan
University, Middletown, Connecticut, 1988. Photo by Michael Fanelli

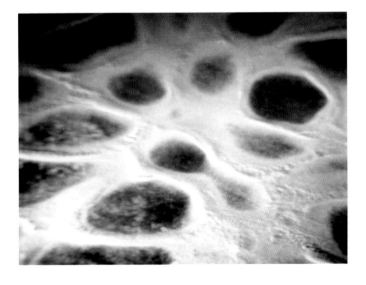

ALVIN LUCIER
The Queen of the South, 1972 (above and opposite). Both photos taken in 1975.
Electronic Music Studio, Wesleyan University, Middletown, Connecticut. Photo
by Carol Reck

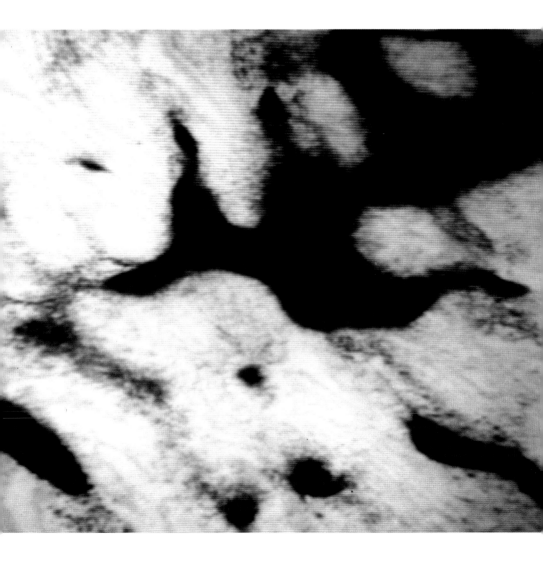

RYOJI IKEDA
data.spectra, 2005. Digital installation. Graphics by
Shohei Matsukawa. Courtesy Forma

RYOJI IKEDA
data.spectra, above and opposite

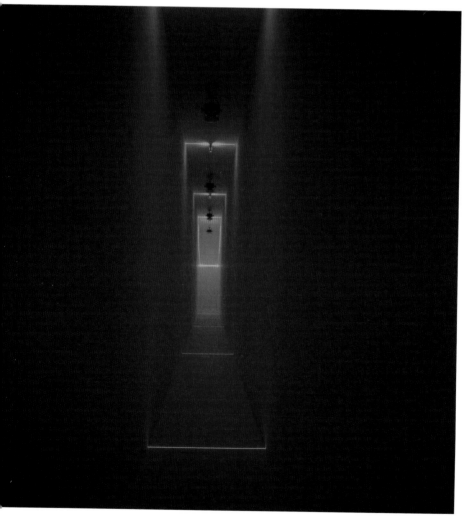

RYOJI IKEDA
spectra II, 2002. Installation with lasers, strobe
lights, and electronic sound. Courtesy Forma

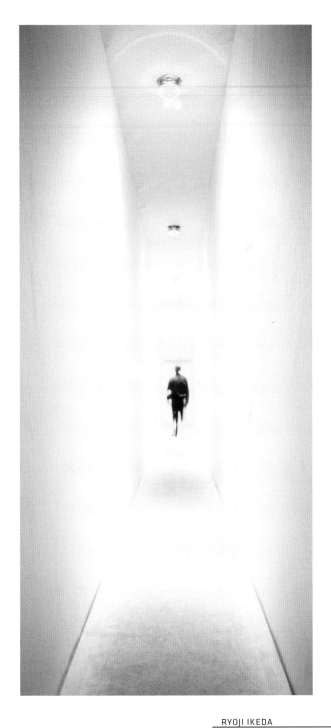

RYOJI IKEDA
spectra II. Photo by Robin Reynders.
Courtesy Forma

Artists' Biographies

HARRY BERTOIA (1915–1978)

"When I was a very young boy, living in a small Italian village, I sensed one day that a celebration was about to take place. There was a feeling of great excitement in the air, people began putting up arches of flowers and someone told me, 'Yes, a bishop from China is coming for a visit.' The day he arrived I was full of the intense anticipation only children feel. All the cathedral bells in all the little villages were ringing, and the visitor from China seemed to me to fill the world with a wonderful sunny color. I think my work with sound may be an attempt to recapture the magic of that moment but of course, it's much more than that."[1]

Harry Bertoia, the Italian-born American sculptor and furniture designer, is well-known for his metal sculptures that generate an array of musical tones when activated by hand or set in motion by the wind.

After studying art and design at the Cranbrook Academy of Art in Michigan, Bertoia gained recognition for his metal jewelry and abstract monotypes. But it wasn't until he designed furniture for Knoll Associates—particularly the widely successful "Diamond" chair, with its mesh pattern of welded steel that was introduced in 1952—that he had the financial stability to devote himself to his interest in sculpture. (The accompanying CD in this book features a piece by Steve Roden in which he extracts sounds from the "Diamond" chair.)

Bertoia began to develop his sound sculptures, also known as tonal sculptures, in 1960. However, he happened upon these pieces by accident. While he was working on a sculpture inspired by the form of desert grasses, a wire broke off and struck another wire, creating a resonating vibration. The resulting body of work consists of thin vertical rods fastened at one end to a base. When activated, the rods sway and collide to produce bell-like chimes and metallic drones. Bertoia experimented to create a spectrum of sounds, varying the dimensions of the sculptures, the type of metal (copper, brass, bronze) used, and the number of rods. Other sound sculptures by the artist include gongs of silicone bronze and "hanging bars" of beryllium copper.

In the 1970s Bertoia and his son Val amassed hundreds of sound sculptures in a renovated barn in rural Pennsylvania (see pages 222–25), where they gave

concerts, made hundreds of recordings, and produced eleven albums on their Sonambient label. Bertoia's sculptures are featured in numerous performances and recordings by artists, from American composer Daniel Goode to the innovative string ensemble, the Kronos Quartet.

FRANÇOIS (B. 1920) AND BERNARD BASCHET (B. 1917)

"My brother Bernard and I want to make a synthesis of the following three elements: shapes, sounds, public participation. We make shapes and objects with which music can be produced manually—that is without electricity or electronics. Therefore, anyone can play on them."[2]

Since the 1950s, the Paris-born Baschet brothers have been recognized as pioneer inventors of sound sculptures that function as acoustic instruments.

The brothers—François, a sculptor, and Bernard, a sound engineer—wanted to create new instruments for the modern age, recognizing that few instruments had been developed since the eighteenth century. They have since fabricated dozens of sound sculptures, or "sculptures sonores," using industrial materials. The instruments consist of metal or glass rods that are vibrated, often with wet fingers, with other objects placed on them (glass, metal, piano wire, plastics) that interact with each other to enhance overtones and echoes. The sound is then amplified acoustically by inflated balloons, cones, or sheets of metal (see pages 226–27). When first created, the ability of these acoustic instruments to produce synthesizerlike sounds was astonishing. Half a century later they're sonically reminiscent of many of maverick composer Harry Partch's self-made, microtonal instruments, but are still among the most visually striking sound-producing devices ever invented in the twentieth century.

The Baschets' sculptures have toured internationally, beginning with an exhibition at New York's Museum of Modern Art in 1965. Their instruments have been used in numerous performances and recordings. In the mid-1950s, the duo formed an ensemble with musicians Jacques and Yvonne Lasry and performed in concerts and festivals. Other artists such as French composer Paul Boisselet, Japanese composer Toru Takemitsu, and vocalist Sarah Gorby, in her unusual 1976 album of concentration camp songs sung in Yiddish, have featured the instruments. The Cristal, a keyboardlike instrument that is perhaps the Baschets' best-known invention, has been used by a range of performers, from French musician Jean Michel Jarre to American musician and film score composer Cliff Martinez.

JEAN TINGUELY (1925–1991)

Swiss artist Jean Tinguely is internationally celebrated for his kinetic sculptures in which both mechanical movement and sound are vital components of the artworks.

Tinguely studied art in Basel and moved to Paris in the early 1950s. By the mid-'50s he was exhibiting what he called his "meta-mechanical" works, assemblages consisting of scrap metal, found objects, and eventually electric motors. In his *Méta-méchanique sonore* (1955), little hammers strike glasses, bottles, and tin cans. Viewers could activate the sculptures, in which parts would spin at varying speeds and produce a strangely musical ding, clang, and thud.

Tinguely was inspired by the Dada antiart aesthetic and parodied the excesses of an industrial society in his work. One of his most infamous works was *Homage to New York* (1960; see pages 98–99), an enormous self-destructing assemblage—including wheels from eighty bicycles, tricycles, and baby carriages; an assortment of metal drums; fifteen motors; a piano; a radio; and a bell—that created a great spectacle when it went up in flames in the Museum of Modern Art's sculpture garden.

Tinguely experimented with materials to create different movements and sounds. His assemblage *Gismo* and a drawing machine titled *Cyclograveur* (both 1960) use wheels and motors with pots and pans as sound resonators. In his "Radio Sculptures" series of 1962, Tinguely incorporated radio parts in which tuning knobs were set in motion, randomly emitting patchy radio sounds. Tinguely delighted in the anarchic, free-for-all spirit of his machines. For *Hannibal II*, he invited members of the public to bring their instruments and play along and he invited a pianist to improvise with the sound of the machines.

One of his most complex works is the monumental sculpture *Eureka* (1963–64), created for the Swiss National Expo '64 in Lausanne, and now installed in the Zürichhorn Park in Zurich. It consists of seven independent parts; as the piece is activated the sound of its movements gets louder and softer with its vertical motion. Tinguely's most important later works are his fountain sculptures, designed to create rhythmic sound patterns with water. These include *Carnival Fountain* (1977), in Basel, featuring ten sculptures equipped with different water nozzles to create a variety of aural effects in a shallow pool of water, and the popular *Stravinsky Fountain* (1983; see pages 220–21), located near the Centre Pompidou in Paris, with its seven whimsical sculptures, including one of a treble clef. The *Stravinsky Fountain* was created by Tinguely in collaboration with his wife,

the artist Niki de Saint-Phalle.

Tinguely and Saint-Phalle also participated in mixed-media events during the 1960s, including one at the Jewish Museum in New York in 1965 called "The Tinguely Machine Mystery, or Love Suicides at Kaluka," a play written by Kenneth Koch and starring poets John Ashberry and Kenward Elmslie and artist Larry Rivers. Modern composer Morton Feldman provided the music, which was played alongside sound sculptures. The *New York Times* reported one overheard reaction: "The best performers were the machines."

MICHAEL SNOW (B. 1929)

Michael Snow is a Canadian visual artist, musician, and experimental filmmaker whose use of sound and music in his diverse works is internationally acclaimed.

Snow studied art in Toronto and worked as a professional jazz pianist in the early 1950s. He moved to New York in 1963 and through his friend, the trombonist Roswell Rudd, he was exposed to the free jazz scene. At the same time, he became well-known for his "Walking Woman" series of paintings and mixed-media works. His experimental film, *New York Eye and Ear Control* (1964), which features the "Walking Woman" motif, is now legendary for its free jazz soundtrack, with music by Rudd, saxophonist Al-

bert Ayler, trumpeter Don Cherry, and others. By instructing the musicians to simply play and not worry about playing a melody to start, Snow arguably helped usher in the free improvisation movement.

For *Wavelength* (1967), perhaps his best known experimental film, Snow composed an electronic glissando score to accompany the forty-five-minute visual of a seemingly continuous zoom from one end of an eighty-foot loft to the other. The same year he presented a sound piece at the Montreal Expo called *Sense Solo*, in which twelve tape recorders each played different sounds through loudspeakers in a circular auditorium while a free-jazz group improvised in the center, in the dark. (He was unaware of Cage's similar works at the time).[3] In collaboration with his then-wife, the late artist Joyce Wieland, Snow created the twelve-minute *Dripping Water* (1969; see page 88), a tape recording and film of his own leaky faucet. The recording was broadcast on WBAI radio in New York.

Returning to Toronto in 1970, Snow recorded with the Artists' Jazz Band, a pioneering Canadian free-jazz group, and formed the improvisational group CCMC (Canadian Creative Music Collective), in which he played trumpet and piano. Of CCMC, Snow has said, "One of the artist's functions has been to explore and map 'nonsense.' That's

what the CCMC does with 'chaos.' It's an adventure. In the form of tapes and records, the music becomes a 'product,' and 'object,' but in its formations it is a process of trying to encounter the un-recognizable and get to know it …"[4] He has also done conceptual pieces like the *The Last LP* (1987), a fake ethnographic album of tribal sounds, and *Sinoms* (1989), a spoken piece with twenty-two participants speaking the names of every mayor of Quebec City, mixed and processed by Snow.

ALVIN LUCIER (B. 1931)

"So often, when I'm writing a piece, I have to de-compose, I have to not com-pose. I have all these ideas about the piece that come from compositions that you study. I have to eliminate those things that distract from the acoustical unfold-ing of the idea. For each piece, it's a little bit different. I get an idea, usually about a sound that is not realized, you don't know it yet, like echoes or brainwaves. I'm very interested in that, that's what gets me started. To reveal it, I have to work hard to put it in a form that allows it to reveal itself and the magical quality it has without the interference of other ideas that don't fit in."[5]

Alvin Lucier is an American com-poser and performer of experimental music and sound installations. Using electronic devices, from tape recorders

to handheld oscillators, he explores the characteristics of sound waves and the acoustic properties of space.

Born in New Hampshire and trained in classical music, Lucier moved away from traditional composition after seeing performances by experimental composers John Cage and David Tudor in 1961. He participated in the ONCE festivals' annual multimedia events in Ann Arbor in the mid-'60s, and was a member of the Sonic Arts Union, an electronic music ensemble, with com-posers Robert Ashley, Gordon Mumma, and David Behrman, who played each other's work in the 1960s and '70s.

Lucier's contributions to the Sonic Arts Union repertoire included *Music for Solo Performer* (1965), a live per-formance in which human brain waves triggered sound. In this piece, Lucier attached electrodes to his head to detect alpha brain waves. The brain waves were then transmitted via amplifiers to loudspeakers that resonated percussion instruments in the concert hall.

One of his best-known works to date is *I Am Sitting in a Room* (1970), in which Lucier repeatedly rerecords a recording of his voice reciting an expla-nation of the piece, which begins "I am sitting in a room … " Over the course of fifteen minutes, the space's acoustic properties overwhelm the original vo-cal. "What you will hear, then," he says in the piece's narrative, "are the natural

resonant frequencies of the room articulated by speech." Lucier has noted the piece performed in different rooms produces different sounds: "every room has it's own melody, hiding there until it is made audible."[6]

Another notable work is *Music on a Long Thin Wire* (1977; see pages 242–43). For this piece, Lucier stretched an eighty-foot wire across a large room, and, with the aid of a magnet, amplifier, and electronic oscillator, the wire produced amplified vibrations at different frequencies. The sound changed depending on "fatigue, air currents, heating, and cooling, even human proximity," said Lucier. A landmark of sound art, *Music on a Long Thin Wire* removed the performer from the process by relying solely on electronics and environmental factors.

PHILL NIBLOCK (B. 1933)

Phill Niblock is regarded as one of America's leading minimalist composers. Using audiotape or a computer, he manipulates recordings of long tones played on acoustic instruments to create dense compositions of sound. Niblock is also an accomplished filmmaker, often presenting his music and film together.

Niblock did not have formal training in music, but he was an avid jazz and classical record collector early on. Born in Indiana, he moved to New York in 1958 and worked as a photographer of Duke Ellington and other musicians. In the 1960s he began to create experimental films, mostly shorts that profiled artists. Niblock's *The Magic Sun* (1966), a beautifully abstract black-and-white film of jazz great Sun Ra and his Arkestra, should be considered an underground classic. At this time he also got involved in intermedia events, usually contributing short films to dance performances.

Niblock created his first sound piece in 1968, in which his collaborator, Meredith Monk, played the organ and he mixed in prerecorded organ sounds. Influenced by composer Morton Feldman's longtone pieces as well as Minimalist painting (Sol LeWitt and Barnett Newman) and sculpture (Donald Judd and Robert Morris), Niblock began creating his own stripped-down tape pieces. He recorded musicians playing the tones he wanted to use, then he layered them and edited out the attacks (the initial part of a sound) and the breaths in order to make a continuous sound. Unlike his contemporaries, the composers La Monte Young and Terry Riley, Niblock never worked in just intonation; instead, he made the out-of-tune tones create throbbing beat frequencies that contribute to the heavy-metal appeal of his work. (Niblock insists on having his pieces played at top volume to reveal all of the overtone activity.)

As part of Experimental Intermedia, an organization supporting intermedia artists (since 1968), Niblock, in the 1970s,

established a concert series in his New York loft for composers and sound artists. Every year, to celebrate the winter solstice, Niblock presents his own music in a six-hour stretch, accompanied by his films featuring long takes of people engaged in manual labor. The films underline Niblock's aesthetic of repetition as a quotidian, earthy device, rather than the cosmic associations of the drone favored by Young and other composers. Of his work, Niblock has said:

> I've really only made this one music, and I've only been interested in the one idea of close-ratio tones and getting it loud enough to produce a lot of overtone patterns. I'm more interested in making architectural, environmental sound pieces, which one can think of as a big, full box. Within that box, there are many possibilities of things happening, so if you move around the space, the sound changes because of the standing waves . . . Everywhere I play, my music sounds different, because the sound system is different, the architectural space is different.[7]

PAUL PANHUYSEN (B. 1934)

"Convention tends to demarcate: a painting is a painting, an opera is an opera; a visual artist is a visual artist, not a musician or a composer. . . It works like a wall surrounding a closed system—fencing in, fencing out. Embracing this concept means turning one's back to reality as it is: a tangle of circumstances, events, and developments; a perpetual state of madness [in which] people have always striven to find a system . . ."[8]

Dutch visual artist and composer Paul Panhuysen is known for his site-specific works creating drones. He co-founded Het Apollohuis, an important venue for international sound artists and experimental musicians that presented exhibitions and performances as well as operated as a recording label in the Netherlands from 1980 until its closing in 2001.

Panhuysen studied music, art, and sociology, and his professional career has included positions at an art school and a museum. He also served as an artistic advisor to urban development projects in Holland. In 1965 he was a member of the Band of the Blue Hand, an artist group related to the international Fluxus movement, and in 1968 he started the Maciunas Ensemble, an experimental music group named for Fluxus impresario George Maciunas. The ensemble used extended playing and recording techniques and created its own instruments (duochords, tubular aluminum monochords, spring strings, musical bows, and guitars with tails) to produce musical pieces that are centered on the overtone series.

Panhuysen is best known for *Long String Installations* (1982–85), site-specific sound works he created in collaboration with artist Johan Goedhart. They stretched long wires across large spaces—churches, concert halls—in ways that highlighted the architecture, and then activated the "strings"—playing the wires by hand or with mallets or other implements—to create thick drones with soaring overtones. They experimented with sound by using different wires of different materials (steel, brass, nylon) and incorporating instruments (connecting the wires to the soundboards of pianos) and found objects.

In the 1990s Panhuysen created installations with dozens of canaries singing in response to the drones produced by the long-string instruments. (Of the piece he said, "You're better off with the canaries than with the Brabants Orchestra."[9]) He later developed a system called the Galvanos in which he used galvanometers, devices to detect and measure electric currents, to translate prerecorded material into mechanical vibrations that would activate the long-string instruments. He also used the system to activate metal springs and then reamplified the frequencies. Panhuysen also employed number systems such as magic squares (a series of numbers arranged in a square grid so that the sum of each horizontal and vertical row and of the corner diagonals is always the same) in his visual and sound works.

JOE JONES (1934–1993)

"Maybe I am a better toy maker than I am a musician. It's just how you view things. People could look at my pieces and say 'oh, it's a great toy.' That's a good compliment for me, too. Is it a toy, is it art, or is it music? I don't know . . . If you saw one of my machines in the middle of a toy store, you would have a different feeling than if you saw it in a gallery. An example: in a big store in Germany they had a little thing called the Biene Maya, a bumble bee with a propeller sticking out of its ass, flying around the room. To me that was art. It was funny, it was humorous, and I could change it."[10]

Joe Jones was an American composer and Fluxus artist who created "music machines" that were featured in international performances and exhibitions.

Born in New York, Jones attended the Hartnett School of Music and worked as a jazz drummer. Not finding enough opportunities to perform, he studied experimental music with composers John Cage (at the New School for Social Research) and Earle Brown. They introduced him to early Fluxus artists Dick Higgins and Alison Knowles, who sublet their apartment to Jones in 1962. It was there that he began

to create his music machines as an "experiment in sound." At Knowles's encouragement, he presented them as part of the Yam Festival, an early Fluxus event, in New Brunswick, New Jersey, in 1963.

Jones assembled his music machines from broken toy instruments and motors. He often organized the machines to perform en masse, and called it the Tone Deaf Music Co. These performances resulted in crazy-quilt soundscapes—much like the sounds produced by Jean Tinguely's machines—that were glittering and animated. In 1971 Yoko Ono collaborated with the Joe Jones and his Tone Deaf Music Co. on her double album *Fly* singing to the accompaniment of the music machines. Jones's *Mechanical Fluxorchestra* (see pages 228–29) is depicted on part of the album's sleeve.

Because of the machines' whimsical quality, many of Jones's performances and exhibitions were aimed at children. He built a tricycle with his music machines dangling off of it and rode it around New York. From 1970 to 1972 he ran his "Music Store," where he exhibited and sold his works. In 1978 he began using solar cells as the energy source to operate the machines. He eventually moved to Europe and settled in Germany, where he continued to participate in Fluxus-related events.

LA MONTE YOUNG (B. 1935)

"When I told Richard Brautigan that I liked to get inside of sounds, he said that he didn't really understand what I meant because he didn't visualize a shape when he heard a sound, and he imagined that one must conceive of a shape if he is to speak of getting inside of something. Then he asked, 'Is it like being alone?' I said, 'Yes.'"[11]

La Monte Young is widely recognized as one of the first composers of Minimalist music in the United States. He is known for his pioneering work in which he creates environments of sustained tones.

Born in Idaho, Young was raised in a Mormon family and was a jazz saxophonist as a teenager. His discovery of Indian music and modern classicism inspired him to study composition, which he did in Berkeley and Los Angeles in the late 1950s. One of his early works, *Trio for Strings* (1958), was a first for Western classical music. A twelve-tone serial piece for violin, viola, and cello, it is comprised of only long, sustained tones and silences. In the midst of a serialist atmosphere, Young's step toward isolating and foregrounding the drones of Indian classical music and the pedal points of Western classical music led to the "new tonality" of the 1960s and '70s. His work proved enormously influential, particularly to composer Terry

Riley and electronic musician Brian Eno.

Young moved to New York in 1960 and became involved with artists and experimental musicians. He organized concerts at Yoko Ono's loft and George Maciunas's A/G Gallery. He wrote a series of instruction pieces, including *Composition 1960 #7*, with a score stipulating that pitch intervals are to be held "for a long time," and *Piano Piece for David Tudor #1* (1960), which directs the performer to feed a piano a bale of hay and a bucket of water on stage.

In addition to the Fluxus connection, Young had other associations with the visual arts. Sculptor Robert Morris painted a black bullseye in the center of a gong that Young and Marian Zazeela bowed in concert, and painter Larry Poons designed the performers' seating arrangement for a performance of Young's piece *Second Dream of the High Tension Line Stepdown Transformer* at the Yam Festival on George Segal's farm in 1962. Young's ensemble Theater of Eternal Music (1962–66; see page 131)—with Marian Zazeela, John Cale, and Tony Conrad—once performed at a birthday party for Metropolitan Museum of Art curator Henry Geldzahler. The majority of Young's performances of the 1960s and '70s were in art spaces, starting with the 10-4 Gallery (where Andy Warhol associate Billy Name was holding vocal drone), and one of Young's earliest releases was with an arts magazine. *Excerpt from Drive Study 31 1 69 12:17:33–12:49:58pm* was on a flexi-disc—a thin, flexible single—that was featured in a 1969 issue of *Aspen*, a multimedia magazine on the arts. The issue was curated by artist Dan Graham and designed by George Maciunas.

A quintessential work of sound art is Young's *Dream House* (see pages 62–63, 104), the term for the sine-tone "continuous sound and light environments" that Young created in collaboration with his wife, the light artist Marian Zazeela. *Dream House* has been presented in various venues and has run for continuous periods (from one week to several years). Its rich sound—derived from a chord in Young's magnum opus, *The Well-Tuned Piano* (1964; see pages 62–63)—may initially seem static, but as you move around the space, or even turn your head an inch, different tones appear and disappear. As music critic Kyle Gann described it in 1989, "in effect, the air molecules in the room are marshaled into a fine-grained, geometric pattern, and the moving ear intersects that pattern differently at every point, as though you're walking through a [Victor] Vasarely painting rendered in incorporeal 3-D." Young dates the beginning of *Dream House* in 1962, but it wasn't until 1966 that he began the experiment in his loft, running oscillators twenty-four hours a day for four years.

Young noticed that Cage received sup-

port from people who ordinarily sup-
ported art events, and it's significant that
the early public exhibitions of *Dream
House* were all in art spaces—Galerie
Heiner Friedrich in Munich (1969),
Maeght Foundation in France, the Met-
ropolitan Museum of Art in New York,
Documenta 5 in Kassel (1972), and the
Dia Art Foundation in New York (1989).
These usually included brief, live perfor-
mances in which Young, Zazeela, and a
few musicians sang or played along with
the frequencies in the space for several
hours. Since 1993, Young has oper-
ated *Dream House* in a space in lower
Manhattan.

YASUNAO TONE (B. 1935)

*"In the '90s there was a secession of art
from Western classical music, which
became part of institutions such as
conservatories, opera houses, orchestras
... it is not art music, but nothing differ-
ent from mainstream music. Or from
folk music—they both stopped develop-
ing and deconstructing themselves. So
there's a vacuum, and in this vacuum,
club music has evolved as electronic/
experimental music. Young musi-
cians emerged in this vacuum with the
democratization of technical means for
recording/generating sound by develop-
ment of technology, which brings about
awareness of new art form, sound art."*[12]

Japanese composer and performer

Yasunao Tone was one of the founding
members of the Japanese Fluxus move-
ment of the 1960s. He is best known for
manipulating digital information and
employing indeterminate methods to
create experimental sounds.

Tone was born in Tokyo and studied
literature. In 1960, while still a litera-
ture student, he was one of the founding
members of Group Ongaku, perhaps the
world's first free improvisation-noise
ensembles. "We thought, then, our
improvisational performance could be
a form of automatic writing, in a sense
that the drip painting of Jackson Pollock
was a form of automatic writing ... The
question I posited then was, could Du-
champ's *Paris Air* or urinal be translated
into musical performance. That led us to
use everyday objects as instruments."[13]
Tone did pick up the saxophone for the
group, though he had no music training.

In the early 1960s, Tone participat-
ed in concerts by Fluxus artists Yoko
Ono and Toshi Ichiyanagi. In 1962
Fluxus impresario George Maciunas
published Tone's *Anagram for Strings*,
a graphic score composed of all glis-
sandi (rapid slidings up or down the
musical scale). (Tone subsequently
helped organize the 1965 Fluxus Week
in Tokyo.) Tone made his first sound
installation in 1962, which consisted
of a looping tape recorder covered in
white cloth so as to appear invisible. He
also worked with Hi-Red Center, the

performance art troupe founded in 1963, and Team Random, the computer art group.

Tone moved to the United Sates in 1972 and began composing scores for the Merce Cunningham Dance Company. For his *Geography and Music*, a text translated from Chinese is read alternately by word, syllable, or phrase through two microphones, which control sounds from a piano and viola. It was performed by John Cage and David Tudor, among others.

Tone developed other methods of translating text into sound. For his *Musica Iconologos* CD he created a process using computer technology. He took two ancient Chinese poems and converted each Chinese character into photographic images. He put the images into the computer and digitized them. Then he obtained histograms from the digital files' binary codes and had the computer read the histograms as sound waves. The results are "noise in all senses." It is a technological variation on sound poetry, with the text of the ancient poems translated into a long series of short phrases of splintering electronic noise.

Tone is perhaps best known for his "wounded CD" pieces, which he has made since 1985. He puts Scotch tape with pinprick holes onto CDs and then plays them in archaic players, resulting in skips and sputters.

HERMANN NITSCH (B. 1938)

Austrian performance artist, painter, and composer, Hermann Nitsch is one of the key figures of the Vienna Actionists. He scored the music for his elaborate, multimedia performances.

Nitsch studied graphic design but had immersed himself in painting and performance by the early 1960s. Informed by religious art and notions of Dionysian celebration, Nitsch conceived of a radical theater—the Orgies Mysteries Theater—to stage "actions," theatrical events similar to Fluxus happenings, in which performers participated in bloodletting, ritual animal slaughter, and mock crucifixions (see pages 170–175).

Nitsch's scored music was an integral part of these radical actions. He enlisted horns, choirs, oom-pah bands, and various noisemaking devices that sustained tones in a semi-cacophony. Nitsch's music has been documented on numerous gallery edition LPs and CDs, culminating in *Das 6-Tage-Spiel des Orgien Mysterien Theater* (2003), a fifty-one CD box set that entails forty-eight hours of material documenting the six-day play Nitsch and his theater performed in 1998.

Independent of his performances, Nitsch has composed (or improvised) numerous organ and harmonium pieces, in which the organ is used as a generator of sustained tones. He has also com-

posed several symphonies that employ the "noise orchestras" of his actions, brass bands, folk bands, and choirs. Of his work he has said:

> My music has its roots in the tragic scream of pain, the scream of birth, the scream of death, and the orgiastic scream, that is to say, in emotions beyond the verbal expression, but this structure also reveals the world as a whole through meditation ... This music has ceremonial character. Ceremonial repetitions as if telling ones beads and callings of the cosmos, of infinity and eternity are carried out. The speed of light and the relating (unimaginable) distances are marked off with notes. The depth of the universe is the depth of space withering endlessly. Endlessness, this eternal repetition paints the picture of life into eternity, and the eternal repetition establishes within eternity itself life ... the happening of the worlds should transform into sounds.[14]

BERNHARD LEITNER (B. 1938)

"I believe that it is a very important fact that the body be understood as an autonomous acoustic instrument, as an integral acoustic sensorium. The hollow spaces of the body, the bones, the way the sound is transmitted in the body, how it passes through the skin, and how it is transmitted on. In this sense, the point is to open up, to allow sounds and sound motions to penetrate the body, let them resonate in the body. The average person is, I think, paved over in an acoustic, physical sense. He is apprehensive when sound penetrates him, resonates in him, and then vibrates out of him again."[15]

Born in Austria and trained as an architect, Bernhard Leitner creates sculptures and installations that investigate how sound travels through space.

Leitner began experiments with using sound to define architectural space in the 1970s, and called the resulting configurations "instruments." He programmed loudspeakers according to sequence, intensity (crescendos and decrescendos), and speed of motion. The earliest example is *Sound Cube* (1968; see page 125), which went unrealized until 1980 (at Documenta 7), in which a set of speakers on six walls create sounds that travel through space, "drawing" invisible lines, circles, and planes.

Leitner also explored the interaction between sounds and the human body. In *Platform for Vertical Motions* and *Platform for Horizontal Motions* (both 1976), speakers situated by a bench transmit electronic beats that affect the upper part of the listener's body and synch with the person's breathing. *Sound Chair* (1976) invites participants to lie on a reclining chair and experience the sounds that travel inside it. In

Sound Field IV (1995) ten loudspeakers situated on the floor of a large room are covered with heavy stone slabs, which keep the sound low to the ground. For the participant, this achieves the effect of wading through sound waves. Leitner asserts that humans hear with their skin as well as their ears, and that we hear better with our knees and foot soles than with our calves.

More in keeping with Leitner's interest in architecture is *Le Cylindre Sonore* (1987), a large-scale installation located in the Parc de la Villette in Paris. A construction that resembles one cylinder inside another, the installation consists of concrete walls with twenty-four loudspeakers installed between walls, which carry sounds from the surrounding bamboo forest that are picked up by microphones. In *Tonkuppel (Sound Dome)* (2005) Leitner created an arch out of sound to "replace" a dome in a Berlin church that was destroyed in World War II. He filled the church's open truss with trombone sounds.

Leitner has one CD, *Headscapes* (2003), specifically designed to be listened to through headphones, whose pieces make use of the head as "a globe-like receptacle for time-based acoustic-geometric spaces."

ANNEA LOCKWOOD (B. 1939)

"When I was a student doing post-graduate work in Germany, studying elec-tronic music, I remember one summer, every day for awhile just picking up a particular stone and trying to figure out what that stone felt like, what it felt like to be that stone, what it feels like to be something other than human with a complete belief that there's an inherent being in all of those other phenomena. So when I'm working with rivers ... I'm trying to hear and sense and think my way into what the nature of a river is."[16]

Born in New Zealand, trained as a composer in England and Europe, and living in the United States since 1973, Annea Lockwood has worked in modern composition and is an early pioneer of sound art. Her important early works include *Glass Concert* (1967), made of sounds from glass, and, in performance, incorporating light reflections from the glass to dramatic effect, and *Piano Transplants* (1969–72), inspired by the then-new developments in heart transplants. In this latter work, old pianos were burned, partially submerged in a pond (in Amarillo, Texas, also the site of Ant Farm's *Cadillac Ranch*; see page 107), and partially buried in her English garden.

In the 1970s Lockwood delved into environmental sounds, collecting numerous nature recordings that included sounds of volcanoes, earthquakes, geysers, mud pools, tree frogs, storms, and rivers. For *World Rhythms* (1975) she improvised a live mix of select recordings, accompanied by a gong

or other percussion instrument.

Lockwood's *River Archive* is a collection of recordings of river sounds she has recorded herself and acquired from others. Since 1966 Lockwood has been recording and collecting sounds from rivers worldwide. She has drawn from this resource for several works, including the two-hour installation *A Sound Map of the Hudson River* (1982), in which she took recordings from twenty-six locations along the river from its source in the Adirondacks to its outlet in the Atlantic Ocean and combined them with interviews from people living in the area, including fishermen, river pilots, a ranger, and a farmer. The same year she fashioned a piece around an interview she recorded with sculptor Walter Wincha titled *Delta Run*.

Lockwood also created *Sound Ball*, designed by Robert Bielecki, a foam-covered ball containing six small speakers and a radio receiver, designed to be used by dancers, as well as one hundred sound hats. "Personal mobiles made with pieces of bamboo, ping-pong balls, plastic discs, which made very soft sounds, audible only to the hearer." In the 1990s she turned to more conventional instrumentation for compositions, although she revisited the river map concept with *A Sound Map of the Danube* (2005), a sequel of sorts but in surround sound.

ROLF JULIUS (B. 1939)

"If I combine a normal clear piano sound with a dirty red pigment, it will strike you as odd. This is the kind of experience a sound artist acquires because he knows about the texture of sounds. A composer would not work this way. He doesn't know about texture, or what I would call the surface of the sound. In my work, you concentrate on both the visual and the acoustic elements and, taken together, they result in something new ... sound is not such a big deal—it's a material like any other."[7]

Born in Germany, Rolf Julius is a sound composer and sculptor. He is known for his "small music," made from recorded natural and man-made sounds.

Julius studied fine art and discovered the nascent sound art scene in Berlin in the late 1970s. He created his first piece *Dike Line* in 1979 in which he recorded the sound of an iron bar hitting another piece of iron, transferred the recorded sound to a cheap quality tape, then combined that recording with six photographs of a dike from various angles. German curator René Block saw the piece and invited Julius to participate in the 1980 Berlin show *Fur Augen Und Ohren* (For Eyes and Ears), the first major exhibition of sound art in Europe.

Thereafter Julius began combining sound with objects, placing speakers on

the viewer's eyes (*Music for the Eyes*; see page 8) and on top of a stone, in bowls and flower pots, buried in gravel and dirt, and on sheets of glass coated with pigments to make them vibrate or "sound." He works with small objects and small sounds—chirps, whirs, and drones—to create what he calls "small music," which invites comparisons to Zen and Far East notions of silence and meditation. In gallery installations Julius often uses small speakers in large empty rooms. After an early piece in which he played a tape of piano sounds beside a frozen lake (which was cut short by police as it was "disturbing the peace"; he has created outdoor installations, including putting speakers in quarries in Finland. Titles like *Desert Piece* and the early *Music for the Earth*, further underscore his association of sounds with natural contexts.

More recently Julius has begun composing, with instrumentalists performing some of his graphic scores, and doing large-scale wall works with computer-generated ink prints taken from photographs of his earlier work with pigments, and cello accompaniment (*Cello Piece*, 2002 and *For Cello*, 2004).

MAX NEUHAUS (B. 1939)

"*The important idea about this kind of work of mine is that it's not music . . . it doesn't exist in time. I've taken sound out of time and made it into an entity . . . I never do a piece where I'm not sure that 50 percent of the people who come across it will walk right through it without hearing it. And that means it's available but without imposition, that people find it when they're ready to find it, and by making it anonymous, it means that they claim it as their own—as they should . . . People think seeing is everything. They say, 'Seeing is believing,' but in fact the eye and ear are in constant dialogue . . . Sound is the other half of life.*"[18]

An American musician and artist who coined the term "sound installations," Neuhaus was born in Beaumont, Texas, and studied at the Manhattan School of Music from 1957 to 1962.

Neuhaus toured internationally as a percussionist with composers Pierre Boulez and Karlheinz Stockhausen, and then as a solo recitalist; a 1968 album features his definitive performances of works by John Cage and Morton Feldman. By the mid-1960s he was turning to his sound installations. He organized "six sound orientated pieces for situations other than that of the concert hall." For *Listen: Field Trips Thru Found Sound Environments* (1966–68; see page 23), audience members were asked to meet at a concert hall where they boarded a bus, had their hands stamped with the word "listen," and rode to the Consoli-

dated Edison power station, the PATH subway to New Jersey, or the New Jersey Power and Light Power Plant. In his *Water Whistle* pieces (see page 89) listeners heard sounds produced by jets of water in swimming pools by lying on their backs and putting their heads underwater. His first permanent installation is *Times Square* (1977–92, and 2002–ongoing; see page 103), a soothing drone set under a sidewalk grating in New York, which runs twenty-four hours a day. His drawings planning his works have been frequently exhibited (see pages 20–21).

AKIO SUZUKI (B. 1941)

"Every day, as I strain to catch the sounds around me in my life in Tango [his village in Japan], I learn from the signals that living things like insects and birds are sending. And in the end, the things I have studied come out in my life. The more you put yourself into nature, the more you get from it ... The universe is founded on the act of copying. It has even been suggested that it all started with a copy. And what I'm trying to do is embody this phenomenon."[19]

Born in North Korea to Japanese parents, Suzuki is known for his sound-oriented performances, despite the fact he never studied music or art (although one of his ancestors ran the Shinto Shrine and Suzuki was given a ceremonial stone flute, a family heirloom). Working in an architecture firm in the early 1960s, Suzuki specialized in designing staircases. One day he saw a drawing of a staircase as a kind of graphic score. In a 1963 performance piece, Suzuki threw a barrel of trash down a stairwell in a Nagoya train station in hopes of hearing what he called a "feelgood" rhythm.

Throughout the '60s Suzuki embarked on "self-study events," in which he researched sound in nature and in architectural spaces. In the self-study event *Searching for Echo Point* he first explored a concept that has remained throughout his career—throwing sounds into nature, and then following them and playing with the echo. In the 1970s he invented two instruments that contributed to this study: the Suzuki-type glass harmonica, also known as De Koolmees, and the Analopos, an echo instrument made of a spiral cord and two metal cylinders. The sonic effect they create has been compared to two mirrors facing each other.

In 1988 Suzuki made *Hinatabokko no kukan* (Space in the Sun), in which he sat silently outdoors between parallel walls for twelve hours in order to focus his listening. This was something of a turning point, as Suzuki discovered that only when he stopped consciously listening could he really

listen to every minute sound.

Although Suzuki's first solo exhibition, the sound installation of the Analapos was in 1976, in the '70s he was better known for his performances. These involved not only playing his instruments but also tearing newspapers, breaking dinner plates, and shuffling acetate records with the sounds of Tokyo subway ticket machines and applause on a series of turntables. But by the '90s his emphasis on listening had evolved into installations called *Cause and Effect*, which still involved sounds playing themselves. *Listening to Stones* explored the sound of stones placed on glass panes and set in motion.

In *Otodate*, performed at the first Sonambiente festival in Berlin in 1996, Suzuki charted a map of the city connecting almost thirty points of special audio interest chosen for their echo density. He also performed *Otodate* in other cities, using explosive sounds (from dynamite to a bamboo slit drum) to gauge the echoes.

In 2006 the Scotland-based arts organization Arika launched its location-based Resonant Spaces series with a tour across the Scottish countryside for a duo of Suzuki and saxophonist John Butcher. They improvised outdoors at sites chosen for their resonance and echo, which included an oil tank, a cave, and a mausoleum.

TERRY FOX (B. 1943)

"If you have two strings together it might be an instrument. Or if it's a monochord, because it's built like an instrument, with a sound box, bridges, and it can be tuned. But to attach a wire to something at one end and to something else at the other doesn't make it an instrument. To me it's a sculpture, a straight piece of steel. Like water can be a sculpture. And the sound that it makes is pure . . . it's pure sound. It's not altered or fooled with. That's the most important part. I mean, to be able to vibrate a wall, a huge wall, and have the wall make a sound—that's wonderful to me. That's sculpture."[20]

A self-taught artist from a working-class background, in the late 1960s and '70s, Fox was a performance artist, creating works that tested his body's endurance (fasting, not sleeping, trying to levitate). After doing a performance in Düsseldorf with Joseph Beuys, *Isolation Unit* (1970; see page 161), where Fox used two iron pipes to produce sound waves that would affect other elements of the space (the windows) and other objects in the performance (a candle's flame), he perceived that "sound is sculpture" and subsequently incorporated sound in his performances and work.

During Documenta in 1972, Fox performed *Action for a Tower Room*, playing a tamboura six hours a day for three days "to discover the particular acoustic quali-

ties of this room and transform it into a resonating chamber like the inside of a tamboura."[21] As part of his "Labyrinth" series, modeled after the medieval labyrinth design in the floor of Chartres Cathedral, he made two recordings that have been widely anthologized in collections of artists' recordings. In one, he mixed the sounds of eleven cats purring according to a score that assigns each cat to one concentric ring of the labyrinth. In the other recording he played eleven stretched piano wires. He began using the piano wires in his performances and has become one of the better-known "long wire" performers, along with Paul Panhuysen and Ellen Fullman. In addition to stretching them between walls of a given space, he connected the wires to cars, motorcycles, garden sculptures, and trees.

Fox has also made a score for piano wires, helicopters, and barking dogs based on a map of Berlin, as well as *The Berlin Wall Scored for Sound* (1980–82), in which six acoustic sounds go in an endless loop. In the 1987 installation *Instruments to be Played by the Movement of the Earth,* he created structures that would be sensitive to seismic tremors or vibrations caused by passing trucks and create sounds as a result; one structure was a stack of glasses and glass plates, another a funnel filled with dried peas which would fall into a Chinese wok at the slightest

vibration. In some of his pieces from the 1990s he created standing sound waves (two waves with the same frequency, wavelength, and amplitude traveling in opposite directions) in a room utilizing only tubes and empty bottles.

MARYANNE AMACHER (B. 1943)

Active since the late 1960s, American electronic composer, performer, and artist Maryanne Amacher may be the first composer whose work has been almost entirely site specific. She is interested in how creating an unaccustomed sound environment affects/displaces the listener.

Amacher's "City Links," an ongoing series of works begun in 1967, in which sounds from urban environments—harbors, steel mills, factories, airports—are transmitted in real time via telelinks to another location such as an exhibition space. In *City Links 15,* sounds from New York, Boston, and Paris were mixed in a live radio broadcast on WBAI in New York and also transmitted to Radio France Musique in Paris (long before the internet made such transmissions an everyday occurrence). She discovered that each place had an underlying pitch, a drone tone (Boston Harbor's, for example, was F#). In the early 1970s, Amacher made the idea more domestic and installed a microphone on a window

overlooking the ocean at the New England Fish Exchange in Boston, transmitting the sound into her home studio (and sometimes to her performances).

In another piece, *No More Miles (an acoustic twin) Telelink Work No. 7* (1974; see page 110), she placed microphones in a Budget Rent-a-Car office in Minneapolis and transmitted those sounds into a gallery at the Walker Art Center. The noise of voices, footsteps, and other sounds from the office matched those heard in the gallery. Visiting the gallery, you would hear phantom voices, footsteps, and other sounds as though people were moving and talking around you.

Amacher collaborated with John Cage, composing sound environments for his ten-hour spoken piece *Empty Words/Close Up* (1979) and his multimedia *Lecture on the Weather* (1975), both based on texts by Henry David Thoreau.

For "Music for Sound-Joined Rooms," an ongoing series begun in 1980, Amacher spends weeks on location studying the architectural features of a building and then creates sonic and visual events for each hallway, room, and staircase. This furthers her interest in "structure-borne sound"—"sound traveling through walls, floors, rooms, corridors," as opposed to airborne sound, which is experienced simply by standing in front of a loudspeaker.

By the early 80s, Amacher's use of electronics became more high volume. The volume is necessary for her presentation of high-pitched tones to stimulate what she calls "third ear music," a phenomenon in which sounds seemingly originate from inside one's head and go out through one's ears—the ultimate interior extension of "structure-borne sound." *Sound Characters (Making the Third Ear)* (1999), is the first and only full-length recording of Amacher's work to date, although much is lost in the reduction to two-channel stereo and the limitations of home stereo speakers and amplification. Describing her work, Amacher has said:

In regular music you don't have any models to learn about spatial aspects of music. Usually the performers are on stage or the music's on a record and you don't really hear things far away or close-up, you don't hear things appearing and disappearing and all the shapes that emerge from this ... After a while [when she had the Boston harbor sounds transmitted to her studio] I realized that there was always a fundamental pitch, there was a whole tone of a space. So I made various installations I called "Tone and Place." When I analyzed this I discovered a low F# was coming from Boston Harbor at 91–93 Hz. I did not know exactly what was producing this tone, but that was the

tone of the space, really the color of
it. (The characteristic tone of a con-
tinuous six-month transmission
from New York Harbor in 1979–80
was an E.)[22]

CHARLEMAGNE PALESTINE
(B. 1947)

*"I would probably say that in some
strange way I'm the living hybrid, in my
own work, of the physical gesturality
of Pollock and the spiritualistic color
chemistry of Rothko. If those two had
conceived a child, I'm it … When I cre-
ated body music in video, I knew I hit the
mean, I hit on the basis for a language.
When I started doing strumming music,
I hit on the basis for a language … When
I first played the Bösendorfer, it rang
the way the bells did, it had overtones
like electronics and it was as sensitive
as the voice. The perfect incarnation of
all those things I had been groping with
separately. It helped take my ideas fur-
ther and now I'm ready for the orchestra
and larger forces."[23]*

Palestine was an early practitioner
of the "new tonality" (or Minimalism),
giving legendary solo piano perfor-
mances, and is also known for sculpture
using and inspired by stuffed animals.
After singing in a synagogue choir and
performing as a bell ringer in church,
Palestine studied music in high school
and synthesizers at New York University

with pioneering electronic composer
Morton Subotnick.

In the late 1960s, he began ex-
perimenting with electronic oscillators.
Influenced by the color-field paintings of
Mark Rothko, Palestine created electron-
ic sound fields with minute changes in
overtones apparent only through careful
listening. By 1970 he taught at the Cali-
fornia Institute of the Arts and played
the organ in a nearby Los Angeles church
in what he called his weekly "Meditative
Sound Environments." For these he per-
formed his *Spectral Continuum Drones*,
in which he traced the "evolution of a
sonority" by adding tone after tone over
a period of several hours until the piece
grew into a full spectrum of sound.

Returning to New York a couple of
years later in the mid-'70s, Palestine de-
veloped his piano pieces. In *Strumming
Music* (1974), another additive-process
work, he hammered out a vigorous
tremolo with rapid alternation between
his left and right hands, which Palestine
called "strumming," to produce a cloud
of overtones that hovered above the fray
of his keyboard attack.

He also entered the art world at this
time, exhibiting drawings and doing live
performances at the Sonnabend Gallery.
The gallery also released his double
album, *Four Manifestations on Six Ele-
ments* (1974), and produced several
videos. In some of his gallery perfor-
mances, Palestine ran around holding

a single tone vocally as he barreled into walls; this fit in with the body art of the time (by artists such as Vito Acconci and Chris Burden), but it was also an experiment in acoustics and sound perception. Similarly, in the video *Island Song* (1976), Palestine holds a single tone while riding a motorcycle across an island. When he arrives at the end of his journey, his voice is in synch with a foghorn emitting the same pitch.

Burned out on performance and dispirited by the commercialization of Minimalist music, Palestine shifted his activities to sculpture and mixed media in the early 1980s, focusing on the stuffed animals he often surrounded himself with during his concerts. But a new generation rediscovered him after some of his releases reappeared on CD in the '90s, and he has resumed making music, although largely revisiting the pieces and instruments of his work from the '70s.

BILL FONTANA (B. 1947)

"My work exists one foot in and out of contemporary music, one foot in and out of contemporary art, on the edge of some science, on the edge of philosophy. Sound enters so many different worlds."[24]

Trained as a composer, American artist Bill Fontana is known for his use of the natural environment to create site-specific sound sculptures. Like composer Maryanne Amacher, Fontana specializes in "relocating sounds." Of his work, the artist has said:

> I began my artistic career as a composer. What really began to interest me was not so much the music that I could write, but the states of mind I would experience when I felt musical enough to compose. In those moments, when I became musical, all the sounds around me also became musical ... [25]

In his "Sound Sculpture with Resonators" series (1972–75), Fontana put microphones inside bottles, seashells, and tubes, among other vessels; put the objects on the roof of a building; and then broadcast their sounds to a room inside the building. He was fascinated to see, he said, "how the resonance of these things could turn any sound into something very musical."

For *Kirribilli Wharf* (1976), he turned the sounds captured from eight separate holes in the underside of a pier in Sydney Harbor into an eight-channel gallery installation. For *Distant Trains* (1984), the artist transmitted the sounds of an active train station in Cologne through buried loudspeakers in a field near the Berlin Wall, the former site of a railway station. For the fiftieth anniversary of D-Day, Fontana had Normandy beach ocean sounds

transmitted through forty-eight loudspeakers installed in Paris's Arc de Triomphe in a work called *Sound Island*. In *Metropolis Köln* (1985) he took live sound sources from various parts of the city (a zoo, the Rhine River, a train station, a church, and a pedestrian street) and put them all in a sixteen-speaker installation in the Roncalliplatz, a plaza adjacent to the Kölner Dom cathedral.

Over the years, Fontana has created several works called "Sound Bridges" which link cities thousands of miles apart via simultaneous sound transmissions. In June 2006 he created the more literal *Harmonic Bridge* (see page 87 and accompanying CD) in which he amplified the vibrations of the Millennium Bridge in London, the footbridge that connects the Tate Modern to St. Paul's Cathedral across the Thames, and transmitted them into the Tate's huge Turbine Hall as well as the Southwark station of the London Underground.

CHRISTINA KUBISCH (B. 1948)

"In the beginning it was more the departments of visual arts which were interested in my works, because the sounds I have been offering are not a finalized, fixed composition. As it was something which the visitor has to mix himself, it was not taken serious[ly]. Although it was not meant to be a provocation, it was frowned upon, especially in the music scene."[26]

Christina Kubisch is a German composer and creator of sound installations. She is one of the first artists to use electromagnetic induction—sounds generated from the interaction of magnetic fields—as a method for creating sound installations.

Kubisch studied art and music composition. In the 1970s she applied ideas from performance art to her music performances. In her 1973 "Emergency Solos" series, she performed wearing different gloves—boxing gloves while playing a flute solo, for example. She also collaborated with video artist Fabrizio Plessi in the '70s, creating sounds with different instruments and objects.

By 1980 she abandoned live performance to study electronics in Milan with the intention of developing sound installations. For an early work, *Il Respiro Del Mare* (The Breath of the Sea) (1981), Kubisch created a speakerless sound system that utilized magnetic induction with wire reliefs mounted on walls. Visitors could access sounds when they put receivers up to their ears, one dispensing the sound of ocean waves, the other the sound of breathing—sounds which were meant to be mixed by the listener by changing his or her position. She increased the listener's mobility with cordless headphones in *The Conference of Trees*

(1988–89), in which she put wires on five bonsai trees, which transmitted sounds to the headphone-wearing listeners. Kubisch has also used ultraviolet light and solar energy in her sound installations. In *The Clocktower Project* (1997) she transformed light into sound, programming the bells in the clocktower at the Massachusetts Museum of Contemporary Art to sound based on information about the position and intensity of the sun gathered from solar panels.

In 2003 Kubisch began the series "Electrical Walks" (see page 230), in which visitors wearing electromagnetic headphones, which respond to and amplify electric currents, could walk around a city or area and hear sounds that would be otherwise undetectable—sounds from surveillance cameras, cell phones, transformers, and more. Just as British composer Basil Kirchin discovered hidden sonorities by slowing down tapes of animal sounds and the voices of autistic children, Kubisch has made audible atmospheric electrical signals, taking ambient sound to an entirely new, microscopic level. Experiencing the work in fall 2006 when it was exhibited at the Kitchen, I found only scant buzzing in my wanderings around the nearby streets in Chelsea, but a full-bore drone filled the headphones as I stood outside the Hard Rock Café in Times Square.

BRIAN ENO (B. 1948)

"I think a lot in terms of color of sound. I've always been moved by the moment when a piece suddenly has a geography to it. I suddenly feel that this piece is located somewhere..."[27]

An influential and genre-defining figure in progressive rock and ambient music, Eno has been a key liaison between the rock world and the art world since the 1970s. A self-proclaimed "nonmusician" who was fascinated with tape recorders growing up, he became involved in experimental music performances in art school, and soon joined the band Roxy Music, initially as an off-stage synthesizer player, then as a full-fledged stage performer. He has since produced U2, David Bowie, and Talking Heads albums, among many others.

Eno pioneered ambient music with his 1975 album *Discreet Music*, whose first side sets up a primitive echo-delay system with two tape recorders and a synthesizer. He fed the synthesizer line through the system and played the resulting tape at half-speed, giving it a soothing and slightly out-of-time feeling. The low volume and serene texture also look back to French composer Erik Satie's idea of furniture music that blends in with the sound of knives and forks at the dinner table. Of this work, the artist has said:

An ambience is defined as an atmosphere, or a surrounding influence: a tint. My intention is to produce original pieces ostensibly (but not exclusively) for particular times and situations with a view to building up a small but versatile catalogue of environmental music suited to a wide variety of moods and atmospheres ... Ambient Music must be able to accommodate many levels of listening attention without enforcing one in particular; it must be as ignorable as it is interesting.[28]

Completely out of step with the heavily amplified progressive rock scene that Eno was associated with at the time, ambient music wouldn't really catch on until the early '90s with Aphex Twin and other artists.

Eno was the first rock artist to do sound installations. His *Music for Airports* (1978) was originally installed in New York's La Guardia Airport. Another landmark was his 1982 ambient album *On Land*, in which he tried to re-create specific locations in sound (with works like *Lantern Marsh* and *Dunwich Beach, Autumn, 1960*) in a series of oozing, lava-like soundscapes. His liner notes recommend a three-speaker home stereo system (an "ambient speaker system," with the third speaker situated behind the listener), which made the record a prophetic indicator of home sound installation.

Around the same time he also developed ambient video, mostly shot out of his window, which was displayed vertically on monitors, often in conjunction with ambient music (including pieces from *On Land*). He has also developed music software based on the self-generating systems of ambient music, which keep repositioning predetermined elements in ever-changing and unpredictable ways.

TRIMPIN (B. 1951)

"My work is always visualizing sound. A blind person can hear the movement, and a deaf person can see it. You don't have to understand the science of sine waves, pitches, and timbres to feel the impact of melodic, percussive sounds."[29]

Born in Germany, Trimpin (he goes by one name) is a Seattle-based composer, sound sculptor, and inventor of computer-driven acoustic instruments. His pioneering efforts have influenced many and were rewarded with the granting of MacArthur "Genius" Award in 1997.

Trimpin played flugelhorn and other brass instruments as a child but was forced to quit when he developed a skin allergy. He studied electromechanical engineering, music, and art, and was influenced by the microtonal philosophies of American composer Harry Partch and the sound machines of Jean

Tinguely. He moved to Seattle in 1979, in search of discarded computer parts and other technological junk to build music machines.

Trimpin began creating large-scale installations of instruments he invented. He built a computer-operated, six-storey microtonal xylophone in a spiral staircase in an Amsterdam theater. He also created a gamelan whose pieces are suspended in air by magnets; when struck they sustain the sound for an unusually long period because there's nothing to stop the decay.

Trimpin uses computers, MIDI (Musical Instrument Digital Interface) in particular, to play his inventions. He never uses electronic sound sources because he feels speaker technology is far behind the rest of current music technology. He has never recorded his work.

Trimpin has made use of the natural elements—water, air, fire—in his works. In *Pffft* (1992) he used two hundred air-activated sound sources (whistles, wind instruments, and pitch pipes) that are set into motion by gallery visitors via sensors, and play different compositions controlled by a computer. In *Liquid Percussion*, computer-controlled water valves drip into different glass containers, triggered by a keyboard accessible to visitors and by a motion sensor that detects their movements. Another piece, *Fire Organ* (see pages 32–34), consists of Bunsen burners set inside Pyrex cylinders that resemble organ pipes.

The burners are controlled by computer to vary the flame, which in turn makes different tones and colors in the flames.

In 1999 he completed a sculpture in the Experience Music Project, in Seattle, called *If VI was IX*, but more popularly known as "the guitar tower." It consists of 650 guitars and rises forty feet in the air. Thirty of the guitars are played and tuned by computer control.

Several years after that work, Trimpin created the large-scale work *Der Ring* (2006) for the Phaeno Science Center, in Wolfsburg, Germany. It's made of three circular aluminum tracks of differing sizes supported by a pulley system, with an aluminum ball on each one that is set in perpetual motion to produce a low, soothing hum. The pulleys control the speed of the balls, and are in turn hooked up to a MIDI-controlled gearbox. Trimpin also prepared a quieter version called *Shhh*, with one track and a glass orb filled with glass pebbles and glass rods, installed at a Seattle architecture firm.

MIKE KELLEY (B. 1954)

"My early interest was to try and make sculpture out of a rock band situation. I had discovered pictures of Joseph Beuys's more musical performance pieces, and I was really interested in how all the equipment he used was sculpture. I was also intrigued by the pictures I'd seen of John Cage's performances, where his equipment with

all of the wires was left lying around like post-Minimalist sculpture. I said, 'Let's try and do something like that, but mix it with the ridiculousness of a theatrical rock band like Alice Cooper.'"[30]

Mike Kelley is one of the preeminent multimedia artists in the world today, and one of the best known contemporary Los Angeles artists. Kelley was listening to avant-garde jazz and electronic music in high school in the late 1960s. He met artist Jim Shaw at the University of Michigan art school and the two began doing noisy Dada-inspired performances, resulting in the formation of the band Destroy All Monsters, in 1974, along with Cary Loren and Niagra. The group made films, a magazine, and recorded a variety of homemade electronic noise experiments, some pieces with Giorgio Moroder–inspired electro-rhythms, and a few songs (see accompanying CD). In the '90s Kelley resurrected the project as The Destroy All Monsters Collective, creating mixed-media environments (see pages 176–79).

When Kelley attended the California Institute of the Arts (1976–78), he played in the noise orchestra for a Hermann Nitsch action, and organized the band called the Poetics with video artist Tony Oursler. Originally attempting songs, the two revised their thinking to create imaginary film soundtracks. Kelley took up percussion for the ven-

ture, and other members came and went. This, too, became the basis for a series of mixed-media presentations in the '90s under the name the Poetics Project, some of which included video interviews with underground rock musicians.

In 1986, Kelley performed with the band Sonic Youth in a piece called *Plato's Cave, Rothko's Chapel, Lincoln's Profile*. He recited a poem while the band droned in the background. He collaborated with British electronic musician, Scanner on an installation for *Sonic Process*, a 2002 exhibition about electronic music and the visual arts, which was held at the Centre Pompidou in Paris. He formed a group called Gobbler with video artist Cameron Jamie and performance artist Paul McCarthy (there was also a trio with McCarthy and Japanese noise musician Violent Onsen Geisha). McCarthy and Kelley also provided musical backing for French theorist Jean Baudrillard's poetry reading in a 1996 performance. In Kelley's mixed-media installation *Day is Done* (2005; see pages 238–39), music is heard everywhere in the space (almost every review used the word "cacophony" to describe it), and he's released a soundtrack on his own Compound Annex label.

CHRISTIAN MARCLAY (B. 1955)

"We tend to think of music as this sightless thing because recordings have distorted our understanding of music.

We think it's this totally abstract thing that comes from nowhere and just exists as a recording, a disembodied invisible performance. Going to a club and experiencing music being made on the spot is totally different. What I don't like about live recordings is it never gives you the full picture."[31]

Christian Marclay is an American artist and improvisor known for his multiple turntable performances and sound-oriented visual works.

In 1980, while a student at the Massachusetts College of Art in Boston, he organized Eventworks, a festival that explored the relationship between music and art and included pioneering rock band Mission of Burma, underground filmmaker Jack Smith, and artist Dan Graham, among others. Marclay also participated in the performance duo The Bachelors Even, using guitar, voice, and background tapes, and applied concepts of performance art and body art to their live turntable performances.

Marclay recalls finding a badly damaged "Batman" record in the street as a youth, taking it home and playing it, as a seminal inspiration for using records in performances. This influence is further evident in his piece *Footsteps* (1989; see page 234), in which he covered a gallery floor with acetate records he made of a tap dancer, after which he then packaged and released the records, which had been repeatedly stepped on by gallery visitors.

He moved to New York in the early '80s and concentrated on music, particularly free improvisation where he became a presence in the emerging downtown scene, John Zorn and Elliott Sharp circles, regularly performing with Zorn, Sharp, and David Moss, as well as permforming solo.

For his "Recycled Records" series (1980–86; see page 232), Marclay created collages of broken and reassembled vinyl records that he played on turntables in performance, and sold as art objects. He likens his recycling of the records, which are mostly thrift store finds, to the 1980s trend of appropriation art, in which artists like Sherrie Levine and Richard Prince incorporated images borrowed from high art and popular culture into their work.

Marclay issued a one-sided record of one of his solo performances, *Record Without a Cover* (1985), that was distributed without a sleeve, a pioneering work that straddles the border between mass-produced commodity and artist multiple. Unprotected, it's intended to be scratched and therefore different every time it's played. Inevitably damaged, it is at odds with typical consumer values.

Marclay's obsession with records and tapes has carried over to a wealth of visual artworks: collages made from album covers; a framed vinyl 45 of Simon and Garfunkel's *The Sounds of Silence*; sculptures made from record-

ing tape; homages to Duchamp using CDs; graphic scores created by posting blank music paper around Berlin to be graffitied; and visual pieces of musical instruments that lie mute without a performer to play them.

In recent years Marclay has increasingly expanded his concerns to video. In the 2005 video installation *Shake Rattle and Roll (fluxmix)*, Marclay produced sound from a variety of Fluxus objects by shaking or banging them against a surface. In *Video Quartet* (2002) he fashions a collage of Hollywood film clips that feature instruments being played. Another video piece is *Guitar Drag* (2000), in which an electric guitar, plugged into an amplifier and tied to the back of a pickup truck, is dragged across a Texas landscape. *Guitar Drag* references not only the 1998 racist murder of James Byrd, Jr., and Nam June Paik's piece where he dragged a violin behind him on a string through the streets of Brooklyn, but also sustains the Earthworks and sound art connection as the instrument is battered by both pavement and a series of grass and dirt terrains.

CARL MICHAEL VON HAUSSWOLFF (B. 1956)

Carl Michael von Hausswolff is a Swedish composer and visual artist. Admittedly "too lazy" to learn a musical instrument, since the late 1970s he has worked mainly with the tape recorder as his instrument, creating drone-based works that accompany his art installations.

His sound-making activities include his interests in electricity, frequency, architecture, and tone in their pure forms. Towards this end he has enlisted radar, oscilloscopes, sonar, and other technologies in his sound work. He is also interested in sound and paranormal activity in the form of communication with the dead. He is inspired by studies of Electronic Voice Phenomenon, in which voices of the dead are heard in radio static. This comes to fruition in the installation *Operation of Spirit Communication* (1998).

In the more socially oriented pieces *Thinner, Low Frequency Bar, Glue (Tobacco),* and *High Frequency Lounge* (Momentum Biennial, 1998) he set up situations in which visitors could smoke cigarettes and sniff paint thinner or glue to the accompaniment of low or high sine tones.

Von Hausswolff is also active as a curator. He organized Freq_Out (2003–present; see pages 70–71), an ongoing festival in which he divides the frequency range from 15 to 12,000 Hz among twelve invited sound artists, gives them a mixing desk and a PA, and lets them compose with their assigned frequencies. Then they play back the results simultaneously in the given space. As curator for Gothamburg's Second International Biennial in 2003, he included sound works by artists, composers, and musicians such

as Ryoji Ikeda, John Duncan, Phill Niblock, Kim Gordon, and Russell Haswell. In addition to his curatorial activities, he created a record label, magazine, and production company called Radium (1986–91), and established another label Anckarström.

JANET CARDIFF (B. 1957)

Janet Cardiff is a Canadian artist who uses sound to create audio walks and installations as well as film installations.

For her audio walks, Cardiff provides participants with headphones and a Walkman or CD player and guides them through a site (such as London's East End or New York's Central Park) via her recorded narration. Underneath her narration, she records sounds by walking through the site while holding a dummy head with microphones on its ears with the aim of capturing the experience of human hearing. She serves as an invisible companion and guide, giving directions for the route, as well as asking questions. She also fabricates events in the narration to blur the line between fact and fiction, some of which do serendipitously occur in the course of a walk, and inserts multiple storylines, usually inspired by sci-fi and film-noir genres, often using herself as a character. Movielike sound effects and other extraneous sounds (conversations, sometimes documentary or historical sounds) are incorporated

into the aural landscape as well.

Unlike much sound art, though, the walks are time-based in that they are created with a beginning, middle, and end in mind. Cardiff's sound walks have taken place in museums as well as through the streets of London and the paths of New York's Central Park. Cardiff has increasingly used video in the walks, giving the participants a camcorder as well as an audio guide, which further displaces the emphasis on sound. With her husband and artistic collaborator George Bures Miller, she has also created installations that reference the film experience, such as *The Paradise Institute* (2001), in which they assembled a sixteen-seat theater where the visitors watched a film that depicted a crime in a way that blurred the line between fiction and reality.

Perhaps more purely in line with the definition of sound art than the audio walks is the installation *40 Piece Motet* (2001; see page 51). Cardiff recorded each voice of a forty-person choir performing a sixteenth-century choral work by English composer Thomas Tallis. The installation consists of forty speakers in which each voice plays through its own speaker. Depending on where one is in the gallery space, a visitor can hear one voice or all in unison. This allows listeners to make their own mix as they walk through the space and to hear the voices in ways that would not be possible in a performance.

MICHAEL J. SCHUMACHER
(B. 1961)

Michael Schumacher is an American composer of electronic and instrumental works who designs and composes computer-generated sound environments. He trained as a pianist and studied composition with avant-garde composer La Monte Young (he later served as technical director for Young's *Dream House*).

One of Schumacher's early works is *The Aural Site* (1991), a continuous eight-channel sound installation in a bar in lower Manhattan, with speakers mounted under the floor and featuring occasional performances by poets and musicians. In 1995 he began "Room Pieces," a series of multi-channel sound installations of extended duration. They sound like a cross between Morton Feldman's sparse compositions and Young's sine-tone environments. "Room Pieces" has developed into installations with up to thirty-seven channels, and live accompaniment by musicians who are given a timetable of when to play but not a score.

In 2004 Schumacher mounted a twenty-four channel electronic sound installation in his own apartment, running night and day. Speakers were installed in every room, closet, and hallway, with different sounds piped into different spaces. The sounds' collective volume and density was also calibrated to the time of day, becoming quieter and more diffuse as day turned to night. Based on this work, he is developing a computer program that would bring changing sound installations into private homes. The software, dubbed Sustento, would feature one of Schumacher's sound compositions as well as works by other composers. Schumacher's piece, entitled *Living Room Pieces*, envisions a "personalized home sound system that incorporates not only his electronic sound environment but ambient sounds from the space, building, neighborhood, the web, the owner's CD collection, field recordings, and, of course, silence."

Schumacher has also developed a computer program featuring five sound installations for the generic home environment. "Sound by nature is somewhat intrusive," he says, and the aim of the software would be to treat "sound as a part of your environment and not as a thing you choose to enhance your mood—the way people put on a CD when they feel like listening to that artist."

Schumacher has been an important figure in bringing sound art to new audiences by operating galleries that feature work by contemporary composers. In New York he ran Studio Five Beekman (1991–2000), with visual artist Ursula Scherrer, and then Diapason (2001–present; see page 111), with dancer and choreographer Liz Gerring. Of Diapason, he has said:

There's sound art, but no sound artists. Specifically for the purposes of Diapason gallery, I use this idea that there aren't so much sound artists as people from a wide variety of disciplines—music, visual art, architecture, computer programming, etc., who make, among other things, sound art. I think this is basically true (though of course there are people who call themselves sound artists), but it is also useful in terms of expanding people's idea of sound art, rather than thinking of it as a narrowly defined discipline with an equally narrowly defined group of practitioners. It also helps in seeing why sound art is different than music, or mixed-media art, since the array of practitioners suggests the inclusion of the features of their respective disciplines in the underlying conception of a work, no matter who's making it.[32]

FRANCISCO LÓPEZ (B. 1964)

"I want to develop a music that shows the possibilities of the openness of content. In this quest, the role of the listener is as important as (if not more than) that of the composer... Music is listening to any sound with dedication. Any listener can be an absolute composer, and for this it is advisable not to go to music school."[33]

Born in Spain and trained as an eco-logist and entomologist, Madrid-based Francisco López is a composer best known for his ambient soundscapes made from processed field recordings.

One of his major works, *La Selva* (1998), is based on his recording of a tropical rain forest in Costa Rica. Instead of adhering to the traditional bioacoustic practice of foregrounding animal sounds against an environmental backdrop, López puts equal value on all the sonic elements of the environment, from animals and rain and wind even to the sounds of plants not readily audible. López stresses that *La Selva* is an artistic version of the forest, not a document of it.

López is interested in "an extreme musical purism." Most of his works are untitled, and he minimizes the sounds' visual referent to the point of asking audience members to wear blindfolds. His albums are marked by extreme dynamics, with long periods of silence interrupted by loud washes of sound, or extremely slow-building crescendos. Particularly in these latter works, López has fashioned a post-Minimalist style of musique concrete that is perhaps more palatable to the contemporary listener than the herky-jerky stylings of his modernist forebears such as Pierre Henry and Pierre Schaeffer.

He also combines sounds of animals or natural phenomena with industrial or

urban sounds. One of the most prolific sound artists, he has nearly two-hundred releases to his credit and has given concerts and created installations in over fifty countries.

STEPHEN VITIELLO (B. 1964)

American musician and media artist Stephen Vitiello has become one of the most ubiquitous figures on the contemporary sound-art scene as curator, artist, and performer.

He began his music career in the late 1970s as a guitarist in punk rock bands. In 1991 he met artist Nam June Paik and worked for him as an assistant. Vitiello was soon composing soundtracks for video, experimental film, and dance, including collaborations with Tony Oursler and Dara Birnbaum.

Vitiello's own sound work began to take off with a piece he did while a resident artist at the World Trade Center in 1999. He attached contact microphones to the windows of his ninety-first floor studio and recorded sounds of the building's movements, the wind, planes, helicopters, traffic, and people below. The results are a compelling soundscape reminiscent of a ship's creaky hull, and have gained additional emotional resonance after the events of September 11, 2001. (The material served as the basis for his 2001 album *Bright and Dusty Things* and as an installation titled *World Trade Center Recordings: Winds After Hurricane Floyd*.)

His installations *Fear of High Places and Natural Things* (2004; see page 31) and *Wind in the Trees* (2005) have suspended speakers lined up in a wave form, with inaudible bass frequencies making them vibrate—heave and percolate, really—they're attractive and make a compact statement on the physicality of sound, image, and silence. Pieces like a book with speakers mounted inside of it (*Noisy World*); solar cells mounted in a space that are wired to turn light frequencies into sound (*Light Readings*); an artist book of found newspaper clippings and drawings that refer to sound without being about music (*Sounds Found*); contact microphones placed on Donald Judd sculptures (*Listening to Judd*); and a microphone rotating above a speaker creating feedback (*Frogs in Feedback*) are perhaps more a consolidation of ideas gleaned from other sound artworks and gestures that may not add more than a few new wrinkles to the form, but do evidence his obvious expertise and commitment.

In 2000 Vitiello curated the exhibition *I Am Sitting in a Room: Sound Works by American Artists 1950–2000* at the Whitney Museum of American Art, which successfully brought attention to sound art. He has since organized numerous sound-art exhibitions in the United States and Europe.

Of his work he has said:

> I think of myself as a sound artist,
> but then when I write my bio
> I tend to cater it to whatever it
> needs to be. So when I've made
> CDs, they've tended to say elec-
> tronic musician Stephen Vitiello,
> or composer, or something like
> that. But really my background
> is playing in punk rock bands in
> the late '70s, then other bands
> in the '80s, and then starting to
> collaborate with visual artists on
> soundtracks . . . I'm not really a
> visual artist although I'm rep-
> resented by two galleries and I
> do make objects, but people still
> say really basic things like: what
> are the dimensions? . . . I talked
> to Kristin Oppenheim, who is
> also a gallery-based sound artist.
> I said, 'What do I do? I have sent
> in CDs to grants panels and they
> said we don't have a CD player,
> send slides.' She said, 'Well,
> take pictures of the speakers and
> write down your title and a short
> description.' Then I got a $30,000
> grant, which paid for my next
> exhibition. But it was a kind of
> crazy thing about fitting into rules.
> I have never managed to get a grant
> as a composer. All the lecturing
> I do and workshop teaching is
> always in visual arts departments,
> even if I'm talking about sound in

relation to video artists or film, or media art in general.[34]

STEVE RODEN (B. 1964)

Steve Roden is a Los Angeles-based visual and sound artist. As a teenager he fronted the Los Angeles punk band The Seditionaries.

Inspired by John Cage, Roden works by way of "self-created systems of translation," in which he devises systems and rules to translate text into images, objects, films, and sound com-positions. For his painting titled *Listen (4′33″)*, Roden translated a text by John Cage that describes the composer's 1952 silent composition *4′33″*. The system Roden used involved converting the alphabet into numbers and the numbers into rules that determined what colors and length of lines to paint.

For his installation *Chamber Music* (2003), Roden created a silent film, a sound piece, and a series of drawings from the list of names given to clouds by nineteenth-century British meteorolo-gist Luke Howard. (Roden has also used a scoring technique called "cloud forma-tions," where he makes a drawing of a cloud shape and uses it as a graphic score.)

Roden describes his work as "lowercase" sound with a sub-ambient emphasis on quiet sounds and silences, and has released recordings under the name In Be Tween Noise. In the 2004

installation *ear(th)*, Roden collaborated with scientists to translate a visual image of the earth's movement during an earthquake into a set of instructions for eighty robots to strike eighty glockenspiel bars. Roden has also created a series of pieces with wine bottles containing small speakers: *The Moon Gatherers* (2002), based on acoustic and electronically processed sounds of bottles being tapped, blown, and played with a violin bow; *Moon Field* (2002–3; see page 30), featuring an old recording of the first-ever transmission from space by Russian cosmonaut Yuri Gagarin in 1961; and *Fulgurites* (2004; see pages 26–29), based on sounds of a violin. And in the 2003 radio piece *One Hour (As the Bumps of Surfaces)* he recorded the sounds made by a banjo and a lap steel guitar that bounced around in the back of his car while he drove from Los Angeles to Santa Barbara and back, sort of an inverse of Christian Marclay's *Guitar Drag* (2000) video. Of his work, Roden has said:

> The majority of sound art tends to work towards the activation of spaces in ways that don't necessarily shift focus to a performer; but reflect attention back towards the existing qualities (sometimes shouting, sometimes hidden) of the space itself (and in particular to the relationship between the space and the sounds being generated within

it). A Rolling Stones concert could happen anywhere—the site is simply part of the deal, determined by the number of people it might hold. This is a very different kind of intention and focus towards site than for the group of artists with whom I walked through downtown Long Beach, trying to find locations that would inspire our sound-walk artworks. Artists were: listening to the amount of outside noise seeping into a space ... wondering whether or not one could interact with these noises or needed to shut them out ... thinking about how much of a distraction an artwork would be in one spot or could be in another ... or possibly attempting to find a place where sound could secretly coexist with a space and remain relatively hidden except to those with the most perceptive of ears.[35]

Notes

What is Sound Art?

1 Annea Lockwood, "What Is Sound Art?" The EMF Institute, http://emfinstitute. emf.org/articles/aldrich03/lockwood. html.

2 Max Neuhaus, accessed at http://www. max-neuhaus.info/bibliography.

3 Christian Marclay quoted in Philip Sherburne, "This Artist Makes Music Like You've Never Seen Before and Art Like You've Never Heard Before," *Interview* (March 2005).

4 Of course, we know from John Cage's famous visit to the anoechoic chamber that there's no such thing as absolute silence anyway, since our own bodily functions make sounds.

5 An interesting work by Hans Peter Kuhn illustrates this need. In 1988 he was commissioned by the city of Berlin for a public sound work as a picnic, with designated food and blankets and cassette players with specially designed soundtracks for eating the picnic lunch.

6 Lawrence Weiner quoted in Heidi Grundmann, "Re-Play," Kunst Radio, http://www.kunstradio.at/REPLAY/cat-text-eng.html.

7 Donald Goddard, "Sound/Art: Living Presences," in *Sound/Art* (New York: The Sound Art Foundation, 1983), 5.

8 Futurist F. T. Marinetti began his *radio sintesi* around the same time, an early montage of various sounds from the real world.

9 Alberto Cavalcanti, "Sound in Films," in *Film Sound: Theory and Practice,* eds., Elisabeth Weis and John Belton (New York:

Columbia University Press, 1985), 98.

10 Early abstract animator Dwinell Grant, who titled his films *Compositions*, felt that they created their own music and should remain silent. Experimental filmmaker Stan Brakhage felt the same way, which has caused consternation among many Brakhage purists in presentations of his films with simultaneous musical improvisation. The *Text of Light* project I have been involved in since 2001 in which silent avant-garde films, mainly Brakhage's, have been screened simultaneous to improvised music made by myself, Lee Ranaldo, and other performers, not as a backdrop or an illustration but in the spirit of live action, mixed-media collage.

11 Of course, Kabuki theater and Merce Cunningham's collaborations with John Cage later in the century use asynchronous sound and image in a live performance situation.

12 Canadian Arthur Lipsett's 1962 film *Very Nice Very Nice* began as an audio collage; he then filmed a series of still photos as visual accompaniment, using incongruities with ironic intent.

13 In fact, it is early Disney cartoons that influence Eisenstein to revise his opinion in the late 1930s, when he developed his idea of vertical montage, where the visual montage is synchronized to the music score by length, rhythms, even melody and texture, which he utilized in *Alexander Nevsky* (1938).

14 Particularly memorable in *Citizen Kane* is a shot of Gettys leaving Kane's house; we hear Welles shouting "Gettys!" as his house door closes which blends perfectly with

a car horn in passing traffic. Welles also placed his actors at different distances from the mics when recording the audio track for Kane, a radio technique which created a sense of depth echoed in cinematographer Gregg Toland's photography.

15 Adrian Martin, "Recital: Three Lyrical Interludes in Godard," in *For Ever Godard,* Michael Temple, James S. Williams, and Michael Witt (London: Black Dog Publishing, 2004), 258.

16 Ibid., 255. ECM has released the entire sound track to Godard's 1990 *Feature Nouvelle Vague* on two CDs (with liner notes by a blind person) as well as a boxed CD set of his *Histoire du Cinema* video series, almost as proof of the split between sound and images in his work.

17 Michael Snow, "Notes *for Rameau's Nephew by Diderot (Thanx to Dennis Young) by Wilma Schoen*" (1974) in *The Collected Writings of Michael Snow* (Waterloo, Ontario: Wilfrid Laurier University Press, 1994), 97.

18 Walter Murch quoted in Michael Ondaatje, *The Conversations: the Art of Editing Film* (New York: Alfred A. Knopf, 2004), 93.

19 Again Dziga Vertov is a parallel here, as his films like *Man with a Movie Camera* developed his idea of the "kino-eye," departing from reality using technical tricks to produce optical effects that would not be seen in real life.

20 Electronic composer Richard Maxfield wrote "if we watch the soloist while we hear the music he makes, we experience a theater piece rather than pure music," while R. Murray Schafer too insists "A soundscape consists of events *heard*, not objects *seen*."

21 Bernhard Leitner, accessed at http://www.bernhardleitner.at/en.

22 Glenn Gould, "The Prospects of Recording," in *The Glenn Gould Reader* (New York: Vintage Books, 1990), 347.

23 Bela Belazs, "Theory of the Film: Sound," in *Film Sound: Theory and Practice,* eds., Elisabeth Weis and John Benton (New York: Columbia University Press, 1985), 124.

24 Bill Viola, "The Sound of One Line Scanning" in *Sound by Artists,* eds. Dan Lander and Micah Lexier (Toronto, Ontario: Art Metropole and Walter Philips Gallery, 1990), 41.

25 Bill Fontana in Julian Crowley, "Cross-Platform: Bill Fontana," *WIRE* (April 2004): 82.

26 Bill Viola, "The Sound of One Line Scanning," 41.

27 Leitner, "Acoustic Space."

28 Ibid.

29 Brant was a student of George Antheil and Teo Macero was a student of Brant's. Although a composer in his own right, whose compositions for multiple jazz orchestras influenced his teacher, Macero is best known for his innovative production and tape editing of Miles Davis's 1970s electric fusion albums, some of which (*On the Corner, Get Up*) arguably share a kind of simultaneism with Brant's compositions.

30 Xenakis also composed acoustic and electronic pieces requiring instruments or multiple speakers positioned at various points in the hall: *Terretektorh* (1965), "for 88 instruments scattered throughout the audience"; *Nommos Gamma* (1967) similarly for ninety-eight instruments; *Kraanerg* (1968) for four-channel tape and

orchestra; and *Persephassa* (1969) "for six percussionists circling the audience." He had similar arrangements for outdoor works including *Persepolis* (1971) with one-hundred louspeakers located among the ruins of Darius's palace in Iran and *La Legend de Er* (1978) first performed at the opening of the Centre Pompidou as a four-channel tape piece.

31 Jonathan Cott, *Stockhausen: Conversations with the Composer* (New York: Simon & Schuster, 1973) 204.

32 Ibid., 200–201.

33 Hans Peter Kuhn takes this idea to new heights in his installations: in *Blue* he moves sounds recorded in a factory among several speakers at hyperspeed, while an installation at New York's Chelsea Piers moves sounds between nine outdoor towers at lightning speed.

34 Dore Ashton, "Sensoria," in *Soundings*, 15–19.

35 Kahn, *Noise, Water, Meat,* 108.

36 Erik Davis, *Led Zeppelin IV* (New York and London: Continuum Publishing, 2006), 72.

37 Ibid., 74.

Environment and Soundscapes

1 R. Murray Schafer, *The Soundscape: Our Sonic Environment and the Tuning of the World* (Rochester, Vermont: Destiny Books, 1994), 104.

2 Jonathan Cott, *Stockhausen: Conversations with the Composer* (New York: Simon & Schuster, 1973), 211.

3 Michael Nyman, *Experimental Music: Cage and Beyond* (Cambridge, England: Cambridge University Press, 1999), 54.

4 Ibid, 59. Cage also gave Satie concerts at Black Mountain playing the piano alone in his cabin while people milled about outside. See Douglas Kahn, *Noise, Water, Meat: A History of Sound in the Arts* (Cambridge, MA: MIT Press, 1999), 179. Building on Wolff's sensibilities, more recently Johannes Sistermann's *Klangcort* (1992) had twenty-four acapella singers in twenty-four different apartments on the same block chant the room tone of their apartment's space at the same time with the windows open.

5 Cott, 210–11.

6 Alvin Lucier, "On Stuart Marshall: Composer, Video Artist, and Filmmaker, 1949–1993," *Leonardo Music Journal* vol. 11(2001): 51.

7 Luigi Russolo, "The Art of Noises: Futurist Manifesto," in *Audio Culture: Meanings in Modern Music*, eds., Christoph Cox and Daniel Warner (New York: Continuum, 2004), 12. An obscure French composer, Carol Bérard, beat Russolo to the punch with the 1908 *Symphony of Mechanical Forces* that employed motors, electric bells, whistles, and sirens, plus another piece composed of recordings of noises called *L'Aeroplane sur la ville*. Kahn, 130.

8 Karin Maur, *The Sound of Painting: Music in Modern Art* (Munich: Prestel Verlag, 1999), 121.

9 This piece was composed as a soundtrack to the abstract film of the same name but never performed with it, until a synchronized version was finally made for a DVD release in 2005 by Unseen Cinema.

10 R. Murray Schafer, "The Music of the Environment," in *Audio Culture,* 32.

11 La Monte Young, liner notes to *The Second*

Dream of the High-Tension Line Stepdown Transformer from the *Four Dreams of China* CD, Gramavision, 1991.

12 Tony Conrad, "Inside the Dream Syndicate," *Film Culture,* no. 41 (Summer 1966) 5.

13 Ibid., 6.

14 John Cale quoted in Victor Bockris and Gerard Malanga, *Up-Tight: The Velvet Underground Story* (New York: Quill, 1983), 13. This recalls a Neo-Futurist quote from Fluxus artist Wolf Vostell: "in the second half of the twentieth century, it is more satisfying and more important, from a socio-aesthetic point of view, to listen to two jet engines for the duration of a four hour air flight than to spend four hours immobile listening to an opera by Wagner." Jean-Yves Bossuer, *Sound and the Visual Arts: Intersection Between Music and Plastic Arts Today* (Paris: Dis Voir, 1993), 97.

15 Suzann Boettger, *Earthworks: Art and the Landscape of the Sixties* (Berkeley: University of California Press, 2002), 24–25.

16 Ibid., 25.

17 Haacke was one of Christian Marclay's instructors in art school.

18 Boettger, 116.

19 Interestingly, Young and Marian Zazeela made an abortive attempt to record for Columbia Records in 1968 in which they went to the beach and sang with "ocean resonances." Spending a week at Columbia executive John McClure's beach house, they rehearsed and had a sound truck come out to record them one day, but "the ocean didn't sound good and the wind was blowing my pitches all over the place." Young asked to try recording again, but the label preferred the idea of simply overdubbing ocean sounds. Young refused and the project stalled.

20 Janet Kraynak, ed., *Please Pay Attention Please: Bruce Nauman's Words, Writings, and Interviews* (Cambridge, MA: MIT Press, 2003), 50.

21 "Biographical Details," http://www.sfu.ca/~westerka/bio.html.

22 Michael Parsons, "The Scratch Orchestra and the Visual Arts," *Leonardo Music Journal* vol. 11 (2001) 7.

23 Ibid.

24 Liz Bear and Willoughby Sharp, "Discussion with Heizer, Oppenheim, Smithson," in *Robert Smithson: The Collected Writings,* ed., Jack Flam (Berkeley: University of California Press, 1996), 246.

25 Wassily Kandinsky, "On the Spiritual in Art," quoted in Kahn, 106.

26 Tony Smith quoted in Boettger, 57. Expanding on this sentiment, Jennifer Licht has said "Art is less and less about objects you can place in a museum," in Boettger, 211. Schumacher, conversation with the author, May 26, 2006.

27 Kahn, 163 and 188. Interestingly, one of Cage's favorite composers, Erik Satie, was friends with Brancusi.

28 Edward Strickland, "The Well-Tuned Piano: An Interview with La Monte Young," *Fanfare* vol. 11, no. 1 (September/October 1987): 85.

29 Glenn Gould, "Advice to a Graduation," in *The Glenn Gould Reader* (New York: Vintage Books, 1990), 6.

30 Cott, 206.

31 Brian Eno quoted in Eric Tamm, *Brian Eno: His Music and the Vertical Color of Sound*

(Boston: Faber & Faber, 1989), 138.

32 Hans Haacke quoted in Lucy Lippard, ed.,
 *Six Years: The Dematerialization of the Art
 Object from 1966 to 1972* (New York:
 Praeger, 1973), 37.

33 Conversation with the author, May 27,
 2006.

34 Ian Murray, "Towards a Definition of
 Radio Art," quoted in Heidi Grundmann,
 "Re-Play," Kunst Radio, http://www.
 kunstradio.at/REPLAY/cat-text-eng.html.

35 Arnold Aronson, *American Avant-Garde
 Theatre: A History* (London: Routledge,
 London, 2000), 115.

36 Young's *Dream House* installations are
 set up so that visitors may spend hours in
 the space and make repeat visits, and he
 notes "it may be necessary to experience
 the frequencies for a long period of time
 in order to tune one's nervous system to
 vibrate harmoniously with the frequencies
 of the environment."

37 Tony Conrad has commented that the
 music he played with Young, John Cale,
 and Marian Zazeela in the '60s "was an
 effort to freeze the sound in action, to listen
 around inside the innermost architecture
 of the sound itself," which suggests that
 the group functioned as a sort of real-time
 performance sound installation, with the
 performers also functioning as audients
 (something Conrad himself has carried on
 in his own performances). Young himself
 has always considered the live appearances
 to be "excerpts" from an ongoing,
 continuous musical work.

38 Bill Fontana "Resoundings," Resoundings,
 http://resoundings.org/Pages/
 Resoundings.html.

39 Akio Suzuki is a sound artist who has
 investigated echoes as an aural method of
 mapping space.

40 Bernhard Leitner, "Acoustic Space: A
 Conversation between Bernhard Leitner
 and Ulrich Conrads," *DAIDALOS*, no. 17
 (September 1985), accessed at http://
 www.bernhardleitner.at/en.

41 Andy Warhol's early silent films, such
 as *Sleep*, *Eat*, *Blow Job*, or *Empire,* which
 show seemingly static, quotidian human
 activity in real time for durations of twenty
 minutes to eight hours are essentially
 moving picture still lifes which become
 transformative through a theatrical
 presentation whose social etiquette
 requires sitting and watching them all the
 way through (although Warhol also held
 that "people can walk in and out as they
 please"). Their silence calls attention to
 the viewer's surroundings and particularly
 the noises in the screening room. As the
 viewer's mind drifts the movie functions as
 a drone. They also dispense with narrative,
 further anticipating "ambient music."

42 David Toop has commented that *Vexations*
 "was creating a kind of machine or
 installation."

43 Quoted in Gavin Bryars, "Vexations and
 Its Performers," JEMS, http://www.users.
 waitrose.com/~chobbs/Bryars.html.

44 Cott, 214.

45 Michael Ondaatje, *The Conversations:
 Walter Murch and the Art of Editing Film*
 (New York: Alfred A. Knopf, 2002), 120.

46 Liner notes to Bill Fontana's CD *Ohrbrucke/
 Soundbridge,* Wergo, Cologne/San
 Francisco, 1994.

47 Les Levine, "The Disposable Transient

Environment," in *0 To 9: The Complete Magazine 1967–1969,* eds., Vito Acconci and Bernadette Mayer (New York: Ugly Duckling Press, 2006).

Sound and The Art World

1 Morton Feldman, "Between Categories," in *Give My Regards to Broad Street: Collected Writings of Morton Feldman* (Cambridge: Exact Change, 2000), 85.
2 Ibid., 86.
3 Feldman, "Crippled Symmetry," in *Give My Regards to Broad Street,* 147.
4 Douglas Kahn, *Noise, Water, Meat: A History of Sound in the Arts* (Cambridge, MA: MIT Press, 1999), 168.
5 Feldman, "The Viola in My Life," in *Give My Regards to Broad Street,* 90.
6 To a limited degree Rauschenberg has also played a role in the movement of sound to the art world; he was a visiting student at Black Mountain College and participated in the first "untitled event" with Cage there in 1952. In his installation of the work *Oracle* in 1965, he had visitors scan a radio dial randomly via remote control, á la Cage, and his 1968 piece *Soundings* had lights on a series of panels that could only be triggered by visitors making loud sounds.
7 Earle Brown, "Transformations and Developments of a Radical Aesthetic," in *Audio Culture: Meanings in Modern Music* (New York: Continuum, 2004), 189.
8 Building on Calder's work, sound artist Ed Osborn has an installation called *Flying Machines* which consists of sounding mobiles, while Gordon Monahan actually swung speakers to create a kind of sonic mobile that produced a replication of the Doppler effect.

9 Feldman, "The Anxiety of Art," in *Give My Regards to Broad Street,* 30.
10 Kahn, 104.
11 Laszlo Moholy-Nagy, "The New Plasticism in Music. Possibilities of the Gramophone," in *Broken Music,* eds., Ursula Block and Michael Glasmeier (Berlin: Gelbe Musik, 1989), 56.
12 Feldman, "A Compositional Problem," in *Give My Regards to Broad Street,* 110.
13 Electronic music becomes, for many postwar composers, the solution (though not for Feldman). Maxfield has written that "electronic music allows that the composer's "terminal art product is no longer just a plan but a definitive realization in recorded form which can be trotted out like a piece of sculpture to show anybody." Conlon Nancarrow's pieces for player piano, in which he punched the scores into automatic piano rolls himself so that the player pianos would play the music without a human performer, are another solution that Feldman didn't think of.
14 Christian Wolff, the first post-Cage composer to begin composing with no musical background, is in many ways an heir to Duchamp's aesthetic, and was recognized as such by Cage himself.
15 George Maciunas quoted in Jean Yves Bosseur, *Sound and the Visual Arts: Intersections Between Music and the Plastic Arts Today* (Paris: Dis Voir, 1997), 90.
16 Matthew Shlomowitz, "Cage's Place in the Reception of Satie," paper as part of doctoral dissertation at University of California, San Diego, accessed online at http://www.af.lu.se/~fogwall/article8.html.

17 Feldman, "Give My Regards to Eighth Street," in *Give My Regards to Broad Street*, 99.

18 Kahn, 273.

19 Held in Wupptertal, one of the participants in the exhibition was local, free jazz saxophonist Peter Brotzmann.

20 Alan Cummings, "Catch a Wave: Takehisa Kosugi," *WIRE* no. 243 (May 2004): 34.

21 Destroy All Monsters in particular reflects the seeping influence of rock music into the art world and a wave of artists inspired by the influx of experimentalism into rock in the mid-to-late '60s and later by punk rock. Andy Warhol's sponsorship of the Velvet Underground is well documented, with the Exploding Plastic Inevitable (a series of multimedia events) being a bid to wrap up Happenings, discotheques, underground filmmaking, and rock music into a pop-zeitgeist one-stop, but little known is his own (futile) attempt at forming a rock band with Claes and Patti Oldenburg, Lucas Samaras, Jasper Johns, La Monte Young, and Walter De Maria ("I was singing badly," he told Glenn O'Brien). The Velvets also opened up Max's Kansas City, an artist's bar on Park Avenue South in New York City, to live music, which it became known for in the 1970s. That decade also found more and more artists abandoning the galleries for the club scene. Alan Vega was a struggling artist doing trashed assemblages with lights and junk who, inspired by Iggy Pop's performances with the Stooges, formed the peerless duo Suicide in 1971 with keyboardist and electronics maven Martin Rev. Some of their early gigs were at OK Harris (the New York gallery that showed Vega's work), although according to Vega they were poorly received by the art world; thirty years later I was unable to get into a show they did at the New York gallery Deitch Projects because it was so packed.

22 Terry Fox is another important figure.

23 The gallery, Holly Solomon, did issue one 45 itself. Tom Johnson, "Laurie Anderson at the Holly Solomon Gallery," in *The Voice of New Music: New York City 1972—1982, A Collection of Articles Originally Published in the Village Voice* (Eindhoven: Het Apollohuis, 1989), 272.

24 When the Beatles released their self-titled "white album," with a cover designed by Pop artist Richard Hamilton in 1968, the initial issue was stamped and numbered, as an artist's multiple edition would be.

25 Another compilation album of the time, *Revolutions Per Minute*, includes a '60s girl-group style tune by Hannah Wilke, a country song by Les Levine, and a straight-up New Wave rocker by Thomas Shannon.

26 Visual artist/musician Marina Rosenfeld's '90s Sheer Frost Orchestra is another latter-day/post–No Wave Scratch Orchestra: an all-female group made up of musicians and nonmusicians that played electric guitars on the floor with nail polish bottles, and included DNA's Ikue Mori and the Static's Barbara Ess.

27 Phoebe Hoban, *Basquiat: A Quick Killing in Art (Revised Edition)* (New York: Penguin, 2004), 49.

28 Irwin Chusid, "Bill Harkleroad a.k.a. Zoot Horn Rollo on his Captain Beefheart Experience," *Seconds*, no. 50 (1999), 62.

29 Gwen Lee and Doris Elaine Sauter, eds., *What If Our World is Their Heaven? The*

Final Conversations of Philip K. Dick (New York: Overlook Press, 2003), 69.

30 Robert Morris created an "answer" to Duchamp's piece with *Box with the Sound of Its Own Making* (1961), where he recorded himself building a wooden box, then pressed "play," and put the tape recorder inside the box (the tape lasted over three hours).

31 Kahn, 196–97.

32 Leonardo Da Vinci made plans, never constructed, for mechanized violins.

33 Liner notes for *The Sounds of Sound Sculpture*, ARC Recordings, Vancouver, 1975.

34 Norbert Moslang, "How Does A Bicycle Light Sound? Cracked Everyday Electronics," *Leonardo Music Journal* vol. 14 (2004): 83.

35 The 1975 *Sounds of Sound Sculpture* exhibition, organized by John Grayson and David Rosenboom in Vancouver, was more definitive, bringing together work by Bertoia, the Baschets, Von Heune, Jacobs, and Reinhold Pieper Marxhausen.

36 Robin Minard, "Musique Concrete and Its Importance to the Visual Arts," in *Resonances: Aspects of Sound Art,* ed., Bernd Schulz (Heidelberg: Kehrer Verlag, 2002), 46.

37 Video artist Valie Export did one sound piece in 1979, a "sound monument" which positioned huge loudspeakers on either side of a bridge in Graz, Austria, from which recordings of belches bellowed forth. The town reacted in a fury, and the piece had to be dismantled. Another example of sound art creating public outrage: Gordon Monahan did a sound installation that was activated over the subway's sound system at every stop, which caused widespread confusion among passengers and was shut down after two days.

38 Bill Viola, "The Sound of One Line Scanning," in *Sound by Artists*, eds., Dan Lander and Micah Lexier (Toronto and Banff: Art Metropole, 1990), 43–44. Vito Acconci has put it more laconically/poetically—"Film=landscape, silence (the sound comes from something too large to be a person—talk functions as background music, myth-making 'titles'). Video=close-up, sound." Vito Acconci, "Some Notes On My Use of Video" in *Vito Acconci,* Frazer Ward (New York: Phaidon, 2002), 100. Much early video art documents performance pieces (Acconci is a good example of this), so the video camera was conceptually more connected to the tape recorder and very early cinema than modern filmmaking.

39 Viola, 46.

40 Bill Viola, "David Tudor: The Delicate Art of Falling," *Leonardo Music Journal* vol. 14 (2004): 52.

41 Ian McMillan, "Wednesday on the Ranch with Bruce," *Modern Painters,* December 2004, 72.

42 Also intriguing, and unknown at the time this video was created, is the fact that the first known film with an audio track, just recently discovered, is footage of William Dickson playing a violin into a recording horn, from 1894, with an accompanying recording of the violin on a cylinder (not synched, of course).

43 Nauman has admitted that the sound goes out of sync in the bouncing ball video due to technical limitations and his own

impatience. Willougby Sharp, "Interview with Bruce Nauman," in *Please Pay Attention Please: Bruce Nauman's Words, Writings, and Interviews,* 145.

44 Bruce Nauman quoted in an interview with Bob Smith in Janet Kraynak, ed., *Please Pay Attention Please: Bruce Nauman's Words, Writings, and Interviews* (Cambridge, MA: MIT Press, 2003), 303. There is also a Nauman video piece called *Violin Tuned D.E.A.D.* where he plays a violin whose strings are tuned to D, E, A, and D.

45 Ibid., 328.

46 Francesco Bernardelli, "Gary Hill," in *Video Art: The Castello di Rivoli Collection*, eds., Ida Ginaelli and Marcella Beccaria (Milan: Skira Editore, 2005), 104.

47 Michael Ondaajte, *The Conversations: Walter Murch and the Art of Film Editing* (New York: Alfred A. Knopf, 2002), 6.

48 Ibid., 9.

49 Ibid., 19. Or scenes like the one in John Ford's *Stagecoach*, where different music is coming out of every bordello on one street; Welles is said to have screened *Stagecoach* repeatedly before making *Citizen Kane* and uses a similar scene in *Touch of Evil.*

50 Ibid., 119.

51 Ibid., 52.

52 Ibid.

53 *The Conversation* also has several symbolic touches that suggest the importance of sound over image—the mime who is often in the frame with the couple as they're being recorded, or the recordist's trip to confession, where he hears the priest's voice but doesn't see him.

54 Ondaajte, 102. Much also used a musique concrete technique in the making of the sound of a horde of crickets for Coppola's *Apocalypse Now* by multiplying the sound of one cricket dozens of times, noting that "you wouldn't get the same sound if you recorded thousands singing at the same time." So while the sound is recognizable as crickets, it's not naturalistic as the sound of many crickets would make together.

55 Feldman, "Between Categories," in *Give My Regards to Broad Street,* 88.

56 Brian Eno, "Works Constructed in Sound and Light," quoted in *Brian Eno: His Music and the Vertical Color of Sound,* Eric Tamm (Boston: Faber & Faber, 1989), 138.

57 This is unconvincing as sound must surely exist in places where there is no one to hear it (like subterranean areas or outer space).

58 In his 2002 work *Mapping the Studio (Fat Chance John Cage)* Nauman videotaped his studio in his absence at night to record the comings and goings of his cat and several mice which had infested the studio. Lasting nearly five hours as an installation, the bare setting calls particular attention to outside sounds and the limited indoor sounds (heating fans). The Cage reference is inspired by the chance operations of the cat and mice's movements.

59 Bernhard Gal did a similar experiment with a piece of luggage checked at an airport in *Soundbagism* (2004).

60 Sam Adams, "Sounds on the Fringe," *Philadelphia City Paper*, August 28– September 4, 1997.

61 Ibid.

62 Peter Shapiro, "The Illbient Alliance," *WIRE* no. 154 (December 1996): 30.

63 Surprisingly, the world's only sound art museum is not in Germany, but in Rome.

64 There have been many examples of this over

the course of the twentieth century, such
as Edouard Manet and Stephen Mallarme,
Blaise Cendars and Fernand Leger, Tristan
Tzara and Jean Arp, Clark Coolidge and
Philip Guston, and Richard Tuttle and
Charles Bernstein.

Artists' Biographies

1 Harry Bertoia quoted in Julia Cass, "A
 Musician's Sculptor, " in *The World of
 Bertoia*, eds., Nancy N. Schiffer and Val O.
 Bertoia (Atglen, PA: Schiffer Publishing,
 2003), 177.
2 François Baschet, from the liner notes to
 Chronophagie (The Time Eaters), music
 by Jacques Lasry (mid-1960s), Columbia
 Masterworks Records, Undated (mid-
 1960s).
3 Similarly, Snow's 1974 film *Rameau's
 Nephew by Diderot (Thanx to Dennis
 Young)* by Wilma Schoen experiments
 heavily with asynchronous sound although
 he was unaware of Jean-Luc Godard or
 Isidore Isou's work in the same vein.
4 Michael Snow in an interview with Pierre
 Theberge, *The Collected Writings of Michael
 Snow* (Waterloo, Ontario: Wilfrid Laurier
 University Press, 1994), 201.
5 Alvin Lucier in an interview with Frank
 Oteri, newmusicbox.org, April 2005.
6 Alvin Lucier, "In Conversation with
 Douglas Simon," in *Sound By Artists*
 (Toronto: Metropole & Walter Phillips
 Gallery, 1990), 196.
7 Rob Forman, "Phill Niblock at 70," *Weekly
 Dig.*
8 Paul Panhuysen quoted in the introduction
 to untitled essay by Ken Overton, http://
 eamusic.dartmouth.edu/~kov/soundArt/

PaperIntro.html.
9 Paul Panhuysen quoted in Rene van Peer,
 "From Common Ground: Jerry Hunt and
 Paul Panhuysen in Conversation," 1993,
 http://www.jerryhunt.org/van_peer.asp
10 Joe Jones quoted in Rene van Peer,
 "Interviews with Sound Artists Taking
 Part in the Festival ECHO," *The Images of
 Sound by Rene van Peer* (Eindhoven: Het
 Apollohuis, 1993), 13.
11 La Monte Young, "Lecture 1960," in
 Selected Writings, La Monte Young and
 Marian Zazeela (Munich: Heiner Friedrich,
 1969).
12 Alan Licht, "Random Tone Bursts: Yasunao
 Tone," *WIRE* no. 233 (September 2002):
 32.
13 Ibid., 31.
14 Hermann Nitsch, "The Depth of the
 Universe" (October 1986), from liner notes
 to his CD *Harmoniumwerk Vols. 9–12*,
 Cortical Foundation, 2000.
15 Bernhard Leitner quoted in an interview
 with Wolfgang Pehnt, *Künstler im
 Gespräch, Documenta-Documente*
 (Cologne: Artemedia, 1984), accessed at
 http://www.bernhardleitner.at/en.
16 Annea Lockwood quoted in an interview
 with Frank Oteri, *New Music Box*, www.
 newmusicbox.org, January 2004.
17 Rolf Julius quoted in Rahma Khazam,
 "Cross-Platform," *WIRE* (November 2005):
 82–83.
18 Max Neuhaus quoted in Alicia Zuckerman,
 "Max Neuhaus's Times Square," Arts
 Electric, 2002,
 http://www.arts-electric.org/
 articles0203/020530.neuhaus.html.
19 Nobuhisa Shimoda, "Interview: Continuing

Along the Stepping Stones," in *Akio Suzuki "A" Sound Works Throwing and Following* (Saarbrucken: Stadtgalerie Saarbrucken, 1997), 79.

20 Terry Fox quoted in an interview with Rene van Peer, "Interviews with Sound Artists Taking Part in the Festival ECHO," *The Images of Sound II* (Eindhoven: Het Apollohuis, 1987), 86.

21 Ibid., 62.

22 Maryanne Amacher quoted in Leah Durner, "Maryanne Amacher: Architect of Aural Design," *EAR* (February 1989): 29.

23 Charlemagne Palestine quoted in an interview with France Morin, *Performance by Artists*, eds., A. A. Bronson and Peggy Gale (Toronto: Art Metropole, 1979), 109–10.

24 Bill Fontana quoted in Julian Crowley, "Cross-Platform: Bill Fontana," *WIRE* (April 2004): 82.

25 Bill Fontana, "Resoundings," Resoundings, http://resoundings.org/Pages/Resoundings.html.

26 Christina Kubisch quoted in an interview with Sabine Breitsameter, Audiohyperspace, www.swr.de, September 2002.

27 Brian Eno quoted in Gene Kalbacher, "Profile: Brian Eno," *Modern Recording & Music* (October 1982), accessed at http://music.hyperreal.org/artists/brian_eno.

28 Brian Eno, "Ambient Music," from liner notes to *Ambient #1: Music for Airports*, Edition E.G., 1978.

29 Trimpin quoted in Jean Strouse, "Perpetual Motion: Trimpin's Sound Sculpture," *The New Yorker* (May 8, 2006): 40.

30 Mike Kelley quoted in Edwin Pouncey,

"Anti Rock Consortium: Mike Kelley," *WIRE* (September 2003): 36.

31 Marclay quoted in Alan Licht, "CBGB as Imaginary Landscape: The Music of Christian Marclay," in *Christian Marclay* (Los Angeles: UCLA Hammer Museum, 2003), 97.

32 Interview with the author, May 27, 2006, and in an email June 24, 2006.

33 Francisco López quoted in an interview with *The Montreal Mirror*, October 2000, http://www.franciscolopez.net/int_mm.html.

34 "Stephen Vitiello & Marina Rosenfeld" transcript of videotaped interview February 9, 2004, http://www.newmusicbox.org/article.nmbx?id=2414

35 Steve Roden quoted in "Active Listening," accessed at http://www.inbetweennoise.com/activelistening.html.

Index